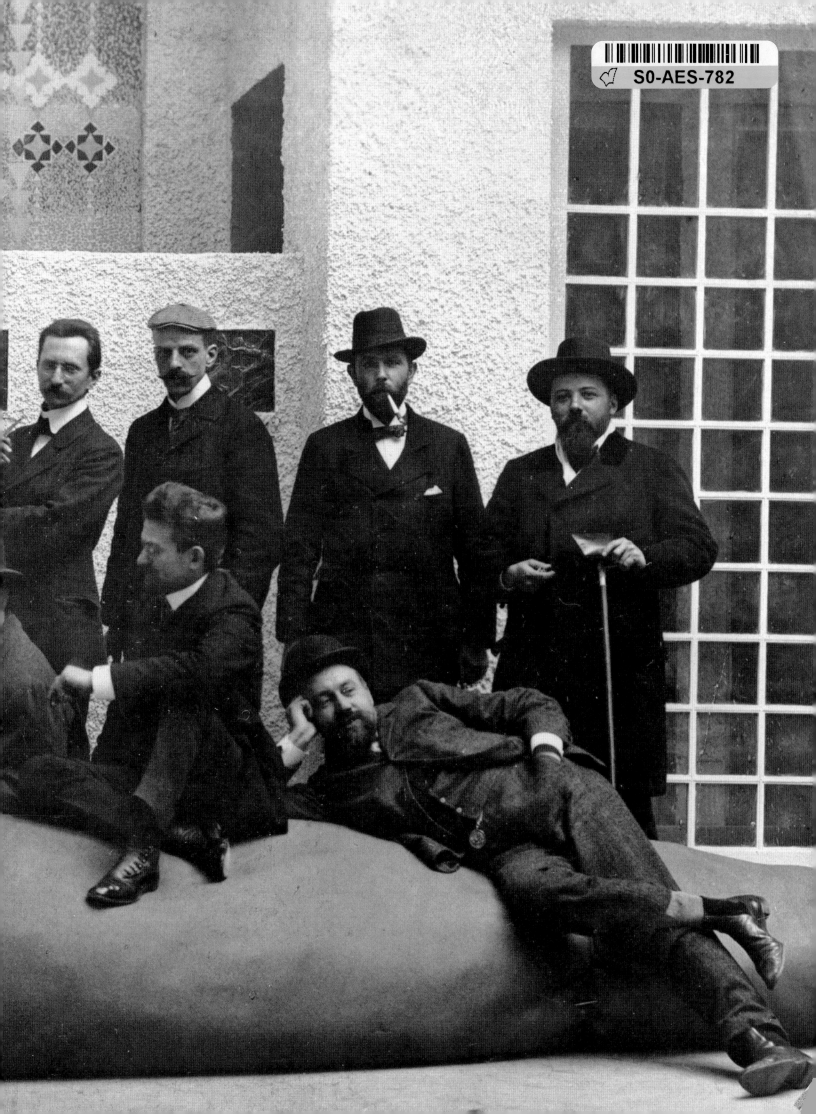

Gustav Klimt
The *Beethoven Frieze*

Gustav Klimt

The *Beethoven Frieze*

And the Controversy over the Freedom of Art

Edited by Stephan Koja

With texts by
Stephan Koja
Manfred Koller
Verena Perlhefter
Rosa Sala Rose
Carl E. Schorske
Alice Strobl
Franz A. J. Szabo

PRESTEL
Munich · Berlin · London · New York

Contents

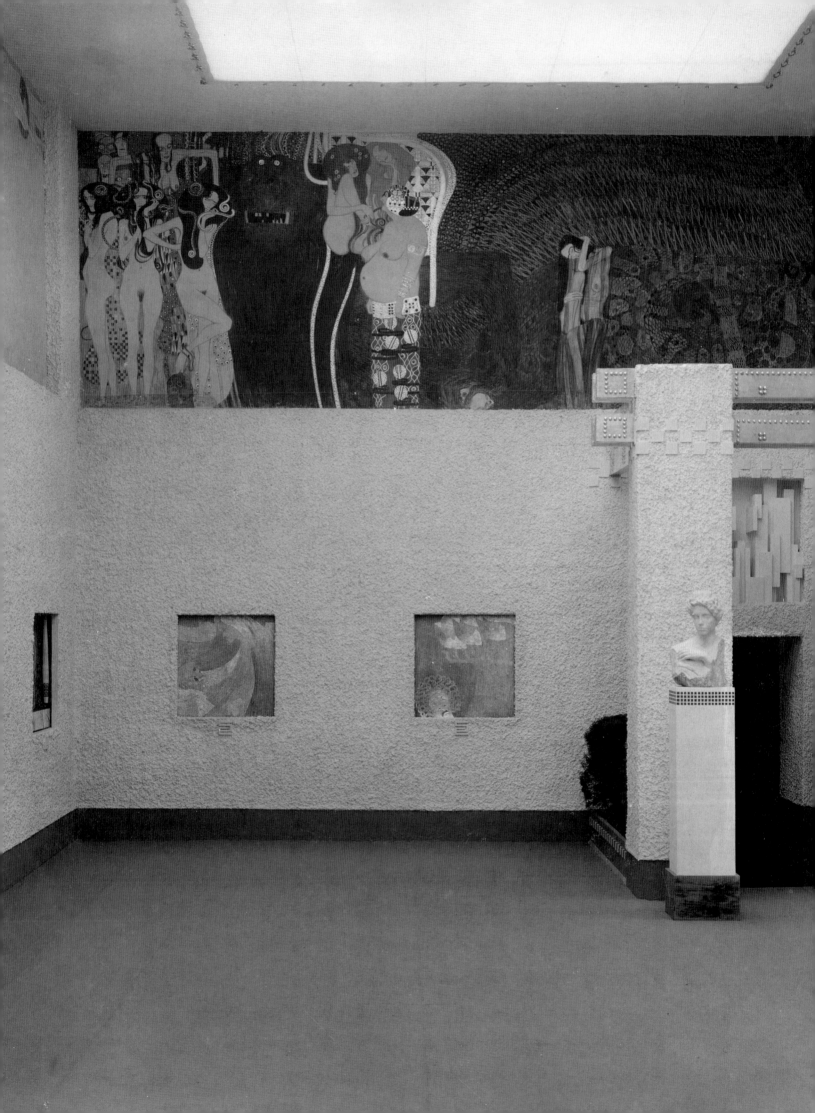

Stephan Koja

Foreword

At the end of the nineteenth century, Vienna underwent a period of radical social change and artistic awakening. With its economic prosperity, the so-called *Gründerzeit* era made many things possible. The vast building project associated with the demolition of the Viennese barricades and the new conception of the city as the capital of the empire had, literally, opened up new perspectives. This was an indication of a radical, generous new beginning which did not stop even at the old quarters of the city, the witnesses to its history.

This same spirit was also seen in the endeavours of the Viennese Secession, founded in 1897, in its striving for an artistic renewal and its desire to set the artistic world of the empire in a broader, international context. A programmatic exhibition hall was constructed in a clear, purist — but still very dignified — architectural style. Exemplary exhibitions were organised which were intended to create a new style of exhibition practice, and their successes were acknowledged throughout Europe. Indeed, internationalism, an important feature of Vienna at this time, was a key component of their view of the arts. They were well aware of what was happening in Europe and the wider world, looking eagerly from eastern Europe to Britain, Spain and Scandinavia, and recognising at an early stage the importance of Japanese art for contemporary art and design. They were also keen to explore the impact of new artistic means of expression like photography by presenting the work of some of the most important Pictorialists in an exhibition.

However, their message was not revolutionary, and certainly not in a political sense. The aim, rather, was the aestheticising of life, a desire to permeate all areas of life with art and thereby to establish an almost redemptive function for art. (Only a few years later, this desire was to find its expression in the founding of the Wiener Werkstätte, whose goal was to overcome the estrangement between craftsman and consumer brought about by the mechanisation of manufacturing.) Consequently, the Secessionists became fascinated by the idea of a 'total work of art' (*Gesamtkunstwerk*) as an answer to the fragmentation of the arts and of ideologies. They wanted a new beginning, a new approach to both art and life.

At the same time, it was precisely Viennese artist who — in spite of their striving for modernity — showed a strong sense of continuity, as can be seen in their interest in symbolism, the decorative arts, public commissions, and the priest-like image of the artist.

Many of these attitudes were shared by Klimt, who, as one of the major personalities of the movement of renewal, had a direct formative influence on many of its projects.

Though he had an early success in the art world of the Danube Monarchy, and saw himself as the legitimate successor to the 'painter-prince' Hans Makart, Klimt took on a public role in support of the new art with great self-confidence. From the beginning he held a dominant position within the Secession, a fact made clear by the photograph of the artists who participated in the 1902 Beethoven Exhibition: Klimt, the first president of the Secession, sits enthroned on a chair designed by Ferdinand Andri, surrounded by his fellow artists.

In his efforts to bring about a renewal of art, Klimt sought for a new truth: that of modern man. Rejecting the naturalism of the previous generation, he attempted to arrive at this new truth by delving into the world of individual experience, the realm of the psyche and the sometimes hidden driving forces in man.

And to do this he did not employ the rationalism of the Enlightenment, that artistic ideal beloved of the liberal bourgeoisie of Vienna, but relied on his own individual interpretation of the world, developing a highly personal symbolism. Art now became a space for soul-searching and contemplation. In this attempt to explore the truth about modern human condition, Klimt began above all to explore the world of sexuality and Eros.

It is no coincidence that Klimt painted Schiller's words "If you cannot please all with your deeds and art, please a few; it is not good to please many" above his *Nuda Veritas*. For in his exploration of these themes it has to be said that he was occasionally quite explicit, and some of his images have to be seen as provocative. One has only to think of *Danae*, a work whose real subject — even if dressed as 'mythology' — is obviously sexual pleasure. In the *Beethoven Frieze*, the stylised male and female sexual organs that appear behind the *Hostile Forces* express the same theme boldly and thereby — by their placement there, and whether consciously or subconsciously — link sex with guilt.

The *Beethoven Frieze* is one of Klimt's key works. Here his artistic concerns — as well as many of his decisive sources and formative influences — are displayed in concentrated form. The frieze is both an expression of the philosophical ideas of the time — particularly those of the highly esteemed thinkers Schopenhauer, Nietzsche and Wagner — and of Klimt's current artistic credo. The *Beethoven Frieze* demonstrates impressively how Klimt took up previously developed visual ideas and here formed them into an effective and cohesive whole. At the same time, the programme of the frieze is embedded in a tradition which reaches back to the artistic programmes of the Baroque: the conquest of evil, hostile forces by the powers of good. There is, for example, the programme of the frescoes in the Imperial Court Library in Vienna, with its 'peace wing' and 'war wing.' Ultimately, this series of pictures leads to a depiction of peace, and Carl VI is depicted as both Hercules and Apollo, figures who flank the medallion containing his portrait. These principles live on in the *Beethoven Frieze*.

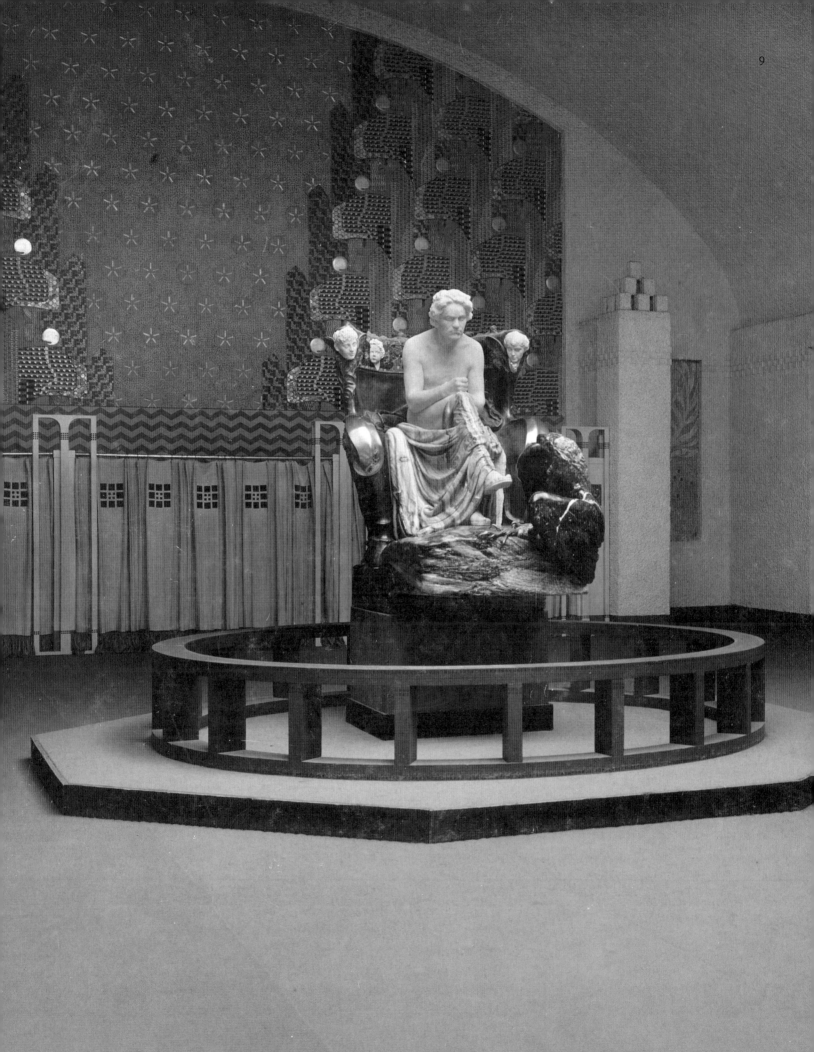

Similarly, in Hans Canon's *Cycle of Life* painting on the staircase of the Museum of Natural History in Vienna, a major work of historicism, all the atrocities and life-threatening forces that beset mankind are finally dissolved into the positive new beginning of the eternal cycle of life.

The *Beethoven Frieze* also demonstrates Klimt's involvement in the international art scene, and in particular his self-image in relation to international debates. He paid particularly close attention to the artistic developments in the rest of Europe, and his pictures, which were exhibited internationally, won prizes and were among the few to be reproduced in exhibition catalogues. In the *Beethoven Frieze* we can see how he made a triumphant entry into the art world by fashioning these many sources — Japanese art, Aubrey Beardsley, Minne, Khnopff, Jan Toorop and others — into an unmistakeable and very personal style.

The *Beethoven Frieze* is, therefore, a major work in a new artistic development. Klimt was searching for a renewal of the pictorial language in which intellectual content was conveyed through ornament. The two-dimensionality of the figures in the *Beethoven Frieze* allowed him to visualise abstraction (though he conceived the *Hostile Forces* of the frieze as considerably more concrete in their representation, with *Lasciviousness*, Lust and Excess being depicted more naturalistically). Klimt, who would never completely give up the artistic language of the period in which he received his education, also used ancient mythology to express modern experience: tradition and modernity are always very close to each other in his works. This makes the *Beethoven Frieze* a statement of the power of art to overcome the adversities and hostile powers of life as well as to provide a refuge from the brutal reality of the world. In this frieze, the tensions of life are dissolved in the harmony of the ornaments in the *Choir of the Angels* of Paradise and in the magnificence of the shimmering gold surrounding the embracing couple in the last section, a scene reminiscent of his later famous painting *The Kiss*.

When Klimt painted the *Beethoven Frieze*, the scandal over his ceiling painting for the ceremonial hall of the new main building of the University of Vienna had already reached its first furious high point. The press had begun to attack him and the professorial staff to organise their opposition.

That is the subject of this book and of the exhibition *La destrucción creadora* at the Fundación Juan March in Madrid — these years of confrontation over the freedom of art, and over art's public role in Vienna.

At the time, there were still clear memories of Whistler's famous lawsuit against John Ruskin in 1877/78, which Whistler, fighting for artistic freedom, had won — though with the symbolic awarding of just one farthing in damages. Whistler was admired by the Secessionists; they had often invited him to send works to be exhibited in the Secession, and he had indeed become a corresponding member of the society.

In hindsight, the Klimt controversy can be regarded as an exemplary clash over society's understanding of the artist and of the freedom of art. It was explicitly acknowledged by his supporters as a debate over basic principles.

Thus, this major artistic scandal at the beginning of the twentieth century, on the

threshold to the Modern, shows all the familiar characteristics of such conflicts: the deliberate building up of emotions, the manipulation of public opinion, and the appropriation of the conflict to achieve other goals. It quickly becomes clear that the real issues were not artistic, cultural or ethical, but political, revolving around the issues of universalism, the demand for the unity of the state, nationalism, and anti-Semitism.

Many of the arguments put forward by both Klimt's supporters and opponents one hundred years ago parallel those employed today. The question of just how free a public art can be is always controversial. In this respect, the debate over the *Beethoven Frieze* was one of many.

Klimt was ultimately unable to take the pressure. His main cause for deep concern was the ambivalence of the government, which had originally commissioned the work in the University but then failed to support him fully. The first part of his response was a programmatic statement: "The state shouldn't be playing art patron when all it provides is charity at best. The state shouldn't arrogate to itself the dictatorship of the exhibition business and artist discussions where its duty is to act only as an intermediary and commercial agent and leave the artistic initiative entirely to the artist." And although he made a striking decision to regain his artistic liberty by repaying the state (with the financial support of a friend) for the advance payments made on the faculty paintings, he was now seized by a serious personal crisis that ultimately led to his withdrawal from all public commissions and made him a private painter — of portraits and landscapes, and hardly of any allegorical paintings.

However, the importance of the struggle by Klimt and his comrades-in-arms in the Secession in the search for freedom of artistic expression cannot be overestimated. It made it possible for the following generations to turn their gaze to subjects that required a more intense personal response, and at the same time created a forum for open discussion.

As a consequence, artistic development in Vienna did not go in the direction of abstraction, as was the case in other art centres, but towards a greater, often dramatic, truthfulness towards reality.

It was the Expressionist painters, including Gerstl, Kokoschka and Schiele, who followed this ethic of uncompromising candour — and who did not shy away from an openly subjective approach to art. They accepted that they would have to take on the role of the outsider, the misunderstood, in society — they even stylised this as a sign of their being the 'chosen ones' in their self depiction as martyrs — notions which were already present in Klimt's priest-like self-interpretation.

In this way, Klimt opened the door to a completely new self-identity for the artist.

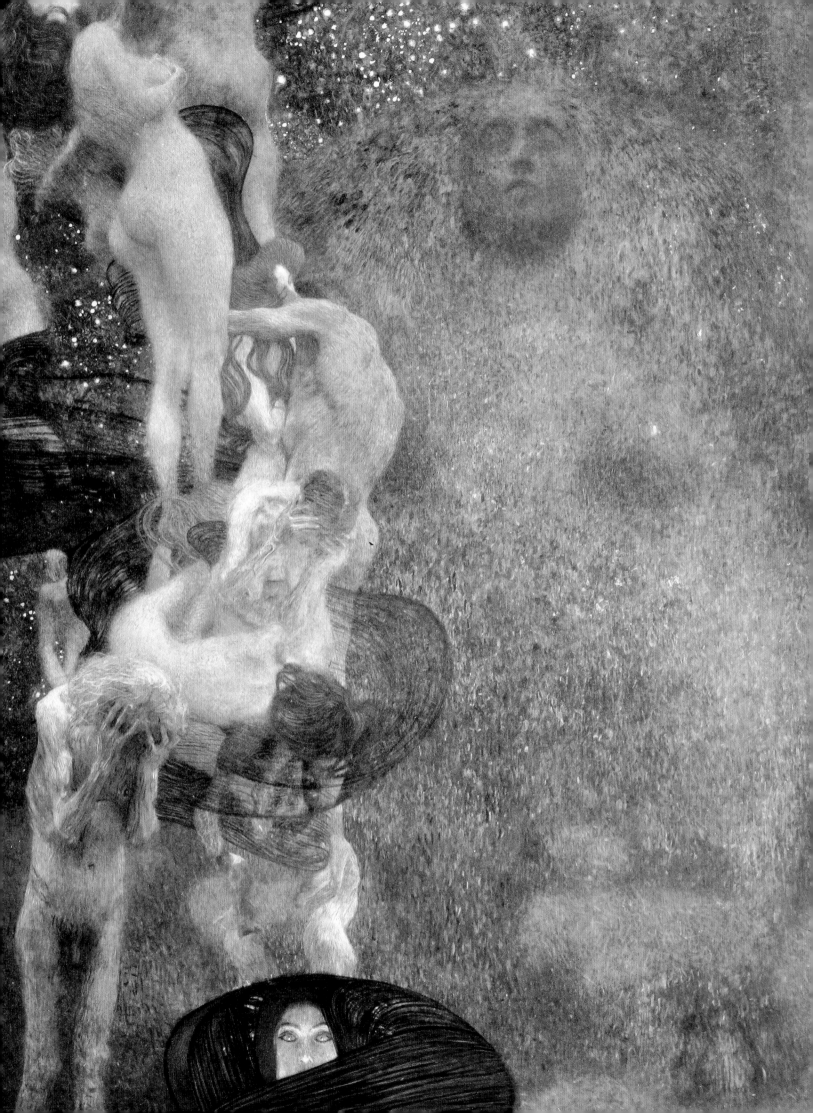

Carl E. Schorske

Gustav Klimt's Faculty Paintings and the Crisis of the Liberal Ego

In 1894, the Ministry of Culture, after consultation with a faculty committee, invited Klimt to design three ceiling paintings for the ceremonial hall of the new University. At that time, Klimt had just risen to prominence as the young master decorator of the Ringstrasse, of which the new University was one of the final monumental projects. But by the time he executed the commission (1898–1904), Klimt had become deeply engaged in the Secession movement and in his own quest for new truth. Painting his new vision for the University project, he brought upon himself the wrath of both old rationalists and new anti-Semites.[1] In the course of the ensuing struggle, the function of modern art in Vienna was vigorously debated by painters, public, and politicians alike. Out of that struggle, the limits of Secessionist radicalism were set with unmistakable clarity. Klimt's personal defeat in the battle brought an end to his role as subverter of the ancient way. It led him both to a more restricted definition of his mission as artist of modernity and ultimately to a new, abstract phase in his painting.

The program of the University paintings was conceived by Klimt's academic clients in the best Enlightenment tradition: "The triumph of light over darkness." Around a central panel on this subject, to be designed by Klimt's partner, Franz Matsch, four paintings were to represent the four faculties. Klimt was to execute three — *Philosophy*, *Medicine*, and *Jurisprudence*. After some preliminary disagreements in 1898 over his initial designs, the faculty commission and the Ministry of Culture granted Klimt a free hand. In 1900 he presented his first painting, *Philosophy*, and in 1901, *Medicine*.

Neither picture reflected an easy conquest of Light over Darkness. In *Philosophy*, Klimt showed himself to be still a child of a theatrical culture. He presents the world to us as if we were viewing it from the pit, a *theatrum mundi* in the Baroque tradition. But where the Baroque *theatrum mundi* was clearly stratified into Heaven, Earth, and Hell, now Earth itself seems gone, dissolved into a fusion of the other two spheres. The tangled bodies of suffering mankind drift slowly by, suspended aimless in a viscous void. Out of the cosmic murk–the stars are far behind–a heavy, sleepy Sphinx looms all unseeing, herself but a condensation of atomised space. Only the face at the base of the picture suggests in its luminosity the existence of a conscious mind. *Das Wissen*, as the catalogue calls this figure,[2] is placed in the rays of the footlights, like a prompter turned around, as though to cue us, the audience, into the cosmic drama.

Klimt's vision of the universe is Schopenhauer's — the World as Will, as blind energy — in an endless round of meaningless parturience, love and death. Peter Vergo has suggested that Klimt drew his understanding of Schopenhauer from Wagner, especially from the latter's concise summary of the philosopher's thought in his widely read essay *Beethoven*, and that the iconography as well as the message of *Philosophy* was influenced by

Gustav Klimt, *Philosophy*,
1898–1907 (detail)
Oil on canvas, 430 x 300 cm
Destroyed 1945

Ceiling of the Great Hall of Vienna University on the Ringstrasse, with copies of the faculty paintings.
Reconstruction by Alice Strobl

Das Rheingold.[3] The figure of Erda, as model for *Philosophy*, in both her placement and her mantic posture, supports such an interpretation.[4] Yet Wagner's Erda is a warm, grief-laden earth-mother; Klimt's *Wissen* is cool and hard. Nor does she worry any more than Klimt and his prosperous patrons about the curse of gold that was so decisive for the politically charged Wagner and his cosmic heroes. Klimt's philosophic priestess betrays in her eerily luminous eyes a different attitude: a wisdom, at once wild and icy, affirming the World of Will. This rendering points, in my view, rather to Nietzsche's than to Wagner's reading of Schopenhauer's existential metaphysic.

Even Nietzsche's explication of his Midnight Song in the glowing finale of *Thus Spoke Zarathustra* reads as though written to elucidate Klimt's painting.[14] Conversely, Klimt's entranced priestess with vine leaves in her hair could serve as an illustration of Nietzsche's midnight singer — "this drunken poetess" who has become, as her luminous upturned eyes suggest, "overwakeful [*überwach*]."[5] Like Nietzsche's poetess, Klimt's *Wissen* ingests into dream the pain — and, more, desire itself [*Lust*] — to affirm life in its mysterious totality: "Do you say 'yes' to a single desire? Oh, my friends, [then] you say 'yes' to all pain." As in Klimt's floating chain of being, "all things . . . are interlinked, entwined, enamoured . . . thus you shall love the world."[6]

It was not thus that the professors of the University saw or loved the world. They had a different conception of "the triumph of light over darkness," and of how it should be represented in their halls. Klimt's painting touched a nerve end in the academic body. His metaphysical *Nuda veritas* had led him, with a few other intellectuals of his generation, into a terrain beyond the established limits of reason and right. Eighty-seven faculty members signed a petition protesting against the panel, and asking the Ministry of Culture to reject it. The fat was in the fire. Klimt's art was becoming an ideological issue and soon would be a political one.

They accused Klimt of presenting "unclear ideas through unclear forms (*Verschwommene Gedanken durch verschwommene Formen*)." The critics' striking adjective, *verschwommen*, suggested well the liquefaction of boundaries which we have seen in the picture. While respecting the virtuosity with which Klimt had employed colour to create an atmosphere to suit his "gloomy fantasm," this virtue could not compensate for the chaos of symbols and the confusion of form they saw as revealing the incoherence of the idea behind the painting. Lacking intellectual grasp, Klimt had produced an aesthetic failure, they maintained.[7]

The rector, a theologian named Wilhelm von Neumann, supporting the professorial resisters, went to the heart of the controversy. In an age when philosophy sought truth in the exact sciences, he said, it did not deserve to be represented as a nebulous, fantastic construct.[8] The ideal of mastery of nature through scientific work was simply violated by Klimt's image of a problematic, mysterious struggle in nature. What the traditionalists wished was evidently something akin to Raphael's *School of Athens*, where the learned men of antiquity — Plato, Aristotle, Euclid, and others — are shown in calm discourse on the nature of things. One professor suggested a scene in which the philosophers of the ages would be shown assembled in a grove, talk-

ing, relaxing, tutoring students.[9] It should be noted that these suggestions centre on a *social* imagery: learned men functioning in society, spreading mastery of nature and human life. Klimt's *Philosophy* had indeed outflanked the social element. In his universe, the socially supported structure of mastery had disappeared in the face of an enigmatic, omnipotent nature and the interior feelings of impotent man caught up in it.

A group of ten professors, led by the art historian Wickhoff, submitted a counter-petition to the Ministry, denying that faculty members had the expertise to make judgments in aesthetic questions.[10]

Franz Wickhoff (1853–1909) brought to Klimt's cause more than his professional authority, important though that was. Along with Alois Riegl (1858–1905), Wickhoff was developing a new view of art history peculiarly suitable to creating understanding for innovation in art. The motto which the Secession had inscribed on its building in 1898 — "To the Age its Art, to Art its Freedom" — could equally have served Wickhoff's emergent Vienna school of art history. As Klimt and the Secession rejected the Beaux Arts tradition and the classical realism of Ringstrasse culture, so Wickhoff and Riegl in the nineties assaulted the primacy of the classical aesthetic. Where their mid-century predecessors dismissed late Roman and early Christian art as decadent in relation to the Greek model, the new scholars saw an original art justified by the new cultural values which gave rise to it. 'Decadence' for them was not in the object but in the eye of the beholder. This produced not progress and regression, but eternal transformation.

Wickhoff and Riegl thus brought to art history the late liberal, non-teleological sense of flux so common in *fin-de-siècle* culture, and so clear in Klimt's *Philosophy* itself.

'What Is Ugly?' In a polemical lecture on Klimt under that title given at the Philosophical Society, Wickhoff suggested that the idea of the ugly had deep bio-social origins, still operative in Klimt's antagonists.[11] Primitive man saw as ugly those forms which seemed harmful to the continuation of the species. Historical man, to be sure, had attenuated this connection. As long as the dominant classes and the people had continued to share a single set of ethical and religious ideals, artists and patrons had moved forward together, with new conceptions of the natural and new standards of beauty evolving together. In recent times, however, humanistic and antiquarian studies had imbued the public with a sense of the primacy, if not the superiority, of classical art. Thus there arose an antithesis between the past-oriented public and the ever-progressing artist. Throughout modem times, Wickhoff said, the educated classes, led by the men of learning–prestigious but "second-class minds" — had identified beauty with the work of the past. They came to perceive as ugly the new and immediate visions of nature generated by artists. Such hypertrophied historical piety, Wickhoff argued, was now reaching its end. The present era has its own life of feeling, which the artistic genius expresses in poetic-physical form. Those who see modem art as ugly, he implied to his philosophic audience, are those who cannot face modern truth. Wickhoff ended his lecture with an eloquent interpretation of Klimt's *Philosophy*. He singled

out the figure of *Wissen* as one who shone forth a consoling light, "like a star in the evening sky" of Klimt's oppressive, spaced-out world.

Although the debate between the two cultures that Jodl and Wickhoff represented — old ethics and new aesthetics — raged on the podium and in the press in the spring and summer of 1900, it was in the political sphere that the issue would be finally decided. Indeed, Klimt's painting achieved full significance only in its wider political context. Always an important constituent in Austrian public life, in the year 1900 art came to occupy a particularly crucial place in state policy. Modern art, ironically enough, came into official favor just when modern parliamentary government was falling apart. Why?

From 1897 to 1900, the nationality problem, with its conflicts over language rights in administration and schooling, had virtually paralysed the government. Parliamentary obstructionism, led by the Czechs and Germans in turn, had finally rendered the construction of ministries out of party representatives impossible. The monarchy, which had begun its constitutional era in 1867 with a *Bürgerministerium* (Citizens' Ministry), suspended it in 1900 with a *Beamtenministerium* (Bureaucrats' Ministry). Austrian liberalism thus reverted to its eighteenth-century tradition of enlightened absolutism and bureaucratic role. The formation of the Beamtenministerium in 1900 was entrusted to an able and imaginative official, Dr Ernest von Koerber (1850–1919), who was determined to transcend the hopelessly dissonant political substance of Austria and to role the country by decree as long as necessary. Koerber's long-range strategy was to outflank political, national tensions by a two-pronged campaign of modernisation, one in the area of economics, the other in culture. For four years, 1900–1904, Koerber's ministry pursued its effort to save Austria through economic and cultural development.

Within this framework of supra-national policy, state encouragement of the Secessionist movement made complete sense. Its artists were as truly cosmopolitan in spirit as the bureaucracy and the Viennese upper middle class. At a time when nationalist groups were developing separate ethnic arts, the Secession had taken the opposite road. Deliberately opening Austria to European currents, it had reaffirmed in a modern spirit the traditional universalism of the Empire. A Secession spokesperson had explained her commitment to the movement as "a question of defending a purely Austrian culture, a form of art that would weld together all the characteristics of our multitude of constituent peoples into a new and proud unity," what, in another place, she called a "Kunstvolk" (an art people).[12] The Minister of Culture, even before the formation of the Koerber ministry, revealed in strikingly similar terms the assumptions of the state in creating an Arts Council in 1899 as a body to represent its interest. He singled out the potential of the arts for transcending nationality conflict: "Although every development is rooted in national soil, yet works of art speak a common language, and entering into noble competition, lead to mutual understanding and reciprocal respect."[13] Even while proclaiming that the state would favor no particular tendency and that art must develop free of regimentation, according to its own laws, the minister showed special solicitude for modern art. He urged the new Council "to sustain . . . the fresh breeze that is blowing in domestic art, and to bring new resources to it." Thus

Gustav Klimt, *Medicine*, 1901–1907 (detail)
Oil on canvas, 430 x 300 cm
Destroyed 1945

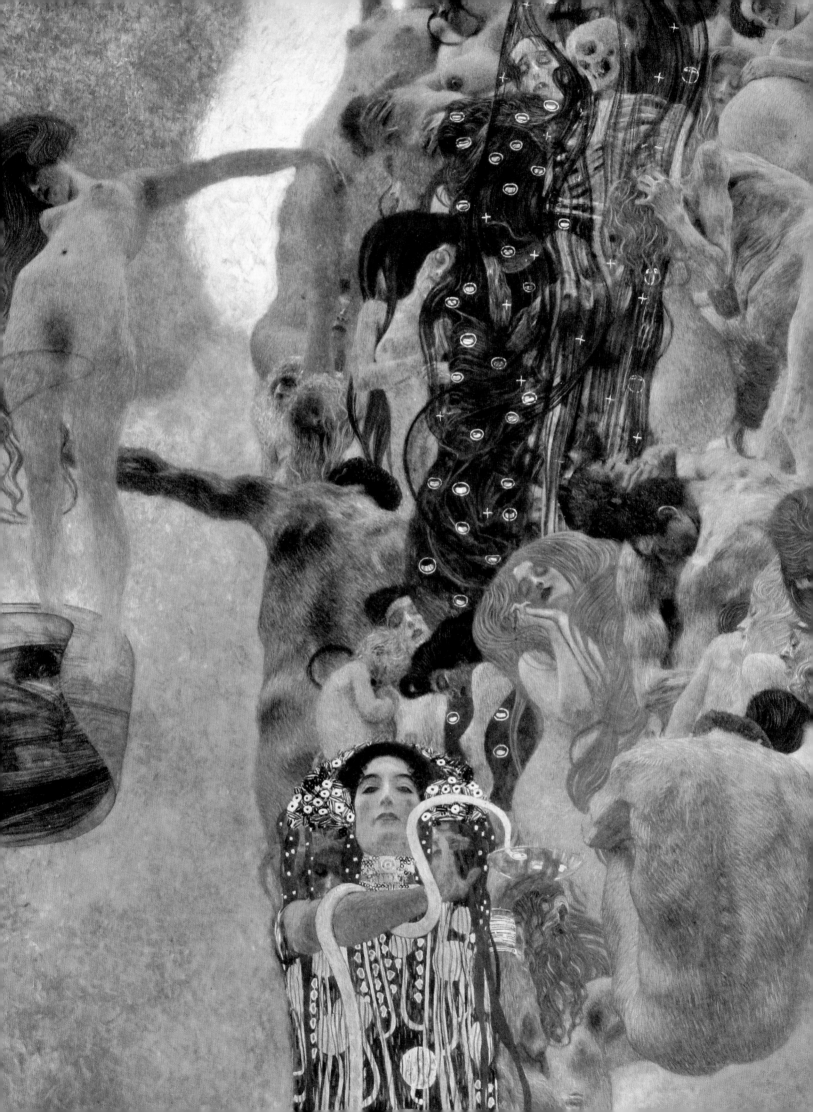

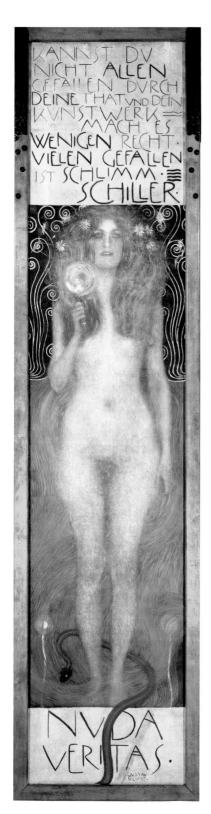

Gustav Klimt, *Nuda Veritas*, 1899
Oil on canvas,
252 x 56.2 cm
Österreichisches Theatermuseum, Vienna

it came about that, while other European governments still shied away from modern art, the ancient Habsburg monarchy actively fostered it.

The arts project dearest to Hartel, however, and one vigorously pressed by the Secession from its inception, was the creation of a Modern Gallery. It was ratified by the emperor in June 1902, and opened its doors in April 1903. Meanwhile, Hartel actively collected by purchase and gifts the artworks for the state's modern collection. Such was the policy context in which Klimt's University paintings were received.

Alas for Klimt and the government's intentions, official patronage of the Secessionists did not pass unchallenged. The language of the new art, far from softening the antagonisms of a divided nation, fed fuel to the flames. From the halls of the University, they spread to the press, and soon to the political arena. It was one thing for the government to cope with professors who scented a subversive counterculture in Klimt's first ceiling painting — Minister von Hartel and his Arts Council simply ignored their petition.[14]

Undaunted by the attacks on his work, and fortified by Baron von Hartel's quiet but firm rejection of the professorial protest, Klimt went on to complete the companion piece to *Philosophy*. On the Ides of March 1901, *Medicine* was shown for the first time at the House of the Secession. Again Klimt confronted the culture of scientific progress with an alien and shocking vision. He presented medicine's field of action as a phantasmagoria of half-dreaming humanity, sunk in instinctual semi-surrender, passive in the flow of fate. Death dwells centrally within this river of life, his black veil swirling strong among the tangled bodies of the living. As in *Philosophy*, there is a priestess figure at the forefront to mediate between the spectators and Klimt's existential *theatrum mundi*: Hygeia. A proud, tall, powerful female, Hygeia is the last of the androgynous protectrix types that marked Klimt's middle period (1897–1901). Like most of the others before her — two of the three Athenas, *Nuda veritas* and *Wissen* — Hygeia confronts the beholder frontally, imperiously, as though forcing from us a recognition of the existential vision behind her. The spectacle of suspended lives over which Hygeia presides is marked by a contrast between the discrete, molded substantiality of the individual figures and the formlessness of their relations in space. The figures drift at random, now locked together, now floating apart, but almost always impervious to each other. Although the bodies sometimes unite, no communion exists among them. Thus the individual psycho-physical experience of sensuality and suffering is abstracted from any metaphysical or social ground. Mankind is lost in space.[15]

Klimt made no attempt to represent the science of medicine as its practitioners conceived it. The reviewer for the *Medizinische Wochenschrift* could with justice complain that the painter had ignored the two main functions of the physician, prevention and cure.[16] His Hygeia merely proclaims in her hieratic stance, through the symbols Greek tradition gave her, the ambiguity of our biological life. In Greek legend, Hygeia is ambiguity *par excellence*; accordingly, she is associated with the snake, the most ambiguous of creatures. Along with her brother Asclepius, Hygeia was born a snake out of the

tellurian swamp, the land of death. The snake, amphibious creature, phallic symbol with bisexual associations, is the great dissolver of boundaries: between land and sea, man and woman, life and death. This character accords well with the concern with androgyny and the homosexual reawakening of the *fin de siècle*: expressions of erotic liberation on the one hand and male fear of impotence on the other. Wherever dissolution of the ego was involved, whether in sexual union or in guilt and death, the snake reared its head. Klimt had exploited its symbolism defensively with Athena, aggressively with *Nuda veritas*, seductively with his watersnakes. Now he employs it philosophically with Hygeia, goddess of multivalences. Hygeia, herself an anthropomorphic transformation of the snake, offers to the serpent the cup of Lethe, to drink of its primordial fluid.[17] Thus Klimt proclaims the unity of life and death, the interpenetration of instinctual vitality and personal dissolution.

Such symbolic statement can be apprehended without being rationally comprehended, as Klimt's contemporaries showed. While Hygeia evoked aggressive reactions, Klimt's most hostile critics had no understanding for the meaning of the snakes and Hygeia's stern play with them. Their indignation found focus and expression rather in the "indecency" of the figures in the background. Nudity had, in the great tradition, been legitimised by idealising its representation. What offended in Klimt was the naturalistic concreteness of his bodies, their postures and positions. Two figures particularly outraged conventional sensibilities: the female nude at the left of the picture, floating with her pelvis thrust forward, and the pregnant woman in the upper right.[18]

With *Medicine*, the thunder that had rumbled at *Philosophy* broke into a violent storm, with crucial consequences for Klimt's self-consciousness both as man and as artist.[19] No longer was it mere professors who attacked his work, but powerful politicians as well. The public prosecutor ordered the confiscation of the issue of *Ver Sacrum* containing drawings of *Medicine* on the grounds of "offence against public morals." A legal action was successfully taken by the Secession's president to lift the censor's ban, but the atmosphere remained heavy with anger.[20]

At the same time, a group of deputies of the Old and New Right, including Mayor Lueger, put pressure on Minister von Hartel, calling him to account in the Reichsrat. In a formal interpellation, they asked the minister whether, through the purchase of *Medicine*, he intended to recognise officially a school of art that offended the aesthetic sense of a majority of the people. Thus the Koerber government's policy of using modern art to heal political cleavages began to deepen them instead. Von Hartel, out of his personal commitment to the new art, originally drafted a defiant response to his critics, praising the Secession for revitalising Austrian art and restoring its international standing. "To oppose such a movement," his draft speech concluded, "would be evidence of total failure to understand the responsibilities of a modern policy in the arts; to support it I regard as one of our finest tasks."[21]

The experience of public obloquy and professional rejection meanwhile struck Klimt with stunning force. The evidence of the depth of his reaction lies not in literary sources — Klimt was given to almost no verbal utterance — but in his art. After 1901 his paint-

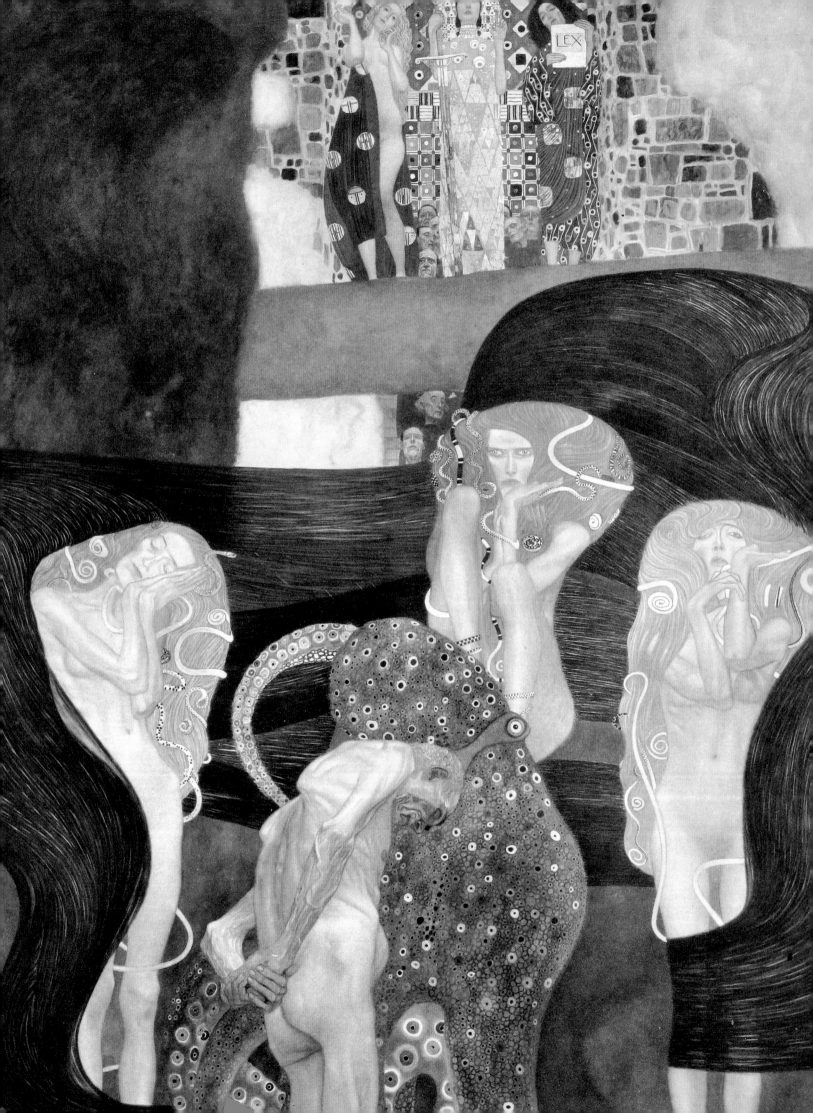

ing manifested two diametrically opposed emotional responses, both symptomatic of a wounded, weakened ego: rage and withdrawal. For each of these responses, during four years of painful oscillation between fight and flight, Klimt developed a separate visual language. We know too little of his personal life to be able to trace his psychological development with clear biographical evidence. That he was in his forties when the crisis broke in earnest may have added private personal ingredients to his public misfortune. What can be said is only what his painting suggests: that Klimt underwent a "reshuffling of the self." For he created an art of anger and allegorised aggression that dissolved his earlier organic style. This in turn yielded place to an art of withdrawal and utopian abstraction. The external event which formally sealed his break with public authority was his suit for the repurchase of his controversial University paintings from the Ministry in 1905.[22] But his counterattack against his critics began in his painting as early as 1905 in the wake of the crisis over *Medicine*. In the third and last of his University ceiling paintings, *Jurisprudence*, Klimt gave his rage its most vehement expression.

During the controversy over the first two paintings, *Jurisprudence* had not progressed beyond the preliminary form of an oil sketch submitted in 1898. When Klimt turned to execute it in 1901, he was ready to invest the work with all his indignation and his sense of injury. The subject — law itself, the most revered feature of Austria's liberal culture — lent itself well to his seething will to subversive statement.

When Klimt began to work on *Jurisprudence* in 1901,[23] he had before him the composition study which he had submitted to the Kunstkommission in May 1898. That sketch differed both in spirit and in style from its companion pieces, *Philosophy* and *Medicine*. The priestess of *Philosophy* and Hygeia in *Medicine* were mysterious, mantic types, in solemn, static postures, while the figure of Justice was at first conceived as active and alive, swinging her sword as she swept through the air to ward off the threat of a shadowy octopus of evil and crime below. Klimt clearly idealised Justice in this version, treating her with the lucent, energetic brush strokes of a Whistler woman-in-white. The spatial ambiance also differs from that of *Philosophy* and *Medicine*; instead of the heavy, viscous atmosphere of the latter, *Jurisprudence* has a bright and airy one. Thus Klimt originally saw Justice as free of the ambiguities of Philosophy and Medicine. To set it off from these, he employed the same contrast in style and technique as in the two panels for the Nikolaus Dumba music room, *Music* and *Schubert*. Where he had conveyed a psycho-metaphysical reality by means of a substantialist, naturalistic technique, he used evanescent, impressionistic means to portray an ideal.

When he resumed work on *Jurisprudence* in 1901, after the University controversy, Klimt drastically altered his conception. The new version must be viewed in relation to the earlier sketch of *Jurisprudence* as well as to *Philosophy* and *Medicine* to appreciate just how drastic was his change in view. The scene has moved from the breeze-swept Heaven of version I to an airless Hell. No longer is the central figure a soaring Justice but rather a helpless victim of the law. In working out the new image, Klimt incorpo-

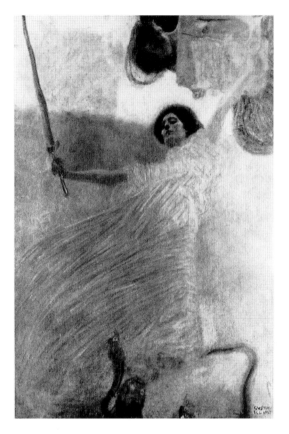

Gustav Klimt, *Jurisprudence*, composition sketch, 1897/98
Oil on canvas, dimensions unknown
Destroyed 1945

Gustav Klimt, *Jurisprudence*, 1903–1907 (detail)
Oil on canvas, 430 x 300 cm
Destroyed 1945

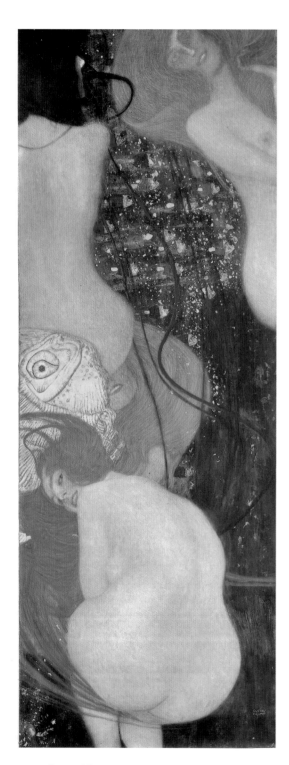

Gustav Klimt, *Goldfish*, 1901/02
Oil on canvas, 181 x 66.5 cm
Kunstmuseum Solothurn, Dübi-Müller-Stiftung

rated three suggestions which the commissioners of the paintings had made for the improvement of the 1898 version. But he did so ironically, so that each change increased the element of terror in his rendering of the law. The commissioners had asked for (1) a "clearer characterization of the central figure"; (2) "greater calm in the tone of the picture"; and (3) a "corresponding improvement to the painting's noticeable void in the lower half." In reply to the first request, the male in the tentacles of the law replaced in all-too-concrete realism the sheer, diaphanous impressionism of Justice in version I. Klimt replaced the fresh, agitated sky of version I with the static, clammy 'calm' of society's execution chamber. And the "noticeable void" was now filled with the frightening spectacle of the law as ruthless punishment, consuming its victims. Thus the painter obeyed all three of his clients' injunctions in a strict literal sense, while flouting their values more aggressively than ever before.

In relation to the two completed panels, Klimt in *Jurisprudence* broke connections too. He transformed the space, inverted the structure, and radicalised the iconography. The fictive space of Philosophy and *Medicine* was still conceived like a proscenium stage in three receding vertical planes. The viewer's perspective was from the audience's side of the footlights. The allegorical figures, *Wissen* and Hygeia, stood in a second plane, stage front, below, mediating between the spectators and the cosmic drama, which itself occupied the third, deepest spatial plane, and dominated the whole. In *Jurisprudence*, the entire space is raked in a unified, receding perspective, but also bisected laterally into an upper and a nether world. Where in version I the focus was celestial, in version II it is infernal, subterranean, even submarine. In the upper world, far removed from us, stand the allegorical figures of Jurisprudence: Truth, Justice, and Law. Iconographically they are the equivalents, the sisters, of Hygeia and the philosophic priestess. But unlike the latter figures, they perform no mediating role to bring us closer to the mysteries of their sphere. On the contrary, in their withdrawal to their lofty perch they abandon us to the realm of terror to share the nameless fate of the victim. Thus only the pretensions of the law are expressed in the ordered upper portion of the picture. It is the official social world: a denatured environment of masoned pillars and walls ornamented in mosaic-like rectilinear patterns. The judges are there with their dry little faces, heads without bodies. The three allegorical figures are impassive too, beautiful but bloodless in their stylised geometric drapes.

The furies who preside over the execution are at once *fin-de-siècle femmes fatales* and Greek maenads. Their sinuous contours and seductive tresses were probably inspired by the female figures of the Dutch *art nouveau* painter Jan Toorop.[24] But Klimt has endowed them with the cruel, Gorgon-like character of classical maenads. Not the idealised figures above, but these snaky furies are the real "officers of the law." And all around them in the hollow void of hell thick swirls of hair entangle and envelop in a terrible sexual fantasy.

Other paintings of the years 1901 to 1903 expressed the defiant mood that dominated *Jurisprudence*. From *Medicine* Klimt lifted as subjects for independent paintings

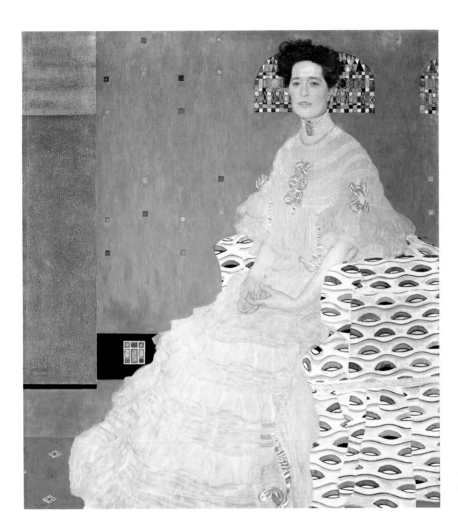

Gustav Klimt, *Portrait of Fritza Riedler*, 1906
Oil on canvas, 152 x 134 cm
Österreichische Galerie Belvedere, Vienna

the two figures that had most offended moralistic opinion. With a deliberate will to shock, he developed their frank sensuality even further. One, entitled *Goldfish*, showed a nude impudently displaying her luscious bottom to the viewer. Klimt had planned to call it *To My Critics* until friends dissuaded him.[25] The other painting, *Expectancy* (*Hoffnung*), presented in more finished form the pregnant woman who had so scandalised the public in *Medicine*. Klimt rendered his subject with a maximum of sensitivity for the ambiguous feelings of a woman in the last heavy weeks before delivery. Both pictures increased the tension between the painter and the Ministry of Culture. In 1903 Baron von Hartel persuaded the reluctant Klimt not to exhibit *Expectancy* lest he should jeopardise the acceptance of his University murals.[26] The Ministry also tried to prevent the showing of *Goldfish* in an exhibit of Austrian art in Germany.[27] Then it refused to allow Klimt's *Jurisprudence* to be the central work of the Austrian exhibit at the St. Louis Fair of 1904.[28] The gulf between the assertiveness of the artist and his friends and the caution of the bureaucrats was growing wider.

After the University crisis, Klimt gave up philosophical and allegorical painting almost entirely. In his previous phases — whether as purveyor of the values of Ringstrasse historicism or as the Secession's philosophic seeker after modernity — Klimt had been public artist. He had addressed his truths to what he assumed to be, at least potentially, the whole society. He had wanted and received contracts from public authorities to formulate universal messages. Now he shrank back to the private sphere to become painter and decorator for Vienna's refined *haut monde*. Perhaps the greatest achievements of Klimt's last fifteen years lay in his portraiture of women, most

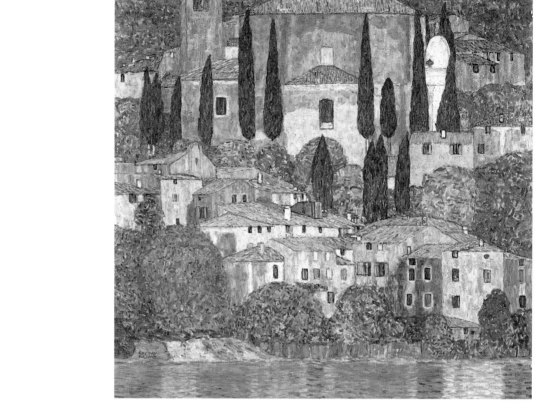

Gustav Klimt, *Church in Cassone*, 1913
Oil on canvas, 110 x 110 cm
Private collection

of them members of wealthy Jewish families. Cheerful landscapes, especially well-ordered gardens, likewise provided subjects for his later painting. The organic dynamism of his style in the *art nouveau* period disappeared, in favour of a static, crystalline ornamentalism. In stance as in style, transcendence replaced engagement.

Text revised by the author, based on his book: *Fin-de-siècle Vienna: Politics and Culture*, New York, 1980.

1. The most detailed analysis of the controversy is by Alice Strobl, 'Zu den Fakultätsbildern von Gustav Klimt,' *Albertina Studien*, II, 1964, pp. 138–169. Hermann Bahr, *Gegen Klimt*, Vienna, 1903, provides a valuable collection of documents.
2. Christian M. Nebehay, *Gustav Klimt. Dokumentation*, Vienna, 1969, p. 208.
3. Peter Vergo, 'Gustav Klimt's "Philosophie" und das Programm der Universitätsgemälde,' *Mitteilungen der Österreichischen Galerie*, 22/23, 1978-79, pp. 94–97.
4. Vergo shows how closely both the stage directions for Erda's first appearance in *Das Rheingold* and the substance resemble Klimt's colour and composition. Vergo, see note 3, pp. 94-97.
5. Klimt had originally conceived the allegorical figure of *Wissen* in the traditional manner of a seated female in profile, bowed in thought like Rodin's thinker. Only in 1899 did he substitute the Nietzschean midnight singer rising in challenging frontality. See note 2, pp. 214-16, figs 311–315. The text of the petition is partially reproduced in Strobl, see note 1, pp. 152–154.
6. Friedrich Nietzsche, *Also Sprach Zarathustra*, part IV, 'Das trunkene Lied,' section 10.
7. The text of the petition is partially reproduced in Strobl, see note 1, pp. 152–154.
8. Strobl, see note 1, p. 153.
9. Emil Pirchan, *Gustav Klimt*, Vienna, 1956, p. 23.
10. Bahr, see note 1, pp. 27–28.
11. 'Was ist hässlich?' The lecture was not reprinted in Wickhoff's collected papers. My discussion of it is based on the extensive report which appeared in the *Fremdenblatt* for 15 May 1900, reprinted in Bahr, see note 1, pp. 31–34.
12. Berta Zuckerkandl, *My Life and History*, pp. 141–143; Berta Szeps-Zuckerkandl, 'Wiener Geschmacklosigkeiten,' *Ver Sacrum*, I, no. 2, February 1898, pp. 4–6.
13. Allgemeines Verwaltungsarchiv, *Protokoll des Kunstrates*, Feb. 16, 1899.
14. Strobl, see note 1, II, p. 153.
15. For a fine reading of *Medicine*, see Franz Ottmann, 'Klimt's "Medizin,"' *Die Bildenden Künste*, II, 1919, pp. 167–171.
16. Quoted in Bahr, see note 1, p. 59.
17. See J. J. Bachofen, *Versuch über die Gräbersymbolik der Alten, Gesammelte Werke*, Basel, 1943 *et seq.*, IV, pp. 166–168. Whether Klimt developed his careful iconography of Hygeia and the snake out of Bachofen, I do not know.
18. Bahr, see note 1, pp. 41–59.
19. A sample of press criticisms is given in Bahr, see note 1, pp. 41–59.
20. Bahr, see note 1, pp. 47–49.
21. Quoted in Strobl, see note 1, p. 168, n. 87. Von Hartel proudly cited Klimt's winning a gold medal for *Philosophy* at the Paris Exposition of 1900.
22. Strobl, see note 1, pp. 161–163; Nebehay, see note 2, pp. 321–326.
23. The date as established by Dobai on the basis of the style; see Fritz Novotny and Johannes Dobai, *Gustav Klimt*, Salzburg, 1967, p. 330.
24. On Toorop at the Secession show of 1900, see Ludwig Hevesi, *Secession (März 1897-Juni 1905). Kritik–Polemik–Chronik*, Vienna, 1906, p. 241; on *Jurisprudence* as a whole, pp. 444–448; on Toorop and Klimt, pp. 449–50. See also the article on Toorop in *The Studio*, I, 1893, p. 247, with its illustration of Toorop's *The Three Brides*.
25. The figure in *Medicine* on which *Goldfish* was based was painted over in the final state reproduced in Figure 46. See Novotny and Dobai, see note 23, pl. 124, p. 325; Nebehay, see note 2, p. 260.
26. Ludwig Hevesi, see note 24, p. 446.
27. Novotny and Dobai, see note 23, p. 325.
28. Nebehay, see note 2, p. 346.

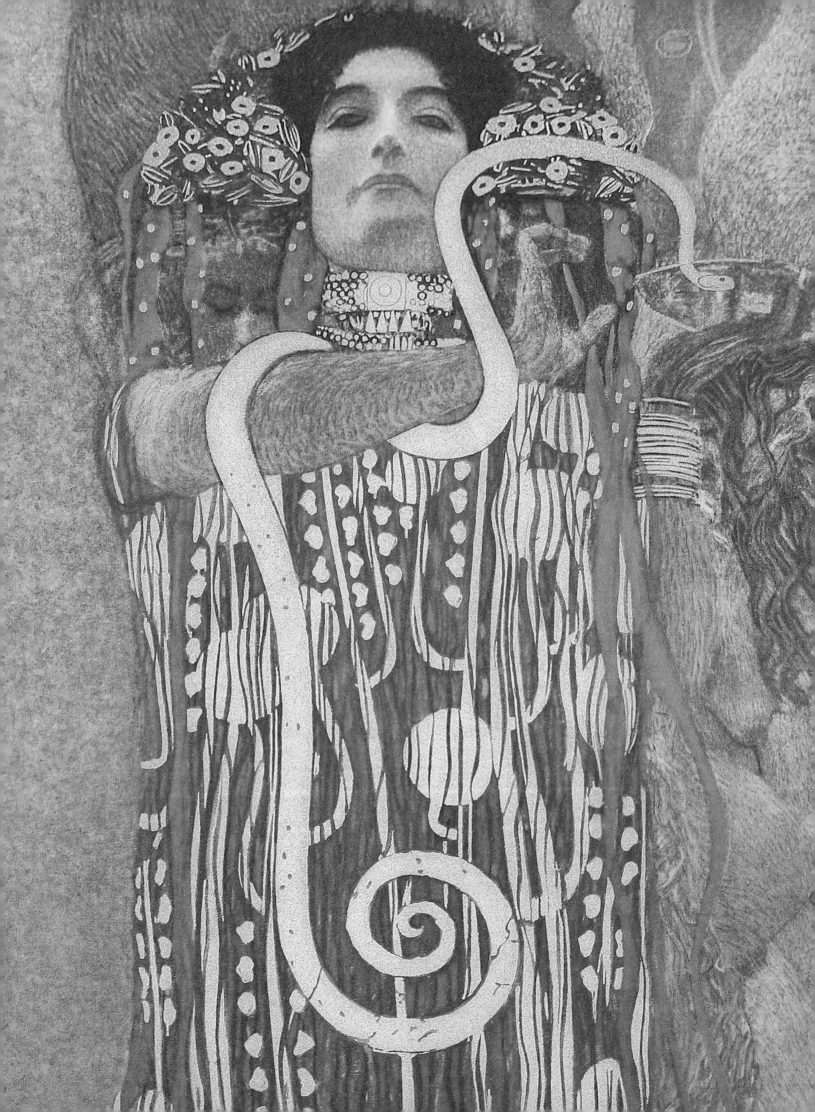

Alice Strobl

Klimt's Studies for the Faculty Paintings *Philosophy, Medicine* and *Jurisprudence*

The commission for the ceiling paintings for the ceremonial hall of the University of Vienna in 1894 was one of Gustav Klimt's greatest challenges, and he found the key to the sophisticated compositions through numerous studies.

This allows us to identify most of the stages in the development of both *Philosophy* and *Medicine*; however, the extant sketches for *Jurisprudence* are much less complete. The sketches for *Philosophy, Medicine* and *Jurisprudence* reach from the first conceptual sketches, through the transfer plan for the first and second stages, to the final result in 1907. The frequent changes and the addition of new figures resulted in a correspondingly large number of studies. There are hundreds of drawings, necessitated in part by Klimt's increasingly precise study of the individual figures. This applies particularly to the figure in *Medicine* which was most denounced — the floating woman — which Klimt prepared in a great number of studies (ills pages 53–56).

Two ignored studies for Hygeia, showing the goddess of healing enthroned on a cloud and holding the bowl with the serpent in her right hand can be linked to the sketches presented jointly by Franz Matsch and Klimt in 1894. Here, the first mention is made[1] of the drawings for the faculty paintings. One of them,[2] on the reverse[3] of which are two studies for *Schubert at the Piano*, the sopraporta painting for the Palais Dumba, can be seen as one of the earliest studies for Hygeia (ill. page 57). It fits in very well with the sketch for the central painting, *The Triumph of Light over Darkness*, which Franz Matsch presented for appraisal by the art commission of the ministry on 21 June 1894, and which was subsequently accepted. On 6 July 1894, they unanimously recommended commissioning this painting from the artists Franz Matsch and Gustav Klimt, and, in the minutes of the meeting of 4 September 1894, there is a record of the two artists being granted the commission. They committed themselves to producing the colour sketches necessary for the painting on a scale of 1:10 and to presenting them, before undertaking work, to the Ministry of Culture and Education. The sketches were to remain the property of the artists. There was no intention of making a cartoon. A total honorarium of 60,000 guldens — consisting of 20,000 guldens for the central painting, 5,000 guldens for each of the four additional ceiling paintings, and 20,000 gulden for the spandrels — was foreseen for the execution of the paintings.[4] Paragraph eight of the minutes stipulated that, should one of the artists be prevented from continuing with his assignment, the other would have to complete the work.

In accordance with the programmatic sketch for the arrangement of the ceiling and spandrel paintings from 1896, Gustav Klimt's *Philosophy* was to be placed next to Franz Matsch's *Theology*, and Klimt's *Jurisprudence* alongside his *Medicine*.[5]

Gustav Klimt, *Hygeia*
(detail from *Medicine*)
Illustrated in colour
reproduction from *Das Werk
Gustav Klimts*, Vienna 1914

Gustav Klimt, *Study for Hygeia*
(detail from *Medicine*), 1901
Illustrated in *Ver Sacrum*, IV, 1901, no. 6

Gustav Klimt, *Philosophy*,
compositional sketch, 1898
Oil on canvas, dimensions unknown
Destroyed 1945

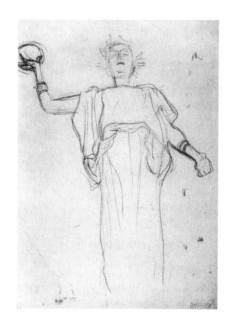

The standing Hygeia figure, shown from below with the bowl in her right hand, could belong to an intermediate stage and would have fitted in well with the painted sketch of the full-figure *Jurisprudence* holding the sword in her right hand. The study (ill. page 72) was in direct preparation for the painted sketch (ill. page 21) which originally showed the robe falling straight down. The generous sweep of the skirt in the painted sketch was probably added only after this had been presented to the commission.

In accordance with the contract, the painted sketches for the faculty paintings and the central painting were created in 1897/98. The lower section of the sketch for *Medicine*[6] is taken up by Hygeia, where the health of the body and soul is elevated to godhood.[7] She is not depicted with the bowl in which she nourishes the serpent, but with a golden upright snake placed to her left. Above this, we see a floating young nude woman, held by the hand of a man beneath her: a human couple, interpreted as a symbol of the preservation of the human race. Klimt dedicated a great number of studies (ills pages 53–56) to the Floating Woman, the most denounced representation in the faculty paintings. The male figure of the couple was also the subject of a series of studies (ills pages 50, 51), the last of which corresponds, to a large extent, to the painted sketch. The personifications of Sickness and Death, both dressed in long flowing robes — Sickness in red and Death shrouded in black — are depicted as antagonists of the floating figures on the right. In this context, the study of an old man, closely linked with the painting *Old Man on his Deathbed*, can be mentioned (Strobl, no. 628, ills pages 62, 78).[7a] The Floating Woman, Sickness and Death, as well as Hygeia, appear like a vision in the frontal zone, standing out against a scene of mainly female nudes for which, according to Werner Hofmann, Louis Sullivan, who was born seven years before Klimt, found the most appropriate description: "Forms emerge from forms, and others arise or descend from these. All are related, interwoven, intermeshed, interconnected,

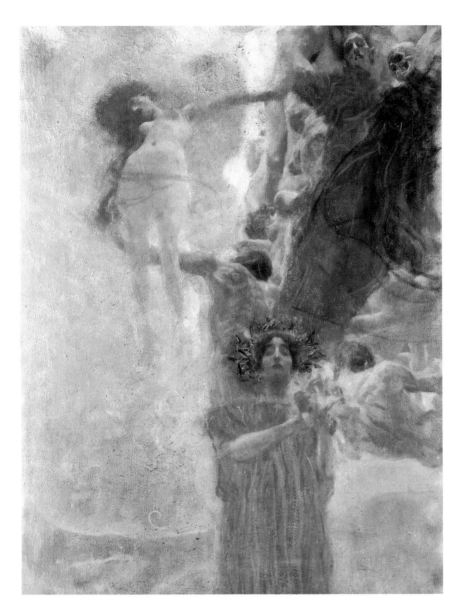

Gustav Klimt, *Medicine*,
composition sketch, 1897/98
Oil on canvas, 72 x 55 cm
Private collection

interblended."[8] The entire action takes place at dawn, in front of a clouded sky, which lets a small amount of blue emerge at the upper left. In the centre, the first rays of sunlight fall on the floating nude, the man beneath her and Hygeia, crowned with a laurel wreath, as well as the figures on the right.

Klimt probably created the study for *Philosophy*[9] as the last representation in the sequence of the painted sketches. The subject made it the most difficult assignment. A completely absorbed, seated, sibylline figure, turned towards the left, which Klimt prepared in the drawing (ill. page 51),[10] is depicted in the lower right corner as an allegory of knowledge. A philosopher can be made out, scarcely visible, in front of her. Above her, also difficult to discern, are two heads of a four-headed marble sphinx in the Kunsthistorisches Museum, which was discovered in Egypt (ill. page 32).[11] The motif of a many-headed sphinx is very rare. Apart from the two specimens in Vienna's Kunsthistorisches Museum, there are only depictions on coins. Three-winged sphinxes, which are assumed to be symbols of divine wisdom, are also shown on the *polos* (headdress) of Artemis Ephesia, from an Austrian archaeological excavation after the Second World War.[12] A stream of people representing the different stages of life can be seen on the left side of the sketch. The subject is very similar to

Hans Canon's *Cycle of Life* (1884/85) in the Museum of Natural History in Vienna, where the artist very closely follows the style of Rubens.[13] Also similar is a stream of people circling round a winged sphinx in the centre, with a globe and the figure of Chronos, resting his head on his hand, below the loving couple with the child, on the right-hand side.

The four painted compositional sketches, as well as the sketch for the middle painting, *The Triumph of Light over Darkness* by Matsch, were presented at the meeting held by the art commission of the Ministry for Education and the artistic commission of the University on 26 May 1898.[14] Even before this meeting, the March number of the Secessionist journal *Ver Sacrum* had published the painted sketch for *Medicine* under the title *Study for a Ceiling Painting of Hygeia*.[15] At this meeting, no objections were raised in connection with Matsch's sketch for *The Triumph of Light* and *Theology*, whereas Klimt's creations for *Jurisprudence*, *Medicine* and *Philosophy* met with a great deal of opposition. As for *Jurisprudence*, demands were made for a more precise characterisation of the main figure, greater balance in its positioning, and an improvement in the very noticeable emptiness in the lower sections of the picture. For the painting of *Medicine*, the principal wish put forward was for a more decent pose for the female figure characterising Suffering Humanity in the centre, which would lead to less controversy and obscene jokes; or, possibly, the replacement this figure with one of a

Hans Canon, *Cycle of Life*, sketch for the ceiling painting in the Museum of Natural History in Vienna, 1884/85
Oil on canvas, 110 x 117.5 cm
Österreichische Galerie Belvedere, Vienna

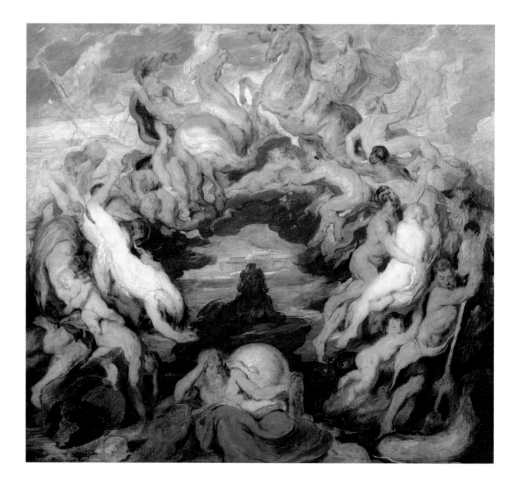

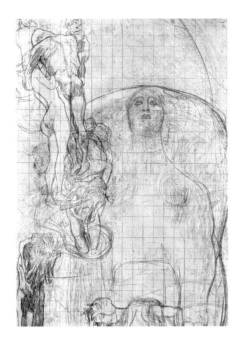 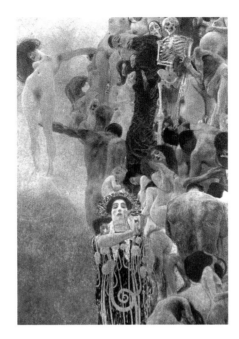 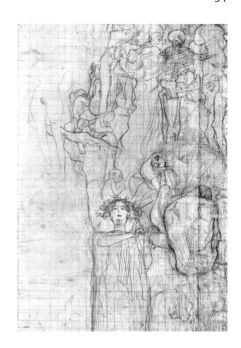

young man.[16] Finally, when dealing with *Philosophy*, demands were made for increased clarity in the execution, namely a brighter tonality, which would facilitate comprehension of the composition. In particular, when dealing with all the paintings, the wish was expressed that the apparent differences in the composition of the works of the two artists be alleviated by a much closer co-operation during the execution, and that the overall impression of the ceiling decoration be more harmonious and unified. On the condition that these wishes be transmitted to the artists in the appropriate manner, both artistic committees declared that the artists should be granted a definitive commission based on the presented sketches — which, however, were to be appropriately modified.[17]

Klimt was embittered by the objections made by the art commissions and immediately wanted to withdraw from the assignment. It was only through the intercession of the ministry's Dr Weckbecker that the contract came into effect. In a minuted declaration dated 3 June 1898, the two artists stated that they were prepared to make the requested changes, taking the limitations of artistic freedom into consideration. Klimt agreed to inform Dr Weckbecker when the sketches had been modified — either in the form of a drawing or coloured sketch — as requested.[18]

Initially, Klimt got out of the affair by presenting Dr Weckbecker with compositional sketches on which a transfer grid had been drawn. In this way, he avoided lightening the darkness criticised in the preparatory sketch for *Philosophy*; he would have not been able to do this in a painted sketch.

As can be seen by the strip of paper attached to the right side of the transfer sketch for *Medicine*, it is clear that Klimt originally intended to have this hardly visible Floating Figure somewhat away from the centre of the painting, at the same position as in the painted sketch. He then moved this figure — falsely interpreted as Suffering Humanity — which was the aspect most criticised by the commission, to the far edge, which made it possible for him to remove a strip of paper of the same size from the left side.[19] In addition, the strip on the right side gave him the possibility of creating a completely new organisation of the section to the right of Hygeia.

This change was brought about by an alteration in the programme for affixing the

Gustav Klimt, *Philosophy*, transfer drawing, 1900
Black chalk and pencil on paper, 89.6 x 63.2 cm
Wien Museum, Vienna

Gustav Klimt, *Medicine*, first version, 1901
Oil on canvas, 430 x 300 cm
Destroyed 1945

Gustav Klimt, *Medicine*, transfer drawing, *c.* 1900
Black chalk on paper, 86 x 62 cm
Albertina, Vienna

Gustav Klimt, *The Sphinx, Loving Couple and Child,*
with a Figure at the Lower Border (detail), 1898
Sketch in Sonja Knips' sketchbook, p. 61
Österreichische Galerie Belvedere, Vienna

Four-headed Sphinx, Asia Minor, 2nd century AD
Marble, 121 cm high, 95 cm long, 44 cm deep
Antiquities Collection of the Kunsthistorisches Museum Vienna

faculty paintings to the ceiling of the ceremonial hall: now *Medicine*, and not *Theology*, would be placed alongside *Philosophy*. This decision must have been reached during work on the drawn sketches for *Medicine*, and it can be assumed that a completed transfer sketch for *Philosophy* existed.

This is made clear in a hurried sketch,[20] drawn as early as 1898/99, on the reverse of which is a study of a seated female nude.[21] This was depicted, for the first time, alongside the seated male nude, on the extreme right side of the transfer sketch.

The records do not show whether Klimt undertook these changes in the grouping of the faculty paintings with, or without, the approval of the commission. Hevesi wrote his account on 29 March 1901 following the completion of the *Medicine* painting.[22] And *Medicine* and *Philosophy* were shown alongside each other in the main exhibition hall of the Secession building during the Klimt collective in 1903.[23]

The new grouping of the faculty paintings unifies the flows of the figures in *Medicine* and *Philosophy* into a single stream, which was interrupted only by the ceiling ornamentation with the Emperor's monogram, which was part of the original decoration carried out by the architect of the new university, Heinrich von Ferstel.[24]

This was why it became necessary to modify the transfer sketch for *Medicine* in the following manner to harmonise with *Philosophy*: a new group of figures, drawn with black chalk, was included, starting next to Hygeia with two nude female figures, one standing and one bending forward. The head of the standing figure is obscured by the male figure of the couple seated above (who possibly represent Adam and Eve). One of Klimt's studies of the standing female nude can be seen on page 66. Somewhat above that to the left, we see a frontal view of a seated nude female as an allegory of suffering; adjacent to this, two wrestling men as the symbol of the struggle for survival, which is represented at the highest point in Canon's painting by two fighting knights. The motif of men in combat interested Klimt greatly, as can be seen in the studies (ill. page 60). Above the wrestlers we see a skeleton leaning forwards which also exists in a study, there turned to the left (ill. page 64). The skeleton in *Medicine* is turned towards a bent old man, a subject reminiscent of Rodin, and, at the top, there is a nude torso.

With its tender linearity, there is a feeling of transparency and unreality in the adjacent group on the left with the allegory of Sickness, which is characteristic of the groups of figures in the painted compositional studies.

In the first version of *Medicine*, we have a more or less exact version of the transfer sketch, with the exception of the torso in the upper right-hand corner. This was replaced by a pregnant woman who can still be seen in the final version from 1907. The monochrome reproduction made of the faculty paintings shows only one detail, namely Hygeia. I saw the painting in 1943 in the Klimt exhibition in the Secession building — at that time called the Friedrichstrasse Exhibition House — and the coloration of the reproduction provides a very good impression of the overall painting. It was dominated by red; the allegory of Sickness was also cloaked in a red robe which,

touching both young and old, reached to Hygeia and, in the coloured reproduction, can still be seen with a circular golden ornament. According to Hevesi,[25] the skeleton of Death was covered with an ice-blue veil that could also be seen in other sections of the picture, such as the baby beneath the floating figure, which was not present in the first version. Reminiscent of Khnopff, the colour reproduction shows Hygeia presenting herself majestically forwards, the golden serpent wound around her right arm, in a crimson robe with circular golden ornaments and antique grass-of-Parnassus vines, which can also be found in *Water Snakes II* and in *The Kiss*. The head is no longer crowned with a golden laurel wreath, as shown in the painted sketch and the other versions, but with a headdress decorated with fresh flowers and long red ribbons, reaching far down her back. This goddess of healing must be interpreted as Klimt's homage to the achievements made in *Medicine* around 1900.

According to Dobai, the impression made by the reconstruction of the four faculty paintings on the ceiling of the ceremonial hall[26] created a major surprise — namely the exceptional ease with which both pictures could be integrated into the architectural framework which, with its shimmering gold ornaments and contrasts of darkness and light, further accentuated the impact made by the pictures.[27]

The comparison of the painted sketch for *Philosophy* with the transfer sketch[28] shows, above all, a great change in relation to the depiction of the *Sphinx*. The four-headed sphinx from the Kunsthistorisches Museum is still dominant. However, she is now shown in full figure, taking up more than three-quarters of the height of the picture; Klimt modelled one of the missing legs of the four-headed sphinx from another sculpture in Sonja Knips' sketchbook.[29] The profile of the sphinx's right head, which was also hinted at in several of the twenty-six sketches included in Sonja Knips' sketchbook, is hardly discernible. This sketchbook was previously owned by Gustav Nebehay and is now in the collection of the Österreichische Galerie Belvedere.[30]

This sketchbook was inaccessible for a long period and it could therefore be dealt with only in my supplementary volume on Klimt's drawings. The magnificent line which integrates three of the four heads of the side view of the marble sphinx was particularly stimulating for Klimt.

An intermediate stage, showing the outlines of the three heads, still separated from each other, can be seen in a small study of an old man.[31] After Klimt had settled on the large-scale form, he studied the many variants of the sphinx in his sketchbook and transferred them to the sphinx in his drawn sketch. Klimt's representation could have a connection with Jan Toorop, whose *Large Sphinx* was shown in the twenty-sixth annual exhibition of the Künstlerhaus in Vienna in the spring of 1899,[32] insofar as Klimt depicted his sphinx in precisely such a striking manner in his transfer sketch. For the first time, there is a hint of the globe above her on the right side. The exceptional size of the sphinx leads to the dimension of the allegory of knowledge being decidedly limited. However, the figures on the left side of *Medicine* were enlarged and made more clearly visible compared with the painted sketch. The standing old man on the lower left makes one think of one of Rodin's sculpture group *The Burghers of Calais*; the

Albert Besnard, sketch for *La Vérité entraînant les sciences à sa suite répand sa lumière sur les hommes*, 1890
Oil on canvas, 94 x 89.5 cm
Petit Palais, Paris

Albert Besnard, *La Vérité entraînant les sciences à sa suite répand sa lumière sur les hommes*, 1891
Ceiling painting, Salon des Sciences,
Hôtel de Ville, Paris

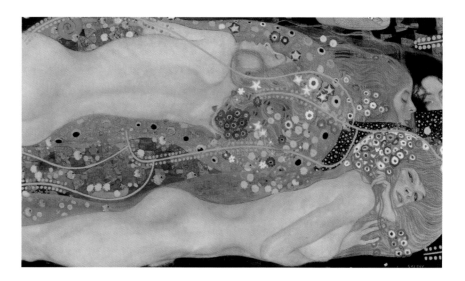

Gustav Klimt, *Water Snakes II*, 1904,
reworked 1907
Oil on canvas, 80 x 145 cm
Private collection

kneeling old woman of Rodin's *Celle qui fut la Belle Heaulmière*; and one of the top-pling figures could be derived from his *Danaide*.

An extremely important change in the representation of knowledge occurred in the first version of the *Philosophy* painting and was kept in the final version of 1907. Knowledge is now depicted as a head, lit from below, protruding into the painting from the lower border and leading to a large empty space beneath the sphinx in which Klimt painted clouds. Both Marian Bisanz-Prakken[33] and Peter Vergo[34] traced the source of the illumination of the head from below to Richard Wagner's stage directions for the mysterious appearance of Erda in *Rheingold*, where it is stated: "The stage has once again sunk into darkness: a bluish glow comes from a cleft in the rock at the side; here, Wotan suddenly sees Erda, who arises out of the depths to half her body height, her noble face is ringed by a mass of black hair [...]." This appears quite feasible, since connections have been made between Klimt's *Fish Blood* and *Flowing Water* and Wag-ner's Rhinemaidens. It is also known, from Klimt's postcards, that he often went to the opera.

The first version of the *Philosophy* painting, which differed from the final version only in that the head of knowledge was somewhat less covered, now appeared as a symphony of colours, which definitely constituted Klimt's main concern for his ceiling paintings. In addition, the depiction of cosmic events, stimulated by Albert Besnard's painting *La Vérité entraînant les sciences à sa suite répand sa lumière sur les hommes* (Truth Teaching Science Pours out its Light on Mankind) (1891) in the Hôtel de Ville in Paris was given much greater importance.

The spheres, which dazzled in all shades of blue and violet, were interspersed with glittering red, blue, green, orange, yellow and gold stars in Klimt's work.[35] He used a dappled colour technique to give the sphinx its almost amorphous appearance. This conscious restraint in her appearance was an indication of his efforts to distance him-self from traditional forms of allegories in order to arrive at purely artistic solutions. This procedure can be followed through the individual stages of the sketches for *Philosophy* and, when compared with the other two faculty paintings, *Medicine* and *Jurisprudence*, are carried out, in this case, in a fascinating way.[36]

The faculty painting *Philosophy*[37] was shown to the public for the first time during the seventh Secession exhibition, which took place from 8 to 12 March 1900. It appeared with the following text: "Creation, growth and passing away. On the right,

the globe, the riddle of the world. Appearing from below: an enlightened figure: Knowledge." It resulted in an unprecedented scandal which manifested itself in numerous press articles, both for and against, and reached its climax in the protest made by the professors of the University against the installation of the painting in the ceremonial hall of the institution.[38]

This criticism was aimed principally against the artistic treatment of the subject and will be repeated here, once again. The text reads:

"If creation, growth and passing away are depicted through a group of human bodies of various ages, various genders and in various activities, floating through an indeterminate space, one might be able to accept it as a form of artistic symbolism. However, if the mystery of the world appears as a greenish shimmering area of fog, out of which the vague contours of a sphinx can be perceived; if knowledge is depicted as a head, glowing from within, which belongs to a figure surfacing from below; then in this case simple linguistic metaphors are converted into pictures or rather hieroglyphic symbols which can have no consequence as an artistic perception but merely as similes or exercises in puzzles.

These symbols and allegories, originating from various sources, become even more unpleasant and ineffective by being united in Klimt's work in such a superficial way to form a composition which clearly reveals its lack of unity through its inextricable construction.

But also the purely artistic qualities of the painting, its forms and the impression made by the colours, are not able to compensate for this ineptitude in dealing with the subject. We wish to refrain from exercising criticism against the unclear movements, the artificial form and the numerous deformities of the human bodies depicted. It is possible that the painter connected these with a certain artistic intention which, however, is not apparent to the viewer. In principle we can see no advantage at all in representing nebulous thoughts through nebulous forms. When dealing with his choice of colours, we gladly acknowledge the virtuosity with which the artist attempts to create the appropriate impression for capturing the dismal fantasy of the picture. However, we are extremely doubtful that this colour symphony is really appropriate, as has been proposed, for conjuring up those associative ideas which would make it possible to clarify the intellectual content of the painting to the viewer."[39]

In addition, it was felt necessary to mention that the artist had neglected to adapt his painting to the architecture of the ceremonial hall.

It is extremely informative to read the riposte made by Klimt, which was published in the *Neue Freie Presse* on 27 March 1900. He explained to a journalist of the newspaper that "I can understand if somebody opposes the ideas which led to the conception of my painting. On the other hand, I must object when somebody — even if he is a university professor — declares that my painting is bad and says that it is not a work of art. I cannot concede that my method of symbolic depiction is not artistic; that could

also be said about other symbolic paintings whose artistic value is widely acknowledged and whose symbolism is understood and appreciated by the general public because they have been exhibited for such a long time and have tradition on their side."

In a published declaration, a group of professors, including the art historian Professor Dr Franz Wickhoff, took up the cudgels on behalf of Klimt. In this, they declared their colleagues to be not competent to make a decision on a purely artistic matter, and for the following reasons: the painting in question formed a section of a still incomplete total composition, and a definitive judgment could be made only after it has been installed. The judgment of the professors could be significant only to laymen, seeing that the majority of them were laymen.[40]

Above all, ideological reasons played a major role in the rejection of the faculty painting, a fact that becomes immediately apparent in a statement by the Rector, Wilhelm Neumann: "In a time when philosophy seeks its sources in exact sciences, it does not deserve to be depicted as a nebulous, fantastic creature, an enigmatic sphinx."[41] Klimt encountered resistance from the professors of the University because he did not depict the "triumphs of science, nor the activity and values of constant, dependable research, but showed science as an area where nature and human life are not an 'object' but an area of eternal struggle, an enigmatic, inaccessible realm of searching, a painful, unconquerable kingdom of activity caught between *vita* and *ratio* in their incommensurability."[42]

It is characteristic that, previously, when Hans Canon had unveiled his *Cycle of Life* on the staircase of the Museum of Natural History in Vienna, nobody had protested against it.[43]

Klimt's *Philosophy* was awarded the Grand Prix at the World Fair in Paris in 1900.

At the tenth Secession exhibition, held in 1901, *Medicine* was subjected to similar attacks. It went as far as being the topic of questions in the Austrian parliament, which will not be the subject of closer discussion here. However, it must be noted that the education minister, von Hartel, took the artist's side.

In an attempt to deal more closely with the intellectual background for the rejection of Klimt's *Philosophy*, it is necessary to quote a description of the *Philosophy* faculty painting which was published in *Kunst für Alle* (Art for All)[44] and which expressed an extremely pessimistic philosophy of life. It stated:

"The painting shows how mankind, seen as a part of the universe, is nothing more than a dull, weak-willed mass which, in the service of eternal procreation, is driven, in happiness and sorrow, lost in a dream, from its first stirrings to its limp descent into the grave. In between, there lies a brief delirium of loving coming together and a painful drifting apart. Love is a disappointment both as happiness and as a discovery. Destiny always remains the same. Mankind stands apart from cold, clear knowledge, and from the eternally veiled mystery of the universe, in its struggle for happiness and knowledge, and always remains a mere tool in the hands of Nature, which uses it for its unchanging purpose, reproduction."[45]

Gustav Klimt, *Jurisprudence*, sketch, 1901
Black chalk
Private collection

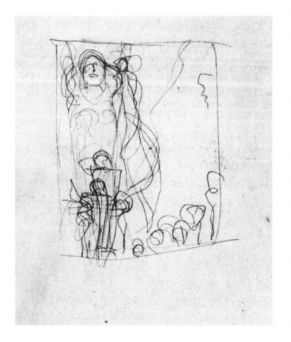

This pessimistic description of the painting makes one think above all of the influence of Schopenhauer on the subject matter of Klimt's *Philosophy*, something I already drew attention to in 1964, and which Peter Vergo has dealt with in great detail.[46] Recent research has also made Friedrich Nietzsche influential on Klimt's *Philosophy*. Berlin and Vienna had been among the centre of Nietzsche reception since the 1870s. In his posthumous work *Ecce Homo*, Nietzsche himself mentions Vienna (along with the cities of St. Petersburg, Stockholm, Paris and New York) as being one of the first cities to discover him.[47] From the 1870s, the anti-liberal students at the University of Vienna, who had emerged from the reading societies, had shown their keen enthusiasm both for Nietzsche and Richard Wagner. Carl Schorske,[48] following in the footsteps of William McGrath,[49] has dealt with the reasons for this development from the historian's point of view. Schorske emphasises the strengthening of the liberal bourgeoisie in Vienna during the second half of the eighteenth century. The liberals celebrated their triumph in an architectural statement — the magnificent complex of the Ringstrasse buildings. The two most important centres of the constitutional government — the parliament and town hall — as well as the two main centres of liberal culture — the Burgtheater and University — were located on that boulevard.

But the new university was the site of a crisis within the bourgeoisie, the conflict between fathers and sons. Due to the lack of liberalism in national and social arenas, a new generation, *Die Jungen* ('the young ones'), not only sought a new form of politics in the 1870s and 1880s, but also new philosophical and cultural institutions.

Timothy Hiles has dealt directly with Nietzsche's influence on Klimt's *Philosophy* faculty painting.[50] He sees in Klimt's painting the acceptance of the metaphysical will of mankind, an idea promulgated by Schopenhauer and Nietzsche, which also found support in anti-liberal groups at the University. According to Hiles, the sphinx in Klimt's painting represents the metaphysical will which mankind, embodied in the stream of manifold individuals of all ages and at all levels of suffering, flows by ceaselessly; whereas the head, lit from below, symbolises the recognition of the truth. Contrary to Schopenhauer's pessimism, however, Klimt depicts a more optimistic conception of will in the sense argued by Nietzsche. The recognition of this will is not terrible because it leads to reincarnation, personified by a child on the right side of the painting. Hiles is also of the opinion that Klimt has portrayed will in the Nietzschean sense of consisting not only of grief and suffering, but also of joy and ecstasy. Finally, Hiles creates a link between Klimt's *Philosophy* and the romantic poem *Der entfesselte Prometheus* (Prometheus Unbound) by Siegfried Lipiner (a member of the University of Vienna reading circle), which the poet wrote in 1876, at the age of twenty, under the influence of Nietzsche's *The Birth of Tragedy from the Spirit of Music*, and which was praised by the philosopher himself.[51]

At that time, the concept of 'the riddle of the universe' also played a role in a completely different context. It had become a standard expression following the publication of Ernst Haeckel's work *Die Welträtsel* (The Riddle of the Universe) in 1899. In 1880, the naturalist Emil du Bois-Reymond had opened the Leibniz celebrations at the

Gustav Klimt, *Justitia with Drawn Sword*, 1898,
sketch from Sonja Knips' sketchbook, p. 125
Pencil, 13.8 x 8.4 cm
Österreichische Galerie Belvedere, Vienna

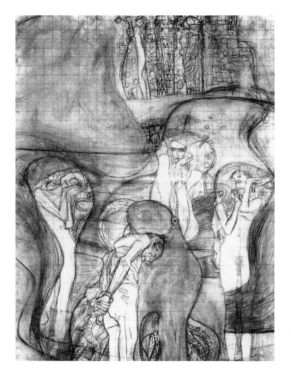

Gustav Klimt, *Jurisprudence*, transfer sketch, 1903
Black chalk, lead pencil, 84 x 61.4 cm
Destroyed 1945

Berlin Academy of Sciences with a lecture on *The Seven Riddles of the World*. In his lecture, he spoke about the limits to understanding nature. This was still a topic as late as in 1920, when Rudolf Steiner (1861–1925) delivered his lecture *The Mysteries of the World and Theosophy*.

This subject was also found in art in Klimt's time. In 1895, during his activities at the Academy of Fine Arts in Vienna, Franz Kupka (1861–1925) created a painting with the title *The Enigmas of the World*, which was exhibited at the Austrian Arts Society in Vienna.[52] Even though the work does not appear in Klimt's monographs, it could have been of importance to him. According to a description of the painting in the theosophical magazine *Sphinx*, it also depicted a gigantic sphinx, the globe, a mother with a child, and a man who, in his dementedness, has torn the pages out of the book of science.

Finally, attention must be drawn to Ferdinand Fellner von Feldegg (1855–1936), an architect and author of aesthetic-philosophical treatises, and his article 'Gustav Klimt's "Philosophy" and the Change in the Cultural Values in Our Day' in the journal *Architekt*.[53] In this case as well, an attempt was made to trace the conflict over Klimt's *Philosophy* to opposing outlooks on life. Fellner von Feldegg maintained that:

"The spirit in Klimt's painting *Philosophy* is a modern theosophical one. It is modern theosophy which speaks out of it — the artist perceived his painting in the spirit of this theosophy. Therefore, there was enthusiasm from the one side and opposition from the other, particularly from the reigning scholarly circles. Klimt's painting — to state it clearly from the very beginning — sees philosophy, contrary to accepted opinion, not simply as the sum of individual 'exact' sciences, but as a homogenous science, not as a doctrine of the sensory comprehensible, but of the extrasensory incomprehensible."

He goes on to state that ideas of modern theosophy are expressed in Klimt's painting which correspond to the "blossoming wisdom of youth" with a mystical, not rational, basis.[54]

At the time, Feldegg was not alone in his assertion; it can also be found in other articles from around 1900. Among these are two contributions by Franz Servaes (1862–1947). Born in Cologne, he belonged to the Strindberg circle in Berlin and was active as an art critic there and in Vienna. In the first article, he characterised Klimt's work as the fruit of a "profound, serious outlook on life, the quintessence of the age of Darwin, viewed in the light of modern theosophy, in a manner of speaking."[55] In the second article, he points out that the mystical, theosophical movement of the period had come to Klimt's ear and taken hold of his mind and imagination.[56, 57]

It is now necessary to deal more closely with the studies and sketches for the third faculty painting *Jurisprudence*. We have already spoken about the painted compositional study. The comments made by Karl Kraus at the end of March 1900 in *Die Fackel* should be considered here: "The design which he presented to the commission at that time

depicted Themis with the tip of his inverted sword on a slain dragon. A man looked inquisitively into the picture from the side — through a door, if I remember correctly. It was difficult at the time to make Mr Klimt understand that Themis represented the exercise of law and belonged in the courtroom, and that the university dealt with the study of law. Nobody on the commission was able to explain just who the man looking into the picture was until Klimt stated, completely seriously, that it was the Austrian constitution."[58] These remarks, which were made two years after the study's presentation, and which cannot be confirmed by official records, show that Karl Kraus was either referring to a previously unknown study for *Jurisprudence*, or could not remember the occasion correctly. However, it is possible that the seated female figure with an open book in her hands in the upper right section of the painted study could be the allegory of the Austrian constitution.

In contrast to the *Medicine* and *Philosophy* faculty paintings, for which transfer sketches existed before 1900, mention of a new study for *Jurisprudence* is not made prior to an interview given upon the completion of *Medicine* in March 1901. When asked in the interview whether he had already begun work on *Jurisprudence*, Klimt replied: "Yes and no. I had prepared a sketch but the committee who had decided on *Philosophy* and *Medicine* wanted changes to be made to it. Now I will design something new."[59] The reason for this decision was probably that, in the meantime, Klimt had artistically progressed beyond the painted sketch. It must be remembered that, following the presentation of the two faculty paintings, *Philosophy* in 1900 and *Medicine* in 1901, he had created important works — the *Beethoven Frieze* above all.

Klimt conceived a self-contained, multi-figure composition for the new design. This also had its roots in sketches made around 1898 in which we find the idea of the criminal and his avenger before the judges — in the sketch,[60] with a terrifying larger-than-life female figure, as in the drawing in Sonja Knips' sketchbook. In both sketches, the criminal, seen from behind, looms into the picture from the lower border of the sketch[61] and Justitia, shown from the front, appears to be threatening him with her drawn sword.[62]

After the completion of *Medicine*, Klimt appears to have made many studies for *Jurisprudence*, and it appears that, here, there were repeated changes which have been handed down to us through newspaper reports. The *Neues Wiener Tagblatt* writes on 3 July 1907: "The most far-reaching changes are in the picture which is intended to be an allegory of Jurisprudence. The slanting wall which went through the picture, and the judges in their red robes, have disappeared; now a horizontal strip of clouds separates the upper from the lower group of figures." Hevesi also reported on a wall which cut straight through the picture after seeing Klimt's unfinished *Jurisprudence* in July 1903. He drew particular attention to the contrast between the old ashlar wall of a court building and the already hinted at brilliance of the upper sphere, which reminded him of the mosaics in Cefalù, Monreale and the Cappella Palatina in Palermo,[63] which he had visited a short time before. It is possible that Klimt, who had visited Ravenna in the spring of 1903, wanted to unite inner and exterior views of

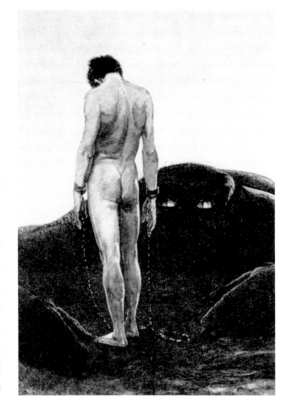

Sascha Schneider, *Feeling of Dependence, c.* 1896
Illustrated in *Meisterwerke der Holzschneidekunst*
(Masterpieces of Wood Carving Art), new series vol. 3,
Leipzig, after 1896

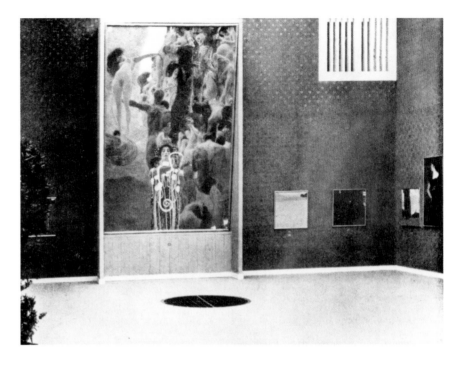

View into the main hall of the tenth Secession exhibition, arranged by Kolo Moser, March 1901 In the centre: Gustav Klimt's *Medicine*, flanked by the artist's landscapes

buildings from that city in an interesting manner. Concerning the disappearance of the wall, Klimt did not include this wall in his transfer sketch;[64] however, he did allude to the heads of the three judges which can be found in the executed faculty painting,[65] where sections of the wall were included in the uppermost section.

Contrary to *Philosophy* and the *Beethoven Frieze*, which were interpreted in the Secession catalogue when they were first exhibited, that of the Klimt collective exhibition only noted: "Jurisprudence, ceiling painting for the ceremonial hall of the Imperial University, unfinished." Obviously, Klimt thought this painting to be understandable in such a way that no explanatory title was necessary. However, the lack of such an explanation was denounced and *Jurisprudence* was regarded as an even greater puzzle then the other two faculty paintings.[66]

The interpretive attempts made in various daily newspapers — except when dealing with the figure of the criminal — were widely divergent. His portrayal of the criminal had its roots in Sascha Schneider's picture *Feeling of Dependence*, a fact indicated by studies of a young man with a sunken head.[67] As can be seen in other studies,[68] Klimt appears to have considered the idea of a female criminal, an idea he discarded, as a concession to the three Erinyes, in order to give the picture greater variety, and went over to an old, bearded man[69] bent over to the right. He wanted this "most lost of lost profiles"[70] to express the entire weight of the misery of this old man. He finally chose a beardless model,[71] which he kept for both the transfer sketch and the final execution. Klimt went much further than Sascha Schneider in the psychological understanding of the criminal. This is expressed with great clarity both in the depiction of the hands, which give the impression of being bound, and the sharp protrusion of the shoulder blades.

The interpretation of the 'polyp,'[72] for which no sketches have been preserved, as is also the case with all the other Klimt monsters, provided the most difficulties. The interpretations ranged from the embodiment of the pangs of conscience, crime itself, to the nickname for a policeman taken from student jargon.[73] A dragon-like creature, tied up at the feet of Justitia, already plays a role in the painted study. In the final

sketch, it becomes a dominating figure with a spotted tiger skin[74] which appears to bewitch the sinner, and which has many associations. First of all, there is a connection with a monster shown in medieval representations of the *Last Judgment*, which swallowed up the damned in its hellish mouth. Unlike this, the polyp had no gigantic jaws but any number of golden, glistening suckers to destroy the criminal entrapped in its tentacles.

The personification of the pangs of conscience, the executors of a higher, supernatural force, were recognised in the three female figures, the Erinyes, or Furies, who surround the criminal and create a link with the belief in the Eumenides of antiquity.[75] They were the subterranean goddesses of vengeance who punished any sacrilege against the unwritten moral laws. This same idea was also expressed by Franz Stuck in his painting *The Guilty Conscience* (1896), based on Pierre-Paul Prud'hon's painting *La Justice et la Vengeance divine poursuivant le crime* (Justice and Heavenly Vengeance Pursue Crime).[76] In Stuck's work, the action of the criminal chased by the Furies is portrayed in a turbulent manner, whereas Klimt transfers the action into the inner being of the figures. The restrained gestures and the facial expressions are proof of this and led Servaes to describe the three Erinyes as the most powerful figures to have been created in art in recent years.[77]

The left, and the right, goddess of destiny with her bold frontal stance was adapted from the central Gorgon of the *Beethoven Frieze*.[78] Klimt had initially planned the third Fury as a standing figure, but in the executed version he used a motif from Michelangelo's *Last Judgment* — the cowering damned figure, covering one eye with his hand — quite independently.[79] The facial expression was inspired by Toorop[80].

Compared with the Gorgons in the *Beethoven Frieze*, the movements of the Furies in the executed version make them appear to be more angular and elongated, which is due, to a large extent, to the fact that their bodies are covered with thin veils, and which led to the painting being called a "Toorop Symphony" or "Tooropiade."[81]

Klimt depicted the allegories of Veritas, Justitia and Lex infinitesimally small at the very top of the picture, a clear indication of his meaning. Here, Klimt's pessimistic attitude towards human judgment is revealed, something which did not go unnoticed by both recent researchers[82] and Klimt's contemporaries. Franz Servaes wrote about this in his critique of *Jurisprudence*: "Small and miserable, even when impressively preened and boastful, we see, at the top of the picture, the doll-like little figures which personify human, worldly justice and legal scholarship: Justitia with the legislature and police force, with a circle of bald, senile judges' heads below her."[83] In a letter written to Hermann Bahr dated 19 November 1903, the scholar Josef Redlich expressed the same feelings, that "in this country, law and jurisprudence have very little to do with each other."[84] However, it must be noted that Klimt created a series of extremely important drawings of judges (ill. page 73).

The studies for the figure of Truth, which was of great significance to Klimt in those years, are the most revealing (ills pages 70, 71). She is the figure on the left in the group of three in *Jurisprudence*. When compared with the book illustration *Nuda Ver-*

itas (1898)[85] and the painted version,[86] the change in her stance becomes particularly striking. In the previous nude depictions, both feet were anchored firmly on the ground, whereas the depiction of Veritas in *Jurisprudence* obtains its more labile stance through the difference between the two legs. This was connected with a change in significance in Klimt's work that is also expressed by the sunken head and the change in the position of the arms, which give the figure a feeling of dancing. In the final phase, Klimt did not show the 'naked truth' but threw a cloak over her as an expression of his doubts about finding truth. Klimt prepared both Justitia and Lex as toga-wearing figures, but made the central representation a figure with a column-like character whose garment was adorned with geometrical motifs — mainly triangles and rhombuses. This appears to anticipate the decorative principles that Klimt was later to use in the *Stoclet Frieze*.[87]

As Hevesi informs us, *Jurisprudence* was dominated by black and gold — actually non-colours — but the line developed an importance, the form a significance, which must be described as monumental.[88]

The exhibition of *Jurisprudence* — along with the faculty paintings *Philosophy* and *Medicine*, which had been completed in 1900 and 1901 respectively — at the Klimt collective in 1903 prompted the art commission to bring Matsch's *Theology* to the Secession building shortly before the opening of the show. On 11 November 1903, the faculty paintings were inspected and a subsequent meeting of the ministry's art commission held. Two questions were addressed: first, whether the pictures could be accepted; second, whether the commission could find an artistic reason for recommending the strongly divergent works by Klimt and Matsch being exhibited in the same room. It is surprising that only Matsch's pictures were dealt with in connection with the first question when one considers the outrage which *Philosophy* and *Medicine* had provoked. The commission unanimously pronounced an unfavourable verdict on the quality of Matsch's pictures. Otto Wagner, Felician von Myrbach, William Unger, Heinrich Swoboda and Rudolf Ribarz rejected them completely. Purely based on what could have been expected, some members of the commission — including Otto Benndorf, Carl Moll and Carl Zumbusch — recommended that they be accepted. There was complete agreement about the enormous difference in the quality of the work of the two artists. There was only dissension over the question of whether the paintings should be installed on the ceiling of the ceremonial hall of the University. William Unger, Carl Moll, Heinrich Swoboda and Otto Wagner were opposed to this. Wagner suggested that, for the time being, only Klimt's pictures be attached to the ceiling and that the completion of the decoration take place at a later date. Director Myrbach endorsed this proposal and Professor Sigmund L'Allemand stressed that there was no way that the Matsch pictures could harmonise with those by Klimt — *Theology* even less than the central picture (see the total reconstruction of the ceiling, ill. page 14). Contrary to this, Hofrat Benndorf expressed the opinion that the artistic quality of the two artists could differ without negatively influencing the overall impression. The proximity would make Klimt appear greater and so in no way diminished. In addition, in

Gustav Klimt, *Jurisprudence* (detail), 1903–1907

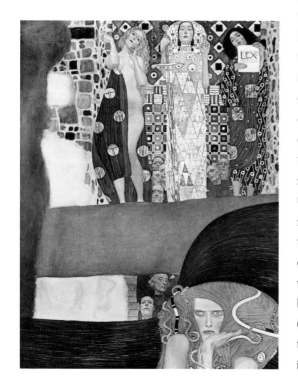

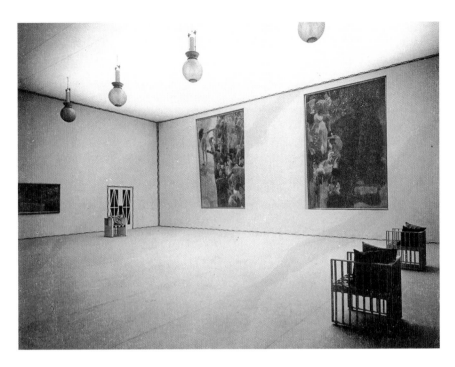

Main hall of the eighteenth Secession exhibition
(Klimt Collective), arranged by Kolo Moser,
November to December 1903
On the left wall: *Music II,* on the right wall:
Medicine and *Philosophy*

around thirty years the common features uniting Klimt and Matsch as contemporaries would have such an influence on the viewers that the ceiling would appear to be homogeneous. In the Renaissance and antiquity, works of artists of various quality had expressed the unity of the zeitgeist. In addition, viewing the works would prove very educational for the artists and the public. He was, therefore, in favour of installing the paintings seeing that, as an *ultima ratio*, they could always be removed. It is regrettable that Bergdorf was not successful with his recommendation. Klimt's paintings might still be preserved today.

After the petition made by the University professors in 1900[89] had recommended that *Philosophy* be exhibited in a state gallery, the idea cropped up of having Klimt's faculty paintings displayed in the Moderne Galerie. Myrbach, however, asked that it be considered that removing Klimt's paintings to the Moderne Galerie could create the impression that they were not good enough for their original purpose. The chairman stressed that the fact that they had not been installed should not be seen as criticism of Klimt, but merely as drawing attention to the incompatibility of the work of the two artists. The chairman summarised the results of the second question as being that, although the works by Klimt and Matsch in no way harmonised, Matsch could not be compromised and that the ministry should consider the future steps with great caution.

It must be stressed that, in no other meeting of the art commissions of the ministry and University was the atmosphere so positive for Klimt as in this case. This situation was due to the presence of Otto Wagner, Felician von Myrbach and Carl Moll, who all came from the same camp as Klimt. However, the decision was not reached in his favour. Klimt would have had nothing against his pictures being installed alongside those of Matsch. It is absurd that ultimately only works by Matsch found their way into the ceremonial hall of the University — his *The Triumph of Light over the Darkness* and all the spandrel paintings. Klimt was meant to paint those relating to philosophy, medicine and jurisprudence, but in 1904 the task was handed over to Matsch by mutual agreement.

On 26 November 1903, Klimt wrote to the ministry asking for a decision to be taken by the artistic commission as to whether his paintings would be used for their intended purpose so that he could "attune them to each other," should this be the case.[90] He had probably heard about the meeting and appears to have rejected the idea of installing his faculty paintings in the Moderne Galerie. The Secession had also suggested that his faculty paintings be shown at the World Fair in St. Louis. The ministry turned this project down, giving as their reason the fact that the large size of the paintings would lead to too few artworks being exhibited and consequently only a few Secession members being represented. This finally led to Austria not being present at the World Fair at all. These reasons might have prompted Klimt to withdraw from his commission to paint the ten spandrel fields in 1904.

In February 1905, after completing most of the spandrel fields, Matsch presented the ministry with a new programme for the ceiling paintings in the ceremonial hall, and also a cost estimate from the Heiland scaffolding rental company for affixing them on a trial basis.[91]

On 27 February 1905, the ministry sent a letter to the chancellery of the University in which it is stated that, due to the high costs of the scaffolding, it was intended to bring the pictures together in the studio of one of the artists. The records indicate that, out of consideration for the former statement by the professorial staff, it did not appear out of the question that they would oppose the temporary installation of the pictures at the intended site.[92] On 10 March there was a meeting of the University's artistic commission[93] at which it refused the proposed temporary installation of the faculty pictures. Its reasons:

"Seeing that, on the one hand, according to comments made by the ministry's representative, the remaining loan for the creation of the paintings cannot be used for the test hanging in the ceremonial hall; and, according to the above mentioned correspondence, an additional loan is currently not available; it can hardly be justified bearing in mind the probably disproportionately high costs of such a test, and in view of the negative effect of having the paintings, which are so divergent in their conception and execution, hung permanently next to each other. On the other hand, it must also be considered whether any kind of test would once again bring up the question, which previously became acrimonious, as to whether the Klimt pictures are suited to their original purpose. We therefore recommend that any test hanging or installation be refrained from."

We can see from these decisions that animosity towards Klimt's pictures was still prevalent at the University even though five years had passed since the professors' petition. There was no longer any talk about the poor quality of Matsch's paintings.

The result of this and a further meeting forced Klimt to act. In a letter to the ministry, received on 3 April 1905, he declared his renunciation of the commission for the ceiling paintings on the grounds that, under the prevailing conditions, he could not

complete them. In addition, he asked for information on the appropriate cashier's office for repaying the advance payments which he had received over the years.[94] The Education Ministry, however, pressured him to hand over the pictures without delay, as they were already the property of the state.[95] After the artist had become aware of the negative attitude of the ministry, the sensational news of Klimt's withdrawal of the faculty paintings appeared in the *Prager Tagblatt* on 10 April. Over the following days, all newspapers once again followed the 'Klimt affair' closely.

On 25 May 1905, Klimt repaid the honorarium of 30,000 crowns to the ministry.[96] He was provided with these means by the major industrialist August Lederer.[97]

After Matsch had installed the central picture and spandrel fields on the ceiling of the ceremonial hall of the University, he sent a letter to the ministry on 21 September 1905 in which he drew attention to the fact that it was absolutely essential to also decorate the four corner fields of the ceiling with paintings in order to create a total artistic effect. He declared himself willing to create the three paintings from the amount which had previously been stipulated in his contract. The University's artistic commission approved the decoration of the side fields of the ceiling with paintings and their creation by Matsch in their meeting held on 11 October 1905.[98] In a minuted declaration, dated 20 December 1905, he was commissioned to execute the three paintings. The date for their completion was set at the end of 1908; however the artist was required to submit sketches before their execution.[99]

The sketches for *Philosophy*, *Medicine* and *Jurisprudence* which Matsch produced in 1907 were rejected unanimously by both the art commission of the ministry and the University's artistic commission, with the comment that, even if the studies were to be reworked, no improvements could be expected from the artist.[100]

In 1945, the faculty paintings, as well as the studies for *Philosophy* and *Jurisprudence*, were destroyed in a fire in Schloss Immendorf. Only the painted sketch for *Medicine* and all the transfer sketches have been preserved.

1. Allgemeines Verwaltungsarchiv: Kunst und Unterricht (General Administration Archive. Art and Education), 15.182/94, fos 3f. Hereafter cited as: A.V.A. K.u.U. This administrative archive was extremely helpful in my research.
2. Alice Strobl, *Gustav Klimt. Die Zeichnungen,* four-volume catalogue of the drawings, Salzburg, 1980–1989, no. 512; hereafter cited as: Strobl.
3. Strobl, no. 305.
4. A.V.A. K.u.U. 27584//93/94, fo. 2.
5. A.V.A. K.u.U. 2698 and 5191/9, fos 1f.
6. Fritz Novotny, Johannes Dobai, *Gustav Klimt*, Salzburg, 1967 (with a catalogue of the works by Johannes Dobai), pp. 303f., no. 88; hereafter cited as: ND.

7. August Friedrich Pauly, Georg Wissowa (eds.), *Paulys Realencyclopädie der classischen Altertumswissenschaft*, demi-volume 17, Munich 1914, columns 94ff.
7a See Marian Bisanz-Prakken, 'Im Antlitz des Todes. Gustav Klimts "Alter Mann auf dem Totenbett", ein Portrait Hermann Flöges?' in: *Belvedere. Zeitschrift für bildende Kunst*, part 1, 1996, p. 27.
8. Werner Hofmann, *Moderne Malerei in Österreich*, Vienna, 1965, p. 40.
9. Dobai, see note 6, ND 87.
10. Alice Strobl, *Gustav Klimt. Die Zeichnungen, 1878–1903*, vol. 1, Salzburg, 1980, p. 138.
11. Strobl, see note 10, p. 147, ill. p. 148.
12. Heinz Demisch, *Die Sphinx*, Stuttgart, 1977. I would like to thank Dr Alfred Bern-

hard Walcher, Antiquities Collection of the Kunsthistorisches Museum in Vienna, for all this information.

13. Strobl, see note 10, p. 144.

14. A.V.A. K.u.U. 13.585/98, fo. 6.

15. Dobai, see note 6, p. 304.

16. As Klimt later reported, the protest against the naked female figure originated with Professor Neumann. *Neue Freie Presse*, 27 March 1900.

17. Strobl, see note 10, p. 142.

18. A.V.A. K.u.U. 13.585/98, fo. 8.

19. This has previously been ignored.

20. Strobl, no. 593.

21. Strobl, no. 602.

22. Ludwig Hevesi, *Acht Jahre Secession (März 1897–Juni 1905). Kritik –Polemik –Chronik*, Vienna, 1906, p. 316.

23. Christian M. Nebehay, *Gustav Klimt. Dokumentation*, Vienna, 1969, ill. p. 312.

24. *Allgemeine Kunst-Chronik*, vol. 18, no. 24, Vienna, 1 December 1884, p. 702.

25. Ludwig Hevesi, *Neue Bilder von Klimt*, 16 March 1901, in: see note 22, p. 317.

26. Strobl, see note 10, ill. pp. 157f.

27. Dobai, see note 6, p. 319.

28. Strobl, no. 477, black chalk, pencil, enlargement net 896.632, Wien Museum, Inv. 71506.

29. Strobl, no. 3341.

30. Strobl, no. 3340.

31. Strobl, no. 474.

32. Marian Bisanz-Prakken, 'Gustav Klimt und die "Stilkunst" Jan Toorops,' in: *Klimt-Studien*, Mitteilungen der Österreichischen Galerie, vol. 22/23, 1978/79, Salzburg, 1978, p. 157.

33. Marian Bisanz-Prakken, 'Jan Toorop en Gustav Klimt,' in: *Nederlands Kunsthistorisch Jaarboek 1976*, Haarlem, 1977, p. 201.

34. Peter Vergo, 'Gustav Klimt und das Programm der Wiener Universitätsgemälde,' p. 94.

35. Hevesi, see note 22, pp. 233 and 252.

36. Strobl, see note 10, p. 150.

37. Dobai, see note 6, ND 105.

38. Strobl, see note 10, p. 150.

39. A.V.A. K.u.U. Präsidium, 1126/1900, fos 1–19.

40. A.V.A. K.u.U. Präsidium, 1126/1900, fo. 15.

41. *Wiener Tagblatt*, 27 March 1900. Here Neumann — intentionally or unintentionally — misinterpreted the sphinx.

42. Richard Meister, 'Klimts Fakultätsbilder. Ein Nachwort zur Ausstellung,' in: *Völkischer Beobachter*, Munich, 2 April 1943, p. 3. R.Meister: *Zur Deutung der Deckengemälde im Festsaale der Akademie der Wissenschaften und der Klimtschen Fakultätsbilder*, special printing from the *Anzeiger der phil. Hist. Klasse* of the Österreichische Akademie der Wissenschaften, 19 November, vol. 1947, 23, p. 230.

43. Hevesi, see note 22, p. 263.

44. *Die Kunst für Alle*, vol. 15, Munich 1900, p. 500.

45. *Wiener Tagblatt*, 27 March 1900.

46. Vergo, see note 34, pp. 71ff.

47. Friedrich Nietzsche, *Ecce Homo*, Leipzig, 1908, p. 55.

48. Carl E. Schorske, 'Österreichischs ästhetische Kultur 1870-1914,' in: *Traum und Wirklichkeit, 1870-1930*, exh. cat., Historisches Museum der Stadt Wien, Vienna, 1985, pp. 12, 16.

49. William McGrath, *Dionysian Art and Populist Politics in Austria*, New Haven/London, 1974, pp. 67ff.

50. Timothy W. Hiles, 'Gustav Klimt's Beethoven Frieze. Truth and the Birth of Tragedy,' in: *Nietzsche and the Arts*, Cambridge Studies in Philosophy and the Arts, Cambridge, 1998, pp. 172–175.

51. Siegfried Lipiner, *Der entfesselte Prometheus*, Leipzig, 1876.

52. Wilhelm Hübbe Schleiden (ed.), *Sphinx, Monatsschrift für Seelen- und Geistesleben*, Organ der Theosophischen Vereinigung, vol. 10, 1895, pp. 110f.

53. Ferdinand Fellner von Feldegg, 'Gustav Klimts "Philosophie" und die Culturumwertung unserer Tage,' in: *Architekt. Wiener Monatshefte für Bauwesen und decorative Kunst*, vol. 6, Vienna, 1900, pp. 23–26.

54. Ibid.

55. Franz Servaes, 'Gustav Klimts "Philosophie,"' in: *Illustrierte Zeitung*, 28 June 1900, no. 2974, p. 952.

56. Ibid, p. 962.

57. Modern theosophy found its source in New York in 1875 when the Theosophical Society was established by Henry Steel Olcott (1832–1907) and Helena Blavatsky (1831–1891). Due to a scandal, it moved to India, first to Benares, then Bombay

and, in 1882, to Adyar near Madras, where it became dominated by Buddhist — in particular, Tibetan — and Hindu wisdom teachings. It also spread in Germany and England. The question of the role it played in Vienna in the last decade of the nineteenth century must be considered. Mention is made in many articles that it was very wide spread in Viennese intellectual circles in the mid 1890s and was regarded by some as the most important event of the century.

58. *Die Fackel*, no. 36, Vienna, end of March 1900, p. 18.
59. *Wiener Allgemeine Zeitung*, 22 March 1901.
60. Strobl, no. 866.
61. Strobl, nos 3470a and 3471.
62. Strobl, nos 3470a and 3471.
63. *Neue Freie Presse*, 29 November 1903.
64. Strobl, no. 42.
65. Dobai, see note 6, ND 128.
66. *Neue Freie Presse*, 29 November 1903.
67. Strobl, nos 868 and 869.
68. Strobl, nos 870–874.
69. Strobl, nos 875–880.
70. Hevesi, see note 22, p. 444.
71. Strobl, no. 881.
72. Actually an octopus, as the polyp has no tentacles (*Brockhaus*, vol. 12, Leipzig and Mannheim, 1997, p. 456).
73. *Die Fackel*, Vienna, 21 November 1903, p. 10; Hevesi, see note. 22, p. 445.
74. Hevesi, see note 22, p. 445.
75. Dr Max Glaß, *Neue Zürcher Zeitung*, 29 November 1903, supplement to issue no. 331.
76. Hermann Voss, *Franz von Stuck 1863–1928, Werkkatalog der Gemälde mit einer Einführung in seinen Symbolismus*, Munich, 1973, 139/2084.
77. Franz Servaes, in: *Neue Freie Presse*, 23 November 1903.
78. Strobl, nos 800 and 801.
79. Dr Hermann Ubell, in: *Die Gegenwart*, no. 52, p. 409.
80. Bisanz-Prakken, see note 32, pp. 199ff., ills 80, 81.
81. *Deutsches Volksblatt*, 15 November 1903; *Wiener Zeitung, Abendblatt*, 17 November 1903.
82. Bisanz-Prakken, see note 33, p. 47.
83. *Hamburgischer Correspondent*, 1 December 1903. Similar report in *Neue Freie Presse*, 23 November 1903.
84. Berta Zuckerkandl, in: *Wiener Allgemeine Zeitung*, 14 November 1903.
85. Strobl, no. 350.
86. Dobai, see note 6, ND 102.
87. Berta Zuckerkandl, in: *Wiener Allgemeine Zeitung*, 14 November 1903.
88. Hevesi, see note 22, p. 448.
89. A.V.A. K.u.U. Präsidium, 1126/1900, fo. 12.
90. A.V.A. K.u.U., 40123/03 fo. 3f.
91. A.V.A. K.u.U., 5874/05, fos 1–9.
92. A.V.A. K.u.U., 5874/05, fo. 2.
93. A.V.A. K.u.U., 9783/05, fos 1–4.
94. A.V.A. K.u.U., 13.109/05, fos 3–5.
95. A.V.A. K.u.U., 13 109/05, fos 1, 2, 6, draft of the letter to Klimt.
96. A.V.A. K.u.U., 20.17.
97. According to information kindly provided by Ms Hilde Glück, August Lederer provided the entire amount Klimt had received as advance payments from the ministry. It was only between 1910 and 1912 that Kolo Moser, who was married to Editha Mautner-Markhof, purchased the paintings *Medicine* and *Jurisprudence* directly from Klimt. These paintings remained in the family until Kolo Moser's death in 1918. Erich Lederer kindly informed me that his father wanted to purchase *Jurisprudence* immediately after Kolo Moser's death but he considered the a mount of one million crowns which the widow demanded too high. He finally succeeded in buying the painting through the intervention of Hofrat Franz H. Haberditzl, who purchased both paintings for the Österreichische Galerie. The money was advanced to him by August Lederer, who was then given *Jurisprudence* for a considerably more reasonable price. According to the inventory list of the Österreichische Galerie, 50,000 guilders were paid for *Medicine*. The inventory list also shows that, in 1944, *Philosophy* and *Jurisprudence* were forcibly purchased from Baron Bachofen for 50,000 marks each.
98. A.V.A. K.u.U., 35.343/05, fos 3f.; 40.413/05, fos 12f.
99. A.V.A. K.u.U., 40.413/05, fos 12f.
100. A.V.A. K.u.U., 6150/08, fos 1ff.

Gallery I
Philosophy

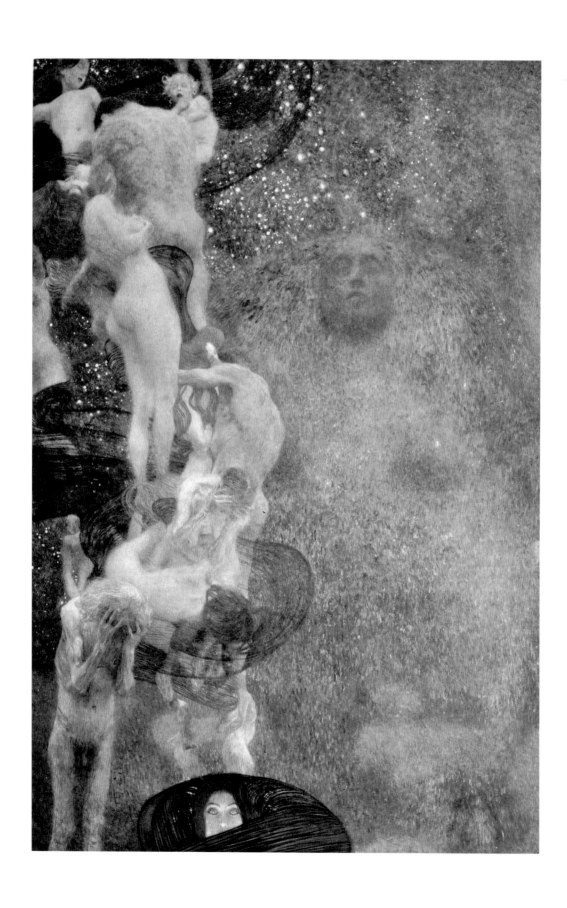

Gustav Klimt, *Kneeling Nude Old Woman, Turned Slightly to the Right,* 1900–1907
Black chalk, 37 x 26.5 cm
Albertina, Vienna
Inv. no. 23655, Strobl no. 469

Gustav Klimt, *Seated Semi-nude Old Woman, Turned Slightly to the Right,* 1900–1907
Black chalk, 44.6 x 31.6 cm
Wien Museum, Vienna
Inv. no. 96482/19, Strobl no. 468

Gustav Klimt, *Philosophy*, 1898–1907
Oil on canvas, 430 x 300 cm
Destroyed 1945

Gustav Klimt, *Male Nude from Behind, Seen from the Left,* 1900–1907
Black chalk, 42.3 x 26.6 cm
Albertina, Vienna
Inv. no. 23654, Strobl no. 459

Gustav Klimt, *Detail Study of an Embracing Couple,*
with a Seated Male Nude Seen from Behind, 1900–1907
Black chalk, 40.7 x 29 cm
Albertina, Vienna
Inv. no. 23644, Strobl no. 479

Gustav Klimt, *Seated Old Woman Supporting Her Head,*
Seen from the Left, 1900–1907
Black chalk, 45.3 x 33.5 cm
Albertina, Vienna
Inv. no. 34556, Strobl no. 455

Gustav Klimt, *Male Nude from Behind,*
Seen from the Left, 1900–1907
Black chalk, 45.4 x 30.7 cm
Wien Museum, Vienna
Inv. no. 74930/143, Strobl no. 461

Medicine

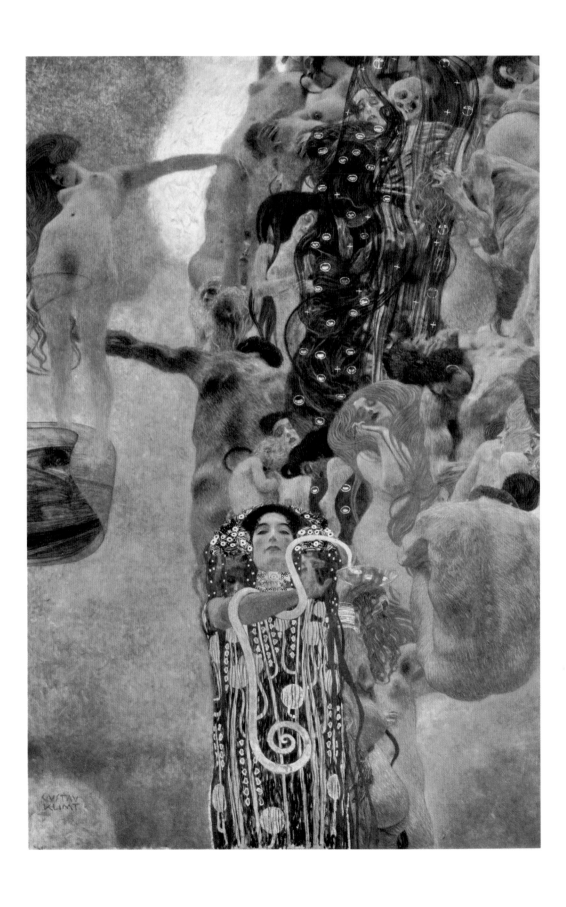

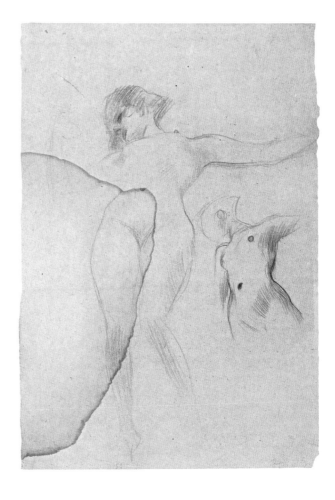

Gustav Klimt, *Floating Figure with Body in Profile,* 1901–1907
Black chalk, 44.6 x 30.6 cm
Wien Museum, Vienna
Inv. no. 96482/11, Strobl no. 618

Gustav Klimt, *Two Studies for the 'Floating Figure,'* 1901–1919
Pencil, 40.2 x 27.5 cm
Albertina, Vienna
Inv. no. 23675, Strobl no. 528

Gustav Klimt, *Medicine,* 1901–1907
Oil on canvas, 430 x 300 cm
Destroyed 1945

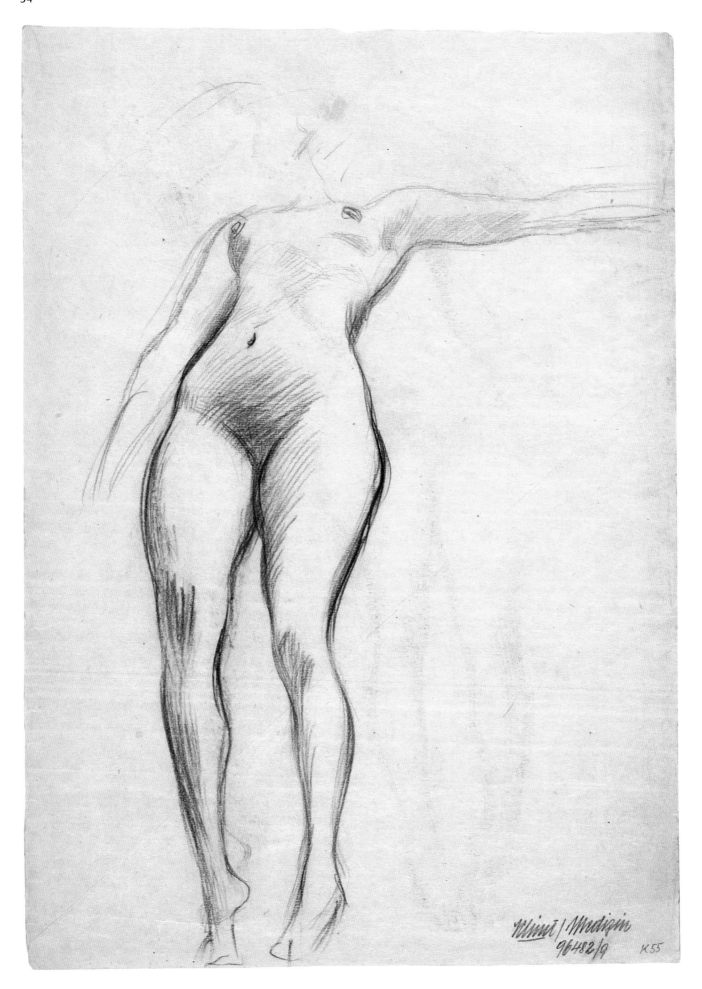

96482/9

K55

Gustav Klimt, *Floating Figure,*
Seen from the Left, with Lowered Right and
Raised Left Arm, 1901–1907
Pencil, 40.5 x 27 cm
Albertina, Vienna
Inv. no. 23665, Strobl no. 535

Gustav Klimt, *Floating Figure, Seen from the Left,* 1901–1907
Pencil, 38 x 27 cm
Albertina, Vienna
Inv. no. 23650 recto, Strobl no. 537

Gustav Klimt, *Floating Figure with Flowing Hair,*
Seen from the Left, 1901–1907
Pencil, 41.8 x 28.7 cm
Albertina, Vienna
Inv. no. 23647, Strobl no. 538

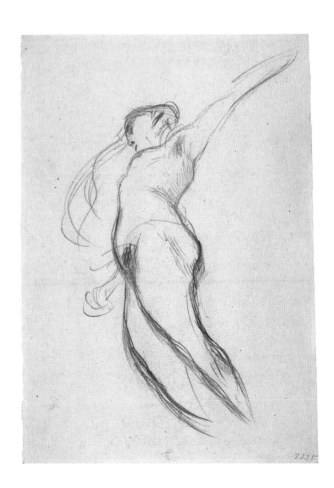

Gustav Klimt, *Floating Figure with Lowered*
Right Arm and Horizontal Left Arm, 1901–1907
Black chalk, 45 x 32.3 cm
Wien Museum, Vienna
Inv. no. 96482/9 verso, Strobl no. 532

Gustav Klimt, *Floating Figure with Outstretched Arms,* 1901–1907
Black chalk, 45.2 x 31.8 cm
Wien Museum, Vienna
Inv. no. 96482/6 verso, Strobl no. 529

Gustav Klimt, *Two Studies for a Standing Nude, Seen from the Left,* 1901–1907
Pencil, 38.2 x 27.9 cm
Albertina, Vienna
Inv. no. 23672, Strobl no. 527

Gustav Klimt, *Clothed Floating Figure with Hanging Hair,* 1901–1907
Pencil, 45.3 x 32 cm
Wien Museum, Vienna
Inv. no. 74930/57 verso, Strobl no. 519

Gustav Klimt, *Seated Hygeia, Seen from the Lower Left,*
with a Bowl and Asclepius Serpent in Her Right Hand, 1901–1907
Pencil, 45.2 x 312 cm
Wien Museum, Vienna
Inv. no. 74930/21 verso, Strobl no. 512

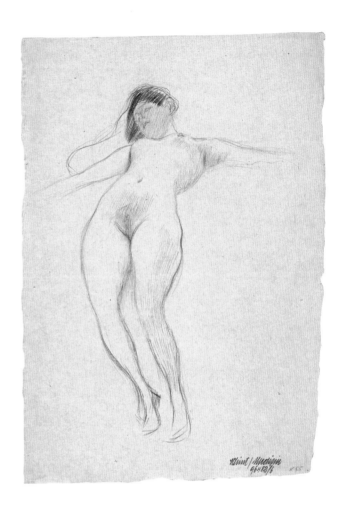

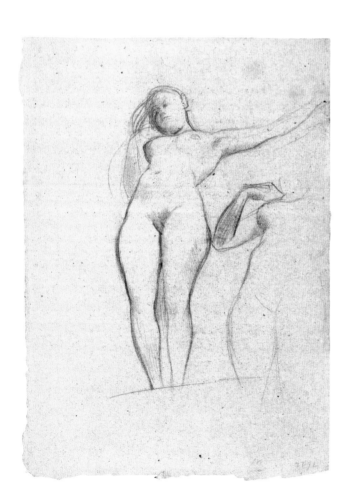

1932

Gustav Klimt, *Floating Male Nude from Behind, Seen from a Low Angle,* 1901–1907
Black chalk, 45 x 31.7 cm
Wien Museum, Vienna
Inv. no. 115858 recto, Strobl no. 539

Gustav Klimt, *Floating Male Nude from Behind, Seen from a Low Angle,* 1901–1907
Black chalk, 43 x 28.4 cm
Albertina, Vienna
Inv. no. 23679, Strobl no. 540

Gustav Klimt, *Male Nude with Outstretched Arms,*
Head and Shoulder Section Repeated, 1901–1907
Black chalk, 37.2 x 30 cm
Albertina, Vienna
Inv. no. 23661, Strobl no. 547

Following pages:

Gustav Klimt, *Two Pairs of Wrestlers*, detail study, 1901–1907
Black chalk, 43.9 x 29.2 cm
Albertina, Vienna
Inv. no. 23670, Strobl no. 594

Gustav Klimt, *Wrestling Men*, 1901–1907
Black chalk, 35.7 x 28.4 cm
Albertina, Vienna
Inv. no. 23673, Strobl no. 595

Gustav Klimt, *Two Pairs of Wrestlers*, 1901–1907
Pencil, 43 x 29.2 cm
Albertina, Vienna
Inv. no. 23657, Strobl no. 596

Gustav Klimt, *Wrestlers*, 1901–1907
Pencil, 37.7 x 29.4 cm
Albertina, Vienna
Inv. no. 23662, Strobl no. 597

Gustav Klimt, *Four Studies of a Child Held by Two Hands*, 1901–1907
Black chalk, 45 x 63 cm
Wien Museum, Vienna
Inv. no. 74930/151, Strobl no. 622

Gustav Klimt, *Three Studies of Recumbent Children,
Seen from the Right; and a Standing Child*, 1901–1907
Pencil, red chalk, 44.3 x 31 cm
Wien Museum, Vienna
Inv. no. 74930/148, Strobl no. 625

Gustav Klimt, *Five Studies of a Sleeping Child*, 1901–1907
Black chalk, 42.7 x 27.4 cm
Albertina, Vienna
Inv. no. 23653, Strobl no. 627

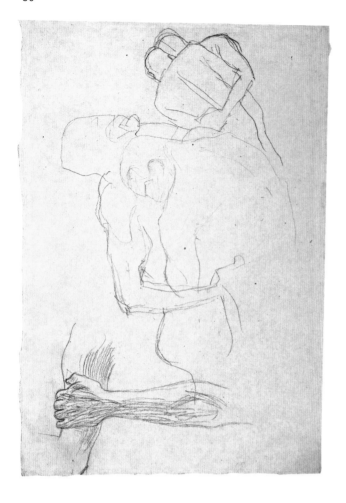

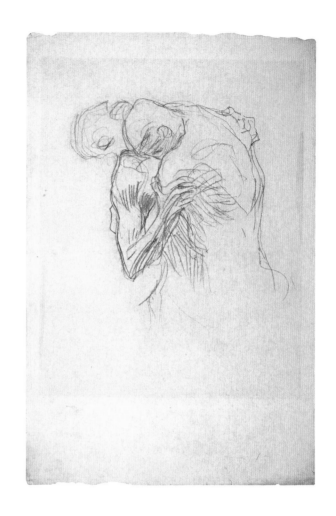

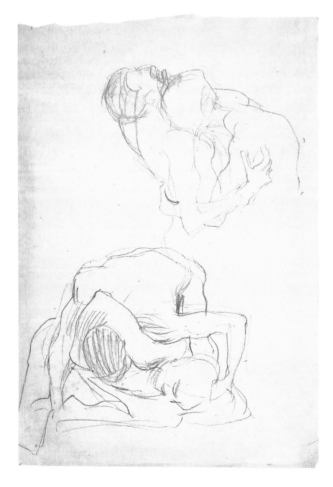

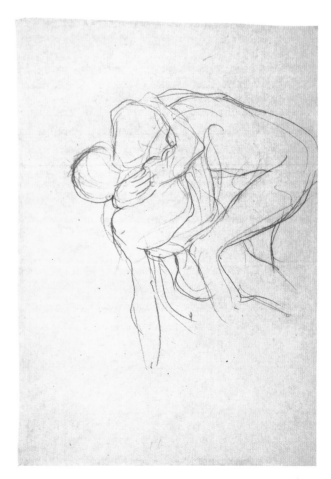

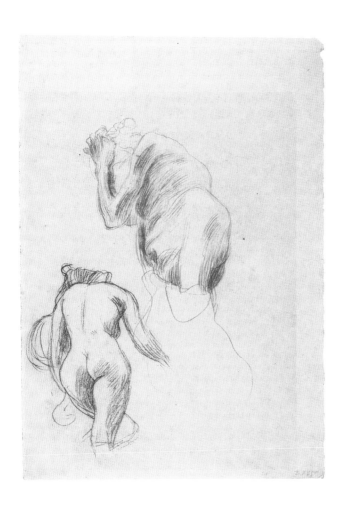

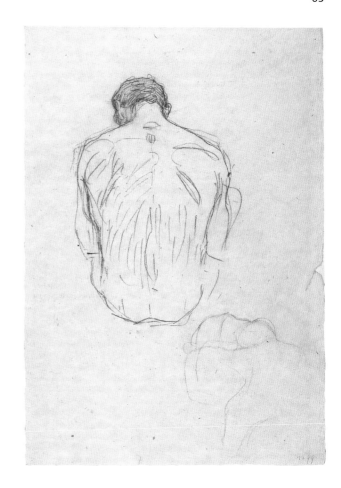

Gustav Klimt, *Female Nude, Seen from Behind;*
Despairing Old Man, 1901–1907
Pencil, black chalk, 38.2 x 28 cm
Albertina, Vienna
Inv. no. 23643, Strobl no. 638

Gustav Klimt, *Seated Male Nude,*
Seen from Behind; Sketch for the 'Wrestlers,' 1901–1907
Black chalk, 41 x 29 cm
Albertina, Vienna
Inv. no. 23646, Strobl no. 603

Gustav Klimt, *Seated Male Nude from Behind,* 1901–1907
Red chalk, 37.5 x 28 cm
Albertina, Vienna
Inv. no. 23669, Strobl no. 666

Gustav Klimt, *Old Man's Head; Seated Female Nude,*
Seen from Behind; the Right Side of a Female Torso, 1901–1907
Black chalk, 38.7 x 29 cm
Albertina, Vienna
Inv. no. 23660, Strobl no. 628

Gustav Klimt, *Two Studies of Skeletons, the*
Upper with the Head Turned to the Left, 1901–1907
Black chalk, 42 x 28 cm
Albertina, Vienna
Inv. no. 23648, Strobl no. 585

Gustav Klimt, *Standing Old Woman,*
Seen in Profile from the Left, 1901–1907
Black chalk, 45.1 x 30.5 cm
Wien Museum, Vienna
Inv. no. 74930/166, Strobl no. 673

Gustav Klimt, *Seated Old Woman,*
Seen from the Left, 1901–1907
Black chalk, 30.6 x 44.8 cm
Wien Museum, Vienna
Inv. no. 74930/39, Strobl no. 669

Gustav Klimt, *Three Studies of a Standing Woman,*
Seen from the Right, 1901–1907
Black chalk, 44.7 x 32 cm
Wien Museum, Vienna
Inv. no. 74930/100, Strobl no. 566

Gustav Klimt, *Female Nude, Seen from the Left,* 1901–1907
Black chalk, 45.3 x 31 cm
Wien Museum, Vienna
Inv. no. 74930/28, *11*, Strobl no. 563

Gustav Klimt, *Two Studies of a Female Nude from Behind,*
Seen from the Left, 1901–1907
Black chalk, 44.6 x 31.9 cm
Wien Museum, Vienna
Inv. no. 96482/29, Strobl no. 611

Jurisprudence

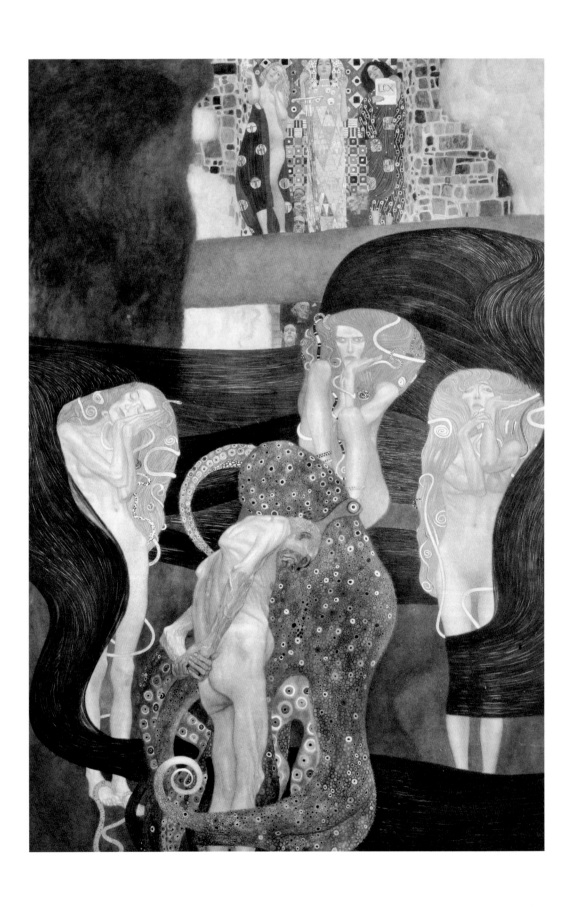

Gustav Klimt, *Bowed, Nude Old Man, Seen from the Right,* 1903–1907
Black chalk, 44.1 x 31.5 cm
Wien Museum, Vienna
Inv. no. 74930/132, Strobl no. 875

Gustav Klimt, *Bowed, Nude Old Man, Seen from the Right,* 1903–1907
Black chalk, 45 x 31.8 cm
Wien Museum, Vienna
Inv. no. 74930/265, Strobl no. 879

Gustav Klimt, *Jurisprudence,* 1903–1907
Oil on canvas, 430 x 300 cm
Destroyed 1945

Gustav Klimt, *Standing Female Nude with Raised Arms,*
Seen from the Front, 1903–1907
Black chalk, 44 x 32.9 cm
Wien Museum, Vienna
Inv. no. 74930/34, Strobl no. 917

Gustav Klimt, *Standing Female Nude with Raised Arms,* 1903–1907
Black chalk, 44 x 32.9 cm
Wien Museum, Vienna
Inv. no. 74930/269, Strobl no. 918

Gustav Klimt, *Standing Man with Sunken Head,*
Seen from the Right, 1903–1907
Black chalk, 45 x 31.5 cm
Wien Museum, Vienna
Inv. no. 96482/8, Strobl no. 868

Gustav Klimt, *Standing Female Nude with Raised Right Arm,*
Seen from the Front, 1903–1907
Black chalk, 44.9 x 31.7 cm
Wien Museum, Vienna
Inv. no. 74930/268, Strobl no. 919

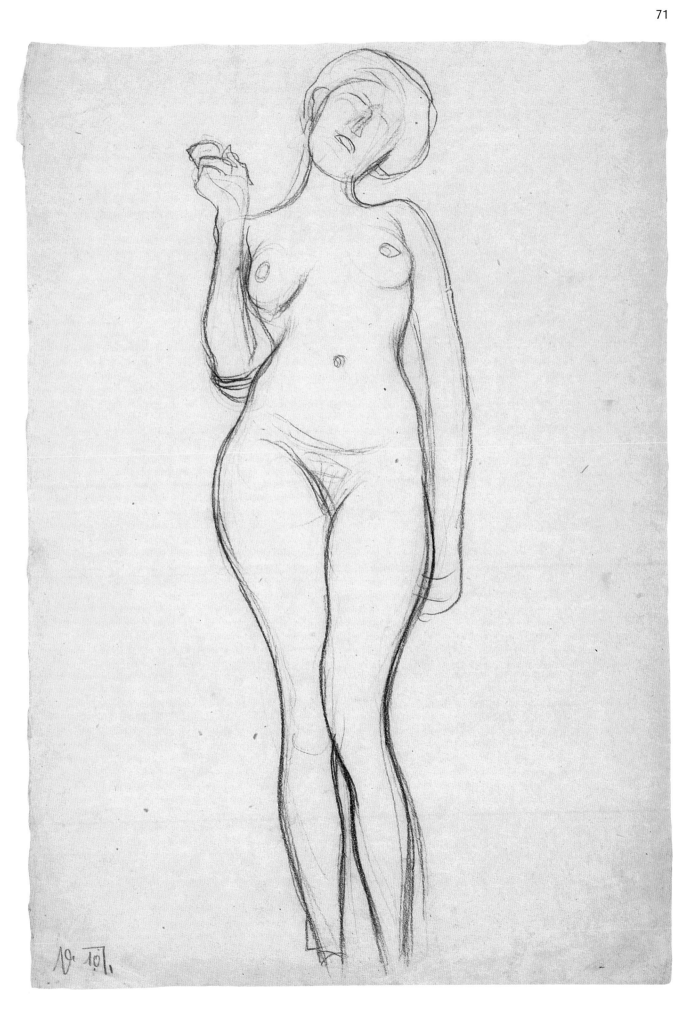

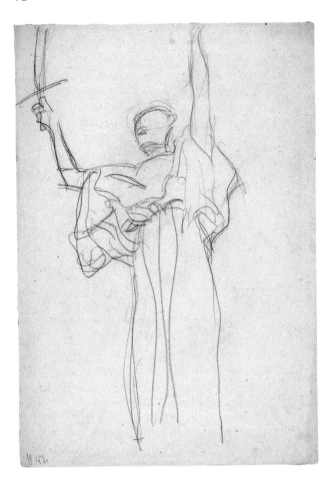

Gustav Klimt, *Bowing Man in a Toga,* 1903–1907
Black chalk, 44.9 x 31.3 cm
Wien Museum, Vienna
Inv. no.74930/117, Strobl no. 908

Gustav Klimt, *Head-and-shoulders Portrait of a Man, Seen from the Front,*
1903–1907
Black chalk, 44 x 32.2 cm
Wien Museum, Vienna
Inv. no. 74930/61, Strobl no. 911

Gustav Klimt, *Three-quarter Portrait of a Man in a Long Robe,*
Seen from the Right, 1903–1907
Black chalk, 44.4 x 30.8 cm
Wien Museum, Vienna
Inv. no. 96482/14, Strobl no. 910

Gustav Klimt, *Man in a Long Robe, Seen from the Front,* 1903–1907
Black chalk, 44.5 x 30.4 cm
Wien Museum, Vienna
Inv. no. 186207, Strobl no. 909

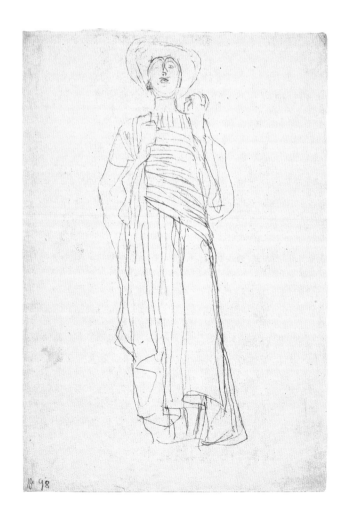

Gustav Klimt, *Standing Figure with a*
Sword in Her Raised Right Hand, 1903–1907
Black chalk, 44.9 x 31.4 cm
Wien Museum, Vienna
Inv. no. 74930/19, Strobl no. 864

Gustav Klimt, *Female Figure in a Toga (study for* Justitia*),* 1903–1907
Black chalk, 45 x 30.7 cm
Wien Museum, Vienna
Inv. no. 74930/103, Strobl no. 929

Related Works

Gustav Klimt, *The Sphinx with Knowledge, the Globe,*
Loving Couple and Despairing Man, 1898
Sketch from Sonja Knips' sketchbook, p. 63
Pencil, 13.8 x 84 cm
Österreichische Galerie Belvedere, Vienna
Strobl no. 3342

Gustav Klimt, *The Sphinx, Loving Couple with Child,*
and Figure at the Lower Edge, 1898
Sketch from Sonja Knips' sketchbook, p. 61
Pencil, 13.8 x 8.4 cm
Österreichische Galerie Belvedere, Vienna
Strobl no. 3340

Gustav Klimt, *Sonja Knips' Sketchbook*, 1897–1905
146 pages, covered in red leather
Drawings and notes in pencil
External dimensions: 14.3 x 9.2 cm
Österreichische Galerie Belvedere, Vienna
Inv. no. 8508

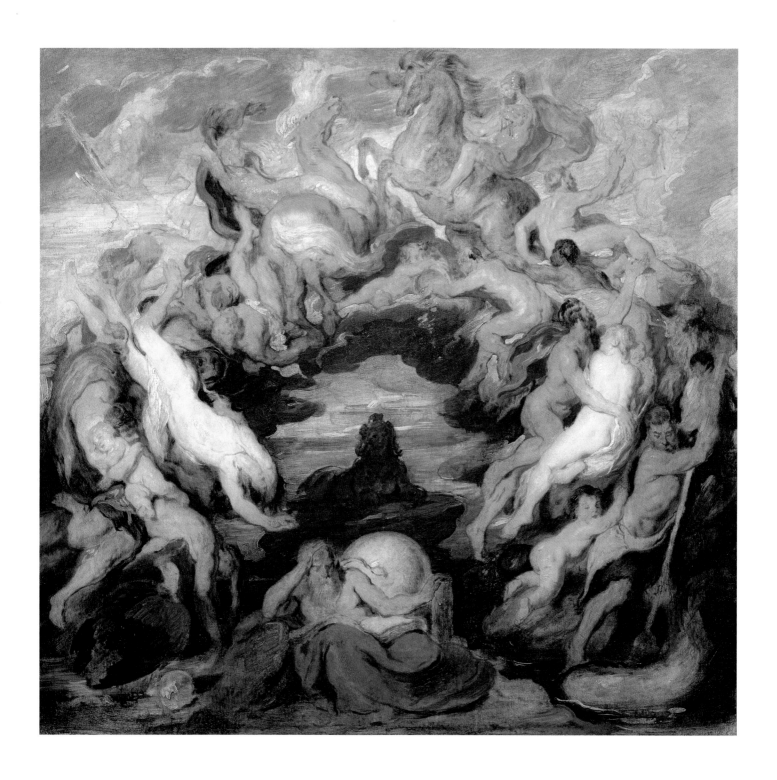

Hans Canon, *Cycle of Life*, sketch for the painting
on the ceiling of a staircase of the Museum
of Natural History in Vienna, 1884/85
Oil on canvas, 110 x 117.5 cm
Österreichische Galerie Belvedere, Vienna
Inv. no. 2084

Gustav Klimt, first exhibition poster for the Viennese
Secession (*Theseus and the Minotaur*), 1898
Lithograph on paper, 97 x 70 cm
Printer: A. Berger, Vienna
Wien Museum, Vienna
Inv. no. 129.001/1

Gustav Klimt, first exhibition poster for
the Viennese Secession, 1898
(censored version)
Lithograph on paper, 97 x 70 cm
Printer: A. Berger, Vienna
Wien Museum, Vienna
Inv. no. 129.001/2

Gustav Klimt, *Old Man on his Deathbed*, 1900
Oil on card, 30.4 x 44.8 cm
Signed lower right: GUSTAV KLIMT 1900
Österreichische Galerie Belvedere, Vienna
Inv. no. 8507, without ND no.

Gustav Klimt, *The Court Actor Josef Lewinsky*
as Carlos in 'Clavigo,' 1895
Oil on canvas, 60 x 44 cm
Signed lower right: GUSTAV KLIMT./MDCCCLXXXV.
Inscribed, upper centre: JOSEF. LEWINSKY./
ALS CARLOS IN CLAVIGO.
Österreichische Galerie Belvedere, Vienna
Inv. no. 494, ND 67

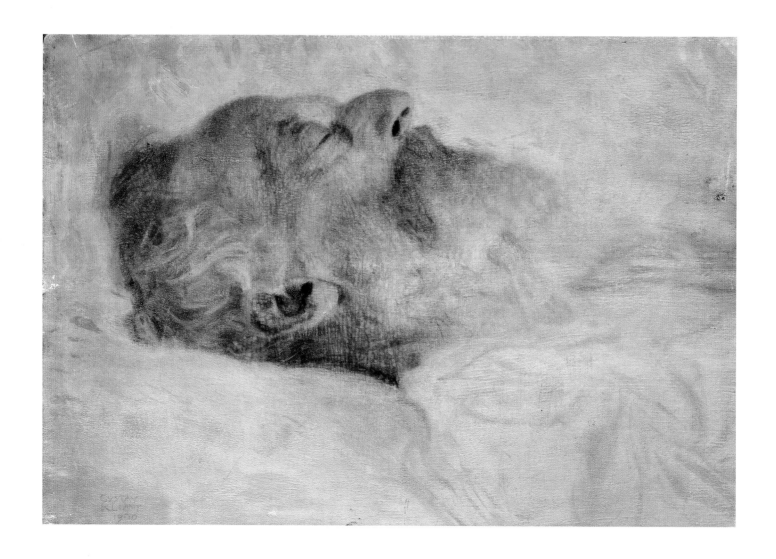

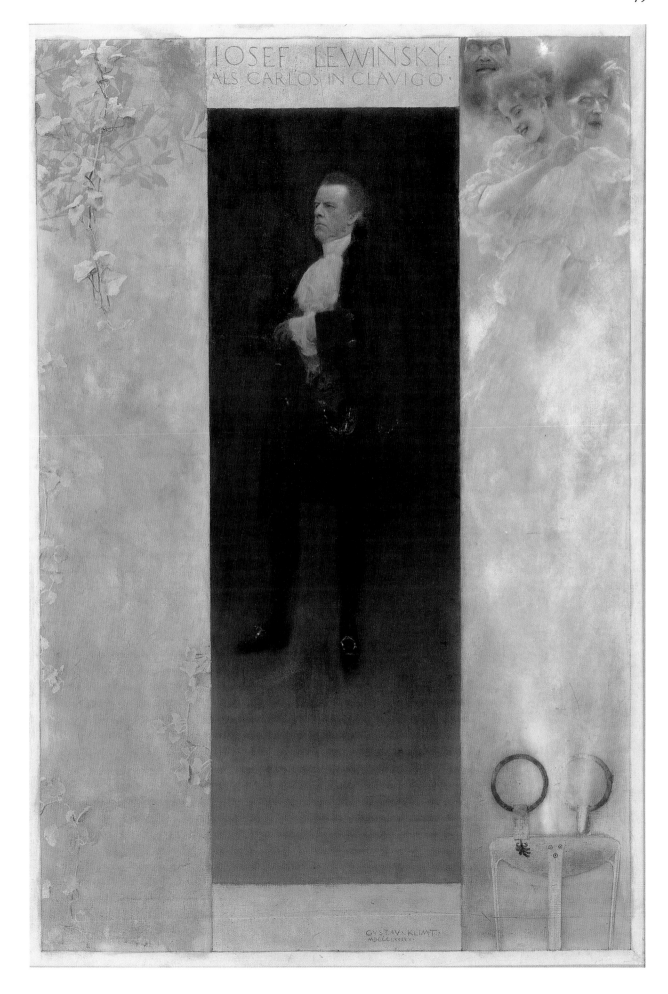

Josef Hoffmann, Sketch for the interior
of the planned exhibition in St. Louis
In: *Ver Sacrum: Die Wiener Secession
und die Ausstellung in St. Louis*, special edition,
Vienna, 1904, p. 15
Private collection

DIE „PHILOSOPHIE" VON KLIMT UND DER PROTEST DER PROFESSOREN.

„In unserer Cultur ist der Aufnehmende
überzeugt, ohne jegliche Vorbereitung so viel
begreifen zu können, als das Genie schafft =
und eher noch etwas mehr." Lichtwark.

DIE VII. Ausstellung der Vereinigung brachte Klimts „Philosophie", das erste der drei Deckenbilder, die der Künstler im Staatsauftrag für die Aula der Uni= versität herzustellen hat. Eine Reihe von Univer= sitätsprofessoren nahm dies zum Anlass, um eine Bewegung gegen die Anbringung des Bildes an seinem Bestimmungsorte zu inscenieren und dem Ministerium einen in diesem Sinne gehaltenen Protest zu überreichen. Infolgedessen entstand eine heftige Zeitungsfehde zwischen Freunden und Gegnern des Bildes, an der sich auch einzelne der protestierenden Professoren im Wege von Interviews und offenen Schreiben = nicht immer in höflichem Tone = betheiligten. ☺☺☺
☺ Das Bild ist gegenwärtig in Paris. Diese Zeilen sollen den Standpunkt präcisieren, den die Vereinigung dem Vor= falle gegenüber einnimmt. ☺☺☺
☺ . Auf die Bemerkung einzelner Professoren, ihre Action entbehre jeder Spitze gegen die Vereinigung, ist zu erwidern, dass die Mitglieder derselben nicht aus freiem Antriebe bei= treten, sondern durch die Vollversammlung ernannt werden. Die blosse Mitgliedschaft eines Künstlers sagt also schon, wie die Gesammtheit der Vereinigung über sein Können

J. M. Auchentaller OM.
Randzeichnung

'Die *Philosophie* von Klimt und der Protest der Professoren'
(Klimt's *Philosophy* and the professors' protest)
in: *Mittheilungen der Vereinigung bildender Künstler Österreichs,*
Ver Sacrum, 1900, no. 10, p.151.
25.7 x 24.3 cm
Private collection

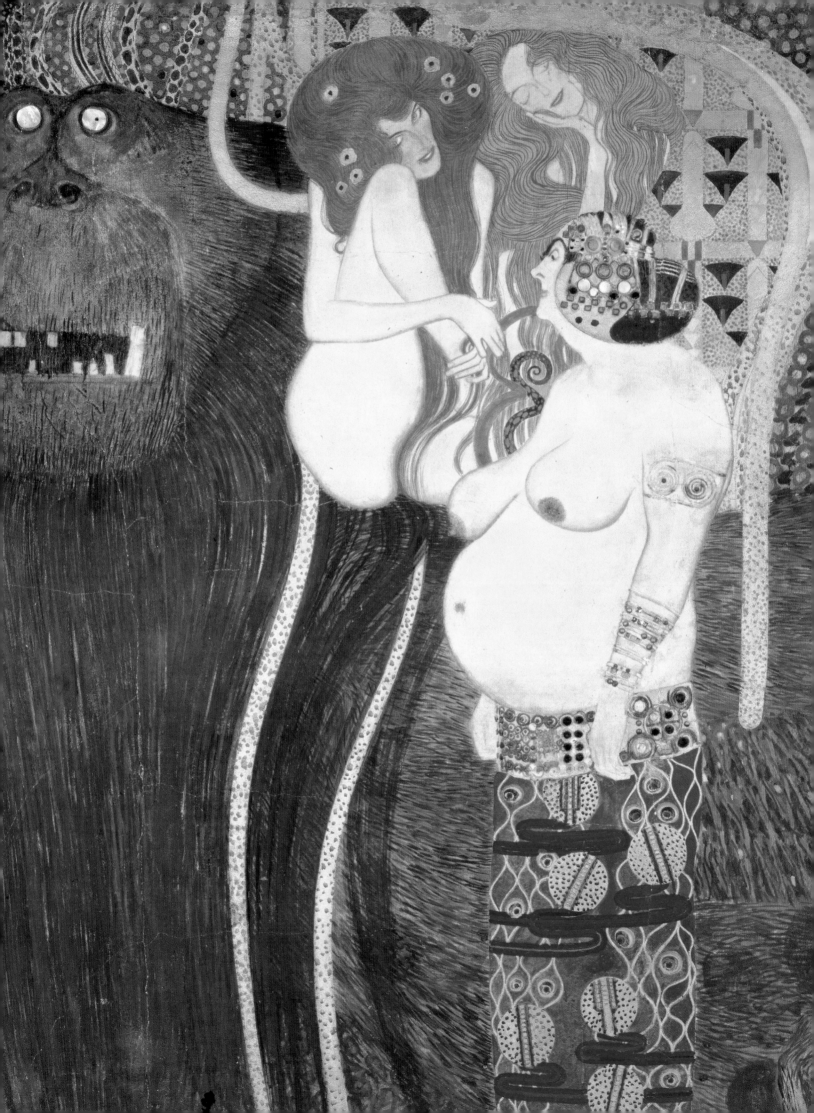

Stephan Koja

"... just about the nastiest women I have ever seen ..."[1]
Gustav Klimt's *Beethoven Frieze*: Evolution and Programme

The Beethoven Exhibition as a 'total work of art'

When it presented Max Klinger's Beethoven sculpture to the Viennese public in a magnificent exhibition completely centred on this celebrated work, the Viennese Secession achieved one of the most spectacular successes in its history — and at the same time triggered off one of the most vehement public scandals.

The sculpture, which had been awaited with great excitement for a long time, drew a phenomenal 60,000 visitors to the exhibition building. It was Klimt's *Beethoven Frieze*, however, which was one of the other gems in this remarkable exhibition, that became the main source of irritation for both the public and the press.

The fourteenth exhibition of the Austrian Artists' Association–Secession took place from 15 April to 27 June 1902 and became famous as the 'Beethoven Exhibition.' Klimt's cycle was a part of the project that Josef Hoffmann had conceived as a 'total work of art' (*Gesamtkunstwerk*) with contributions by twenty-one artists.[2]

As stated above, the heart of the exhibition was Klinger's monumental Beethoven statue, which was placed in the main hall of the Secession building. The proclaimed goal of the exhibition was to unite the individual arts — architecture, painting, sculpture and music — through a common theme: the work of art as the result of the close interaction between interior design, wall painting and sculpture. The bibliophile edition of the exhibition catalogue was intended to reflect this, and became "undoubtedly the most artistically perfect Secession catalogue."[3]

Since the foundation of the association, the artists of the Viennese Secession had pursued a renewal of the arts and artistic life with great earnestness. It was not only intended that art should develop a new, individual and authentic pictorial language; but also that the public should be educated through outstandingly presented exhibitions, and in particular through exemplary presentations of the latest achievements in international art. In attempting to meet these aims, the Secessionists developed a totally new kind of exhibition practice. They liberated themselves from traditional 'salon hanging,' with its overfull walls, and replaced it with a sophisticated and elegant presentation that caused an international furore. For each exhibition, a special committee was formed to ensure the unified appearance of the posters and catalogues. The main driving forces behind the realisation of these ideas were the artists Alfred Roller, Josef Hoffmann and Kolo Moser.

By the end of the nineteenth and the beginning of the twentieth centuries, the Secession had succeeded in becoming a fixed point in international art, and was represented in the faculty of the Viennese School of Applied Arts (Josef Hoffmann, Kolo Moser and Alfred Roller). However, the uproar over Gustav Klimt's faculty painting *Medicine* in the spring of 1901 had once again exposed the deep divide separating "official and new monumen-

Gustav Klimt, *The Hostile Forces: Typheus* and *Lasciviousness, Lust, Excess* (detail from the *Beethoven Frieze*)

Catalogue of the fourteenth Secession exhibition
(Beethoven Exhibition), Vienna 1902, pp. 4, 72 and 73

View into the main room of the fourteenth Secession exhibition,
designed by Alfred Roller, Vienna 1900. Among other works,
pictures by Giovanni Segantini and plaster casts of statues
by Auguste Rodin could be seen

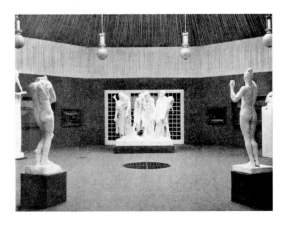

tal art,"[4] with the members of the Secession, naturally, displaying solidarity with Klimt. A militant mood, coupled with a self-assurance resulting from international recognition, helped the Secessionists to decide in favour of a completely new concept for exhibitions. It was intended to create a total work of art, an exhibition that would surpass all previously held exhibitions. In the catalogue, Ernst Stöhr made it absolutely clear that this new venture was intended to "completely change the nature [of exhibitions]." "First of all, it was necessary to create a unified space to be decorated by painting and sculpture working in the service of the spatial idea. So, in theses circumstances, we had to make the individual components subordinate to the totality. This inexorable logic necessitated devoting great attention to the character of the space itself and to adhering firmly to a guiding concept. All this was demanded of the tasks of monumental art and developed, at all times, into the loftiest and finest to which mankind is capable: temple art."[5]

The special characteristic of this new concept was that an exhibition was not intended to be merely an accumulation of works of art, more or less aesthetically arranged over the walls, but a work of art in itself, best described as *Raumkunst*, or 'spatial art.' Klinger had often attempted to achieve this in his own way, but the Secessionists went one step further: the exhibition itself was meant to be a work of art, created collectively and, though it was to have only a brief life-span, to be noble and purifying. The Secession building would become a 'temple' and the artists — Gustav Klimt above all — would be conceived as saviours or prophets. The beauty of this 'exhibition as work of art' should effect the visitors in such a way that they felt this temple was an opportunity for aesthetically elevating their lives, a refuge from the adversity and ugliness of everyday life.

Art and its presentation was invested with a kind of holiness. For this reason, all of the participating artists had to work in the service of creating a completely unified impression and, at the same time, with the utmost care and to the highest standards. Although each work was signed with a device, a comparison with a medieval cathedral building workshop suggests itself, where, in a similar way, a great array of artists created a unified masterwork in the service of an idea.[6] This was characterised by the notion of the equality of all the arts, with good craftsmanship being accorded especial importance. "The creative process was at least as important for the participants in this 'modern' experiment in spatial art as the final result."[7] However, the creation of modern and 'new' works of art was still a matter of concern and, therefore, experimentation with unusual materials and techniques — such as gold lacquer work, mosaics, carved concrete, wood reliefs with metal inlaid work, and so on — can be found in the so-called decorative panels.[8]

And there was one work of art that satisfied all of these requirements and would invest the show with the necessary consecration: Max Klinger's statue of Beethoven. This sculpture was to be Klinger's polychrome masterpiece and to display his theories in a perfect form. Polychromy, which was a subject that preoccupied the nineteenth-century art world, promised in particular a renewal of art through the concept of a total

work of art. In the Beethoven sculpture, not only various precious materials (such as marble of various colours, alabaster, ivory, mother of pearl and amber) were worked with great skill, but also the link with Greek sacred sculpture was explicitly acknowledged — the model Klinger used was Phidias' polychrome figure of Zeus, which was well known from ancient reports. This and the depiction of the heroically revered composer created a clear connection to temple art.

Max Klinger was one of the most celebrated personalities of his time and his work was followed with great public interest. And indeed the 'public relations' methods used in connection with the much-heralded major work were very sophisticated. The preliminary reports on the sculpture, the completion of which was delayed time and time again, created great expectations and even a kind of tension — an approach that calculatedly created an 'event' in today's sense.

It was no coincidence that Klinger the 'artistic genius' had chosen Beethoven the 'musical genius' as his subject, for by the late nineteenth century Beethoven reverence had developed into a cult that reached its peak at the turn of the twentieth century. This passion for Beethoven was greatly influenced by Schopenhauer's and Nietzsche's conception of genius, which saw the lonely warrior as the epitome of the artist, suffering for the salvation of mankind. His life was an example of "the painful struggle for knowledge and the anguish of recognition."[9] Klinger made this idea the programme for his Beethoven figure. The reliefs on the throne represent the polarity between antiquity and Christianity: Adam and Eve and the progeny of Tantalus symbolise the suffering of mankind, while the birth of Venus and the crucifixion of Christ contrast the confirmation of life with renunciation and the willingness to make sacrifices. Beethoven's figure unites aspects of Zeus and the Messiah, his bent-forward posture, with his fist clenched against his body, expressing his intense, innermost feelings.

On the occasion of the altar-like presentation of Klinger's monumental painting *Christ on Olympus* in the third Secession exhibition, it was already widely believed that the picture was not simply dealing with the victory of Christianity over antiquity, but with much more — with the longed-for reconciliation between the two opposed ideologies which had fashioned Western culture.[10] Ludwig Hevesi reported on the religious mood that accompanied the presentation of *Christ on Olympus*: "The entire atmosphere is pervaded by a great, earnest solemnity. A profane temple full of profound works of man."[11] Also seen in the figure of Beethoven was "the prophecy of a more perfect future."[12]

In Klinger's work, Beethoven is represented as a solitary 'hero of sound' who — misunderstood, like Christ — created and suffered in solitude, and through this made his unique contribution to the salvation of mankind. Chiselled in white marble from the Greek island of Syros, he sits half-naked on his throne. This is not an idealised nakedness but the specific physicality of an old man that was intended to emphasise the uniqueness of his genius.

The Viennese Secessionists recognised a close kinship with Klinger's conception of art — they greeted him euphorically not merely because he was presenting them with

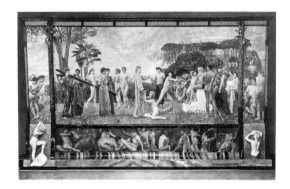

Max Klinger, *Christ on Olympus*, 1897
Oil on canvas, 362 x 772 cm
On permanent loan from the Österreichische Galerie Belvedere,
Vienna, to the Museum der bildenden Künste, Leipzig

Presentation of Max Klinger's *Christ on Olympus*
in the Secession 1899,
Décor by Josef Hoffmann

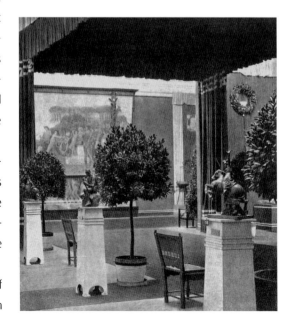

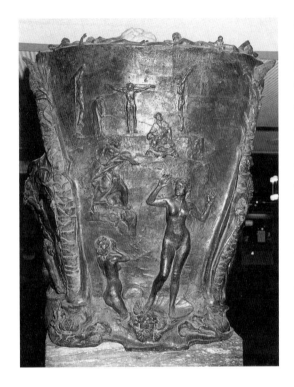

Max Klinger, *Beethoven* (detail showing the back of the throne), 1902
Bronze, various types of marble, onyx, ivory, semi-precious stones
Museum der bildenden Künste, Leipzig

something new, but precisely because he wanted the same as they did. In his *Malerei und Zeichnung* (Painting and Drawing) of 1895, Klinger demanded the utmost skill and spiritual mastery from artists: materials should harmonise with the space in which the work functions and so, through a close link between the technical and the intellectual, create a 'spatial art.' Excerpts from this treatise were even quoted in the exhibition catalogue.[13] "The unity of the space and the imperative of its importance demand that the natural laws of form and colour, which are usually so strictly observed, be done away with in favour of the purely poetic use of these means. The tremendous impact results from having everything which is not crucial to the idea not merely being given less importance, but being fundamentally remodelled so as to suppress any secondary considerations, to prevent any comparison with living nature, and so to lead the viewer's gaze entirely towards the totality of what was desired."[14]

At the time, everybody was talking about the idea of the total work of art. Richard Wagner, who coined the expression, was particularly anxious to confront the fragmentation of the arts, which had become increasingly noticeable, with a work that would unite all creative forces in the service of a single, central artistic idea.

Theories on the interaction between all the arts had already been developed in various countries, though "It speaks in favour of the practical sense of the artists of the Secession that, in their striving, they gave actual form to that which got bogged down in mere theory with most of their contemporaries."[15]

Unlike Klinger, however, who was keen to use precious materials, the Secessionists adhered to their commitment to simplicity and honesty — particularly in their choice of media. The objects they produced displayed a richness of experimentation never before seen. But it was an experimentation which, through the artists' standardised format and, above all, the strict dictates of the room itself (which was designed with a genial simplicity by Josef Hoffmann), actually fused with each other to produce a single entity. The spatial concept of this exhibition stipulated the parameters for the works to be created. This concept eventually led to the setting up of the Wiener Werkstätte, which organised the spontaneous collaboration of the various exhibition artists in order to continue the work of an architect in the very heart of a building. Klimt, and the colleagues around him, later soberly saw that the concept of a purifying art, permeating all areas of life, was doomed to failure.

The Beethoven Exhibition had to be postponed twice because Klinger had not finished his sculpture, and improvised events used as fillers. The extravagant working of the precious materials — Beethoven's throne had to be cast in bronze by a firm in Paris, for example — required more time and effort than was originally assumed. Photographs of the previous twelfth and thirteenth Secession exhibitions show that the wall space was considerably reduced because the frescoed walls created for the Beethoven Exhibition were already in place and temporary walls had to be built in front of them for the interim exhibitions. Shortly before the opening, Berta Zuckerkandl commented: "In this way, the [twelfth] Secession Exhibition, which recently closed, already had the coming exhibition completely finished behind the walls decorated with paint-

Max Klinger, *Beethoven*, 1902
Bronze, various types of marble, onyx, ivory,
semi-precious stones, 310 cm high
Museum der bildenden Künste, Leipzig

ings. Nobody noticed that these were double walls and only a ceiling decoration, which shone through the spanned velum [awning], betrayed something of the future project."[16]

As part of the Beethoven veneration, a new version of the last movement of Beethoven's ninth symphony, arranged by Gustav Mahler, was performed by the Vienna Philharmonic Orchestra at the opening.[17] The organisers were proven right when the high costs involved in organising and 'marketing' this Secession exhibition resulted in its becoming one of the society's major public successes. In addition, it was of fundamental importance for Klimt's development, and that of numerous other participating artists: "The Vienna Secession, as a decorative group style and symbolic bearer of mood, never again articulated itself so clearly as here, and in the art journal *Ver Sacrum*, which appeared at the same time."[18]

"Never before did a work of art of this period receive such a joyous welcome and tribute from the Viennese artistic world as Klinger's *Beethoven*, which was completed on 25 March 1902 and, shortly thereafter, exhibited in Vienna for the first time."[19] Carl Schorske formulated this more precisely: "If ever there was a demonstration of collective narcissism, this was it: artists (the Secession) honoured an artist (Klinger) who, in turn, honoured an artistic hero (Beethoven)."[20]

Others are of the opinion that Klinger and his monument were merely an excuse to make the idea of a total work of art plausible and to express it impressively: "The suspicion that Klimt and his colleagues thought primarily of liberating themselves from the 'hostile forces' of the anonymous market is not so far fetched."[21] In other words the Secessionists' main concern was to create a context for the production and reception of their art. They had broken away from the sales exhibitions of the Academy and the Künstlerhaus: the "Secession's extremely missionary vision of art, which was devoted to the romantic belief that creative subjectivity reveals real values, was vehemently

View of the main hall of the twelfth Secession exhibition, 1901/02
Décor by Alfred Roller

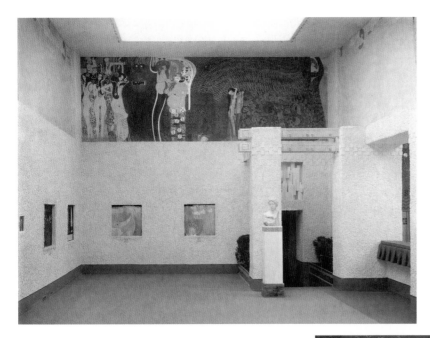

Beethoven Exhibition 1902, left side-hall with Gustav Klimt's *Beethoven Frieze*; on the far wall two reliefs by Ernst Stöhr, one relief by Josef Hoffmann above the door and, in front of this, *Girl's Head* by Max Klinger

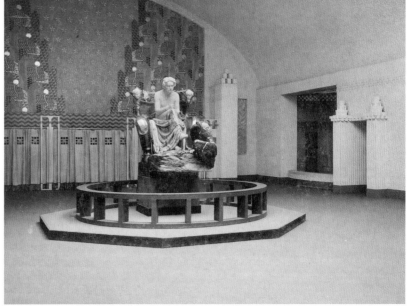

Beethoven Exhibition 1902, main hall with Max Klinger's Beethoven sculpture; in the background, Alfred Roller's *Falling Night*

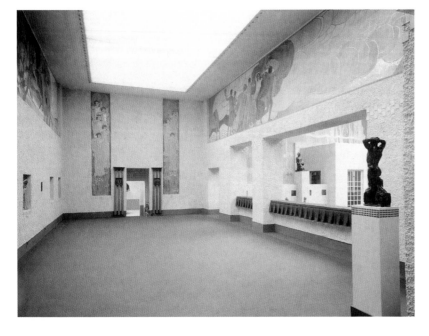

Beethoven Exhibition 1902, right side-hall
Left wall: Ferdinand Andri*, Manly Courage and the Joy of Battle*
Far wall: *Girls Making Music* by Friedrich König
Right wall: Josef Maria Auchentaller's *Joy, Beauteous Spark of the Gods*

Leopold Stolba, carved cement, partially coloured. Intarsia of embossed brass, copper, mother-of-pearl and glass

Othmar Schimkowitz, polished marble relief

Kolo Moser, mosaic of cut and glazed tiles and carved glass feet

Ernst Stöhr, linear drawing carved in plaster with a partial coating of sheet metal

Ernst Stöhr, linear drawing carved in plaster with a partial coating of sheet metal

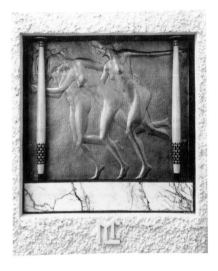

Maximilian Lenz, embossed brass mounted in marble and wood, with small, coloured wooden columns

Rudolf Jettmar, fresco painting with tempera

Friedrich König, embossed copper, partially gilded

Richard Luksch, mosaic of cut, glazed tiles and mother-of-pearl

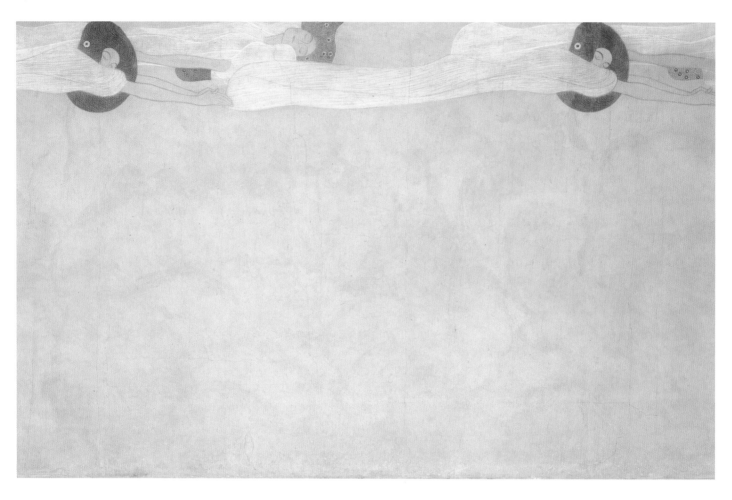

Gustav Klimt, *The Floating Figures – Longing for Happiness*
(detail from the *Beethoven Frieze*)

opposed to the profane, pluralistic offerings of everyday art exhibitions and ordained its artists with higher orders."[22] However, the Secessionists ultimately also had to live from selling their works. Yet in spite of this, they — and Klimt in particular — wanted to elevate themselves above the mass of standard art producers. This made the concept of constructing a 'temple to the arts' (and especially a temporary one) sensible and logical. Josef Hoffmann gave architectural expression to this in the — clearly sacral — form of the exhibition building: three naves with apses (the novelty of the Secession building lies in the possibility of creating new interior spaces by mans of movable walls). Therefore, the contemporary audience experienced the emptiness of the rooms either as "solemn"[23] or as an "Assyrian swimming pool."[24]

However, one should not accuse the Secessionists of glossing over their economic intentions with ideology — the conviction that art could transmit ethical values, even purify people, was just as deeply felt as the image they had created of themselves of heroic cultural warrior of the avant-garde. (Ferdinand Andris's wooden reliefs or his wallpainting in the Beethoven exhibition show this impressively — see ills pages 88 and 159). From the very beginning, the Secession was a movement to which not only painters and sculptors belonged but also architects and craftsmen — the basic idea of a total work of art was (latently) present from the very beginning.

Klimt's *Beethoven Frieze*

To invest the presentation of Klinger's Beethoven statue with the appropriate solemnity, both side-halls were positioned higher than the central hall so that visitors could get a better view of the centrally placed Beethoven sculpture through the openings in the walls. The entire course through the exhibition was designed to prepare visitors for the overwhelming impression created by the encounter with the masterpiece.

This journey through the exhibition began in the hall on the left side, which had been decorated by Klimt. This clearly provided Klimt with a privileged position within the organisation of the exhibition.

Beginning with the side-wall on the left, the three walls form a connected story. The Longing for Happiness, represented by the floating female figures who move around the frieze like "a kind of continuous ornament, just below the ceiling, as a rhythmic succession of flowing forms, of stylised human limbs and heads,"[25] stands at the beginning. These run into the Hostile Forces on the middle wall. The cycle culminates in two themes representing two verses from the last strophe of Schiller's 'Ode to Joy' — 'Joy, beautiful spark of the gods' and 'This kiss for the entire world' — which form the finale of Beethoven's ninth symphony. Klimt's frieze attempts a symbolic translation of

Gustav Klimt, *The Hostile Forces*
(detail from the *Beethoven Frieze*)

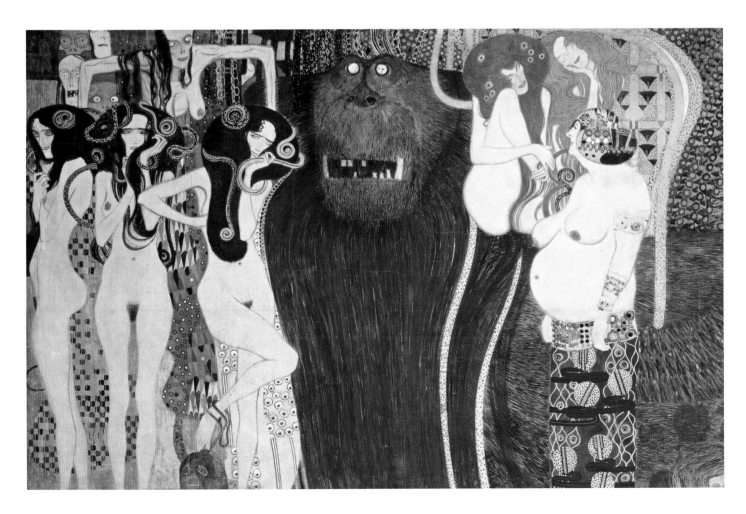

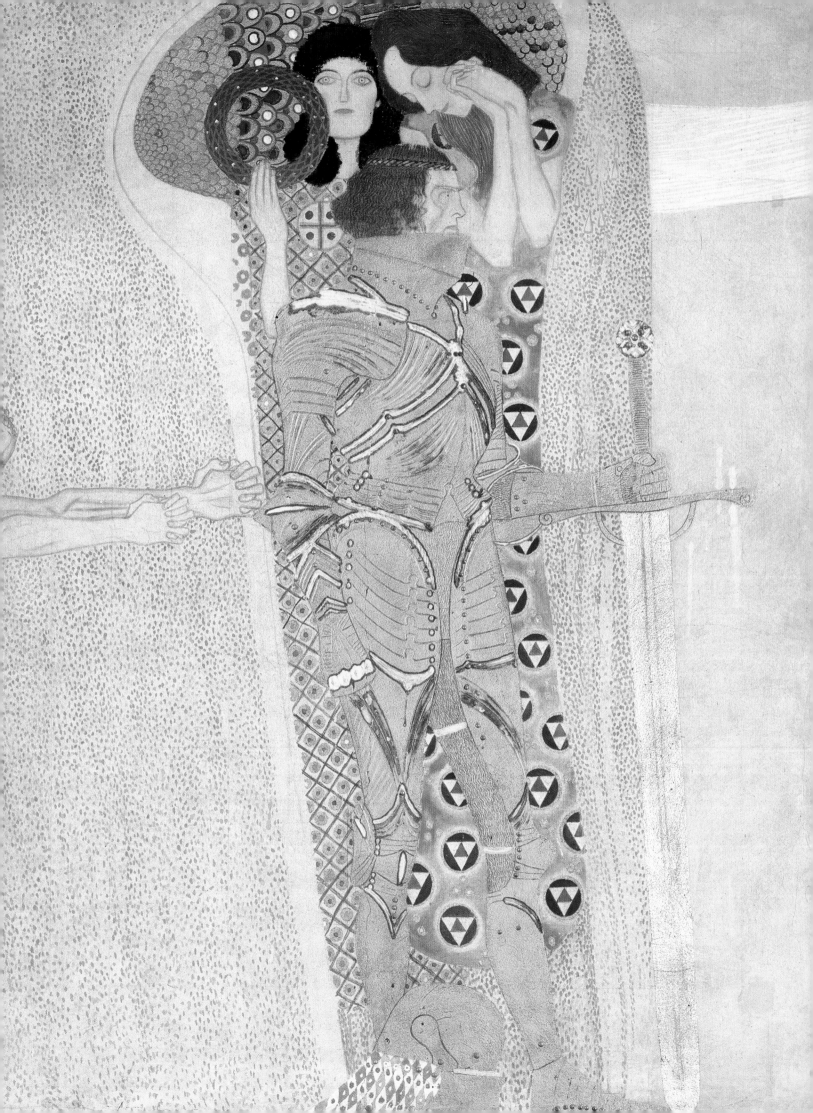

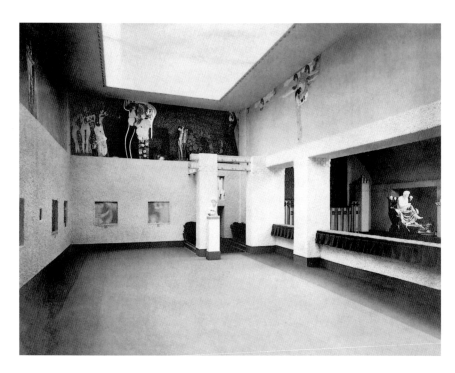

Beethoven Exhibition 1902, right side-hall showing Gustav Klimt's
Beethoven Frieze (far wall) and (through the opening on the right)
Max Klinger's Beethoven sculpture

Beethoven's ninth symphony and, at the same time, a very personal
interpretation.

It is explained in this way in the catalogue that accompanied the 1902 exhibition:

"First long wall, opposite the entrance: the longing for happiness [the floating figures:
author's note]. The sufferings of weak humanity [the standing maiden and the
kneeling couple]: the plea to the well-armed strong man [the knight in shining armour]
as the external driving force, and pity and ambition as the internal ones [the female
figures behind him], to take up the battle for happiness on their behalf. Narrow wall:
the hostile forces. The giant Typheus, against whom even the gods fought in vain [the
monkey-like monster]; his daughters, the three Gorgons [to his left]. Sickness, mad-
ness, death [the grotesque heads and the old woman behind them]. Lasciviousness,
lust and excess [the three female figures on the right next to the monster]. Gnawing
grief [the cowering figure to the side]. The desires and wishes of mankind fly away
overhead. The second long wall: the longing for happiness finds its satisfaction in poet-
ry [the floating figures encounter a female figure playing a cithara]. The arts [the five
overlapping female figures, some of them pointing towards a choir of angels singing
and playing musical instruments] lead us to the ideal realm where we alone find pure
joy, pure happiness, pure love. The choir of the angels of paradise. 'Joy, beautiful spark
of the gods.' 'This kiss for the entire world.'"

It was above all Richard Wagner's interpretation of Beethoven's symphony that influ-
enced the programme of the frieze to a very large degree. Wagner had presented his
thoughts on the symphony in a programme booklet, published in 1846, that became
legendary.[26] Wagner had decided to depict the "inner images" the work aroused in

Gustav Klimt, *The Knight in Shining Armour*
(detail from the *Beethoven Frieze*)

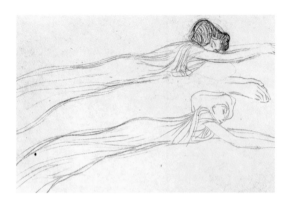

Gustav Klimt, *Longing for Happiness,* study for the floating figures
in the *Beethoven Frieze, c.* 1901
Black chalk, 31.8 x 45.6 cm
Albertina, Vienna

him as an aid to understanding the ninth symphony, which, because of its unusual structure, had previously (according to Wagner) been totally misunderstood: "The opportunity of producing a written interpretation of the choral section provided me with the opportunity to create a guide for the simple understanding of the work, in the form of a programme, in order to make an impression purely on the listeners' feelings — and not on their critical judgment."

The floating figures which open the frieze, the personifications of the Longing for Happiness, threatened by the Hostile Forces, are touched upon in Wagner's interpretation of the first movement: "In a magnificent fashion, the first movement appears to be based on the battle of the soul struggling for joy against the pressure of that hostile force that stands between us and happiness on earth."

The Knight in Shining Armour, who is prepared to do battle against these Hostile Forces, also appears to have his origins in Wagner's words: "We recognise a noble defiance in the confrontation with this mighty foe, a masculine energy of resistance which intensifies in the middle of the movement to become an open battle with the foe."

And finally, the monster Typheus: "In certain light moments, we are able to recognise the melancholic, sweet smile of happiness which appears to be seeking us. We are fighting for its possession and that malicious, powerful adversary holds us back from reaching it, casting a shadow over us with his nocturnal wings so that our view of that distant grace is clouded and we fall back into dark brooding, which once again forces itself to rise up in defiant resistance to a new struggle against the joy-stealing demon."

In the second movement of the symphony, Wagner sees many of the other hostile forces as mankind's hunt for false joys. Citing Goethe,

> Von Freude sei nicht mehr die Rede,
> Dem Taumel weih' ich mich, dem schmerzlichen Genuß!
> Laß in den Tiefen der Sinnlichkeit
> Uns glühende Leidenschaften stillen

> (There can be no more talk of joy,
> I devote myself to rapture, to painful pleasure!
> Let us slake our glowing passions
> In the depths of sensuousness)

Wagner wrote: "We are not meant to regard such a finite cheerfulness as the goal of our restless hunt for true happiness and the most noble joy." These thoughts are personified by the female figures in the middle section, who cannot, however, restrain the longing of humanity (the floating figures glide away overhead). "We are ... driven towards that scene which we encountered previously and which we, this time, immediately push away impetuously as soon as, once again, we become aware of it."

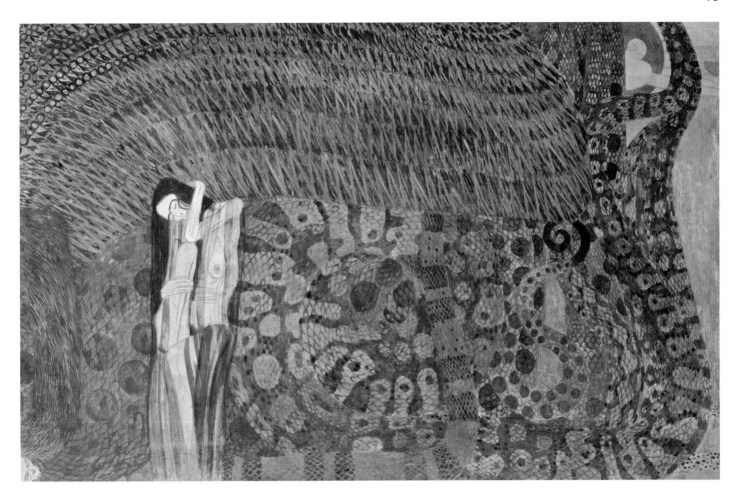

Wagner understands the third movement of the symphony as a "gentle, melancholy emotion," as "sweet longing." Once again, he cites Goethe:

Gustav Klimt, *Gnawing Grief*
(detail from the *Beethoven Frieze*)

O tönet fort, ihr süßen Himmelslieder!
Die Träne quillt, die Erde hat mich wieder!

(Continue to sound, ye sweet heavenly songs!
The tears well up, the earth has me again!)

Here we are dealing with poetry in which the longing for happiness finds its fulfilment.

Finally, the interruption in the narrative of the frieze, which occurs on the second long wall with the opening to Klinger's Beethoven, can be interpreted as a formal expression of the contrast between the final movement, enriched with voices, and the previous three. Wagner was convinced that instrumental music alone is incapable of "expressing an absolute, self-sufficient happiness which cannot be obscured: the unrestrained element appears to be incapable of this limitation; it wells up like a raging sea, sinks back again and, stronger than before, the wild, chaotic cry reaches our ears." It is the human voice that opposes "the raging of the instruments with its clear, assured expression of the language" and calls to them: "O friends, no more these sounds continue! Let us raise ones more pleasant and more joyful." The figures of the arts announce the finale: the embracing couple that represents humanity liberated "from the anguished striving for happiness [...] Then, in union with the God-ordained love of one's fellow man, we are able to enjoy pure happiness."

Jan Toorop, *Fatalism*, 1893
Pencil, black and coloured chalk on card,
heightened with white, 60 x 75 cm
Kröller-Müller Museum, Otterlo

Here Klimt shows a state of pure joy, untroubled by any doubts, protected by the golden aureole that surrounds the embracing couple. In contrast to the pessimistic statement made by the faculty paintings, the *Beethoven Frieze* conveys a "disarmingly optimistic" message.[27]

However, it is obvious that not only Richard Wagner's ideas found their way into the creation of the frieze. As Bisanz-Prakken has shown, some figures were suggested by the philosophy of Nietzsche,[28] a philosopher well known to the artists and intelligentsia of the period. Bisanz-Prakken assumes that the female figures behind the knight, which represent "pity and ambition," could have been prompted by Nietzsche's ideas. In the "knight in shining armour" we (and, also, probably Klimt) identify the heroic struggle of the genius. "The artistic genius desires to create joy but, when he has ascended very high, those who enjoy may be missing: he offers nourishment, but it is not wanted." The genius often has to accept great suffering "but only because his ambition, his envy is so great. [...] In extremely rare cases [...] a type of suffering is added to the suffering mentioned [...] this is the extra- and super-personal of a people, humanity, an entire culture, all feelings turned towards a suffering existence: which attain their value through the union with particularly difficult and remote knowledge (Pity itself is of little value.)."[29] Continuing in this vein, Nietzsche comments that Wagner had become "a revolutionary out of pity for the people."[30]

Berta Zuckerkandl also interprets the Beethoven figure in these terms: "The indignation over the powers of destiny, the frenzied anger of revolutionary generations, and never-ending sorrow — endless suffering speaks out of the massively powerful features — breathes in the body steeled by battle. Klinger has magnificently synthesised the agony of recognition which is always a characteristic of the genius."[31] This might have corresponded with Klinger's own understanding. Music played an important role in Klinger's life and, in an absolutely Nietzschean sense, he depicted his own tragic, heroically conceived artistry in his Beethoven statue.

It is obvious that Schiller's 'Ode to Joy' and, in particular, the idea of 'This kiss for the entire world,' with its idea of bringing nations together, was very attractive for open-minded contemporaries confronted with the growing tensions created by nationalism. For others, it was the promise of a new culture for mankind.

We also have a concrete interpretation of one of the figure — Gnawing Grief — in the frieze. According to Klimt himself, this figure signified the feared, widespread plague — syphilis — which was then rampant in the male population.[32]

The pictorial language of the frieze

For Klimt the artist, this project provided almost ideal conditions: he could create public art while still enjoying absolute freedom. What a difference to the painful experiences he encountered, precisely in these years, in connection with his monumental

ceiling paintings for the University of Vienna, which had led to a storm of indignation, protests and animosity.

In his creation of the frieze, Klimt rigorously stressed its two-dimensionality, which he occasionally (in the Sufferings of Weak Humanity, and the Knight in Shining Armour, for example) achieved by placing the figures in an affected profile. In this way, the contours increased in importance, and the entire attention of the artist was placed on the elegance and beauty of the expressive line.

How important this was for Klimt is shown in the great number of drawings he did — today, we still know of 125 studies for the *Beethoven Frieze* but, if one considers Klimt's typical way of working, there were probably more than twice that number. Here we can recognise a new creative will: strong contours, supple, often rippling lines, and rapid, energetic hatching. And, time and time again, attempts to achieve an even more beautiful flow of lines, an even softer and rounder vibrating harmony, an uninterrupted, continual rhythm for his very animated line.

The inclusion of ornaments in the various scenes shows, once again, how systematically Klimt planned this monumental work, which changes its character according to the meaning conveyed by the figures. The ornament can be of clear-cut severity, as in the Choir of the Angels of Paradise, weaving, pulsating and sensual in the Hostile Forces, or precious and rich in the Embrace ('This kiss for the entire world').

Klimt left parts of the side wall blank, for its opening provided a view of Klinger's Beethoven and he was unwilling to take any attention away from the main work and spiritual heart of the exhibition. He also, as previously mentioned, wanted to indicate the sharp break between the third and fourth movements of the ninth symphony.

As is usually the case with Klimt's work, we can also find a number of identifiable models and influences which he fully adapted to his own style.[33] Only a few of these will be dealt with here.

We are quite justified, for example, in regarding Japanese woodcuts and lacquer work as providing the inspiration for the subtle linear character of the frieze, as well as for the importance of the contours and some of the ornaments. At the time, Klimt was very interested in Japanese art and collected Japanese colour woodcuts. Other clear influences include Aubrey Beardsley's drawings (Beardsley's *Ali Baba*[34] provided the model for the figure of Excess) and, above all, the Mackintosh room at the eighth Secession exhibition in 1900, which also showed a frieze of fine, linear female figures. Jan Toorop, whose work made a great impression on Klimt and the other Secessionists at the turn of the century, provided the source for some of the floating figures and, in particular, for the appearance of the richly curved lines of the hair many of the figures display. Toorop's small *Sphinx* from 1893 was, along with a similar group, the model for the three Gorgons.[35] In this respect, the malicious comment made by the *Plein Air* critic that "Klimt — the most diligent and adroit of all quick-change artists — has this time come dressed up as Toorop," is not without point.[36]

Georges Minne's expressive, emaciated kneeling figures of young men, which were also shown in the eighth Secession exhibition, and which Carl Moll and Fritz Waern-

Ferdinand Hodler, *The Chosen,* 1893/94
Oil and tempera on canvas, 219 x 296 cm
Kunstmuseum Bern

View of the Mackintosh Room
at the eighth Secession exhibition, 1900

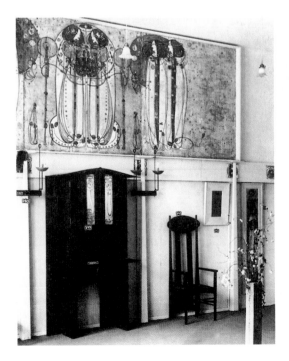

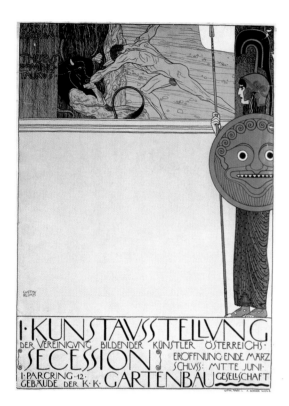

Gustav Klimt, first exhibition poster for
the Viennese Secession, 1898
(uncensored version)
Lithograph, 62 x 43 cm
Österreichisches Museum für Angewandte Kunst (MAK), Vienna

Gustav Klimt, *Love,* 1895
Oil on canvas, 60 x 44 cm
Wien Museum, Vienna

dorfer had in their possession, quite obviously provided the impulse for the couple in the Sufferings of Weak Humanity (ill. page 130). Ferdinand Hodler's serial and symmetrical ordering of his figures and trees provided the example for the rigid appearance of the Choir of the Angels of Paradise, and the perpendicular floating of his angels in *The Chosen One* probably served as a direct model for the floating figures in Klimt's choir of angels). The fused contours of the loving couple in the final scene are reminiscent of the figures in Edvard Munch's *The Kiss*.[37]

Klimt, who was a passionate museum visitor and had often used the collections of the Imperial Court Museum of Art History for his studies, took the elegant suit of armour probably made for Maximilian I by Lorenz Helmschmid (*c.* 1485) as a model for the knight. For the helmet lying next to the knight, however, he chose a helmet that was made in South Germany with a painted decoration that imitates colourful textile, a helmet that he could also see in the museum's collection of arms (ill. page 131).[38]

It is also clear that Klimt was fascinated with the art of antiquity, whether Mycenaean or classical Hellenic. He had this in common with many other Secessionists and it also corresponded with the international fashion of the period, which had taken hold of artists such as Dante Gabriel Rossetti, Lawrence Alma-Tadema, James McNeill Whistler and Aubrey Beardsley. The entire frieze is in effect a monumental transformation of ancient vase painting into a modern pictorial idiom. It is no mere coincidence that the movement's exhibition building had been conceived as an ancient temple and that the decorative scheme of the façade was based on classical sources of inspiration: above the entrance to the building, three Gorgon heads ward off the corrupting spirit of the Philistines.

Klimt depicted similar Medusa heads on Pallas Athene's shield on the poster for the first exhibition of the Viennese Secession in 1898, where Theseus conquers the gruesome Minotaur under the eyes of the patron goddess in order to liberate the youth of Athens. This can also be seen on the breastplate of the goddess in the painting *Pallas Athene* (ill. page 140), with Hercules fighting the Triton in the background. The Austrian Artists' Association–Secession, with its motto created by Ludwig Hevesi inscribed above the entrance to the Secession building — 'For the time, its art. For art, its freedom' — understood itself quite consciously as a movement fighting against the outdated and the philistine. In this sense, Beethoven was also regarded as a lonely warrior for new art and, precisely for this reason, revered.

Klimt also created a connection with ancient mythology in this depiction of Typheus, the most horrible monster in the Greek sagas, in the middle of the Hostile Forces on the narrow wall of the frieze.

In the University paintings and the *Beethoven Frieze*, Klimt also drew on pictorial ideas he had already used before the turn of the century. The embracing couple and the threatening Hostile Forces were already indicated in the early painting *Love*, from 1895.[39] In *Music I* (1895, ill. page 126),[40] the sketch for the decoration of the music salon of the Ringstrasse mansion of the industrialist Nikolaus Dumba, we see the

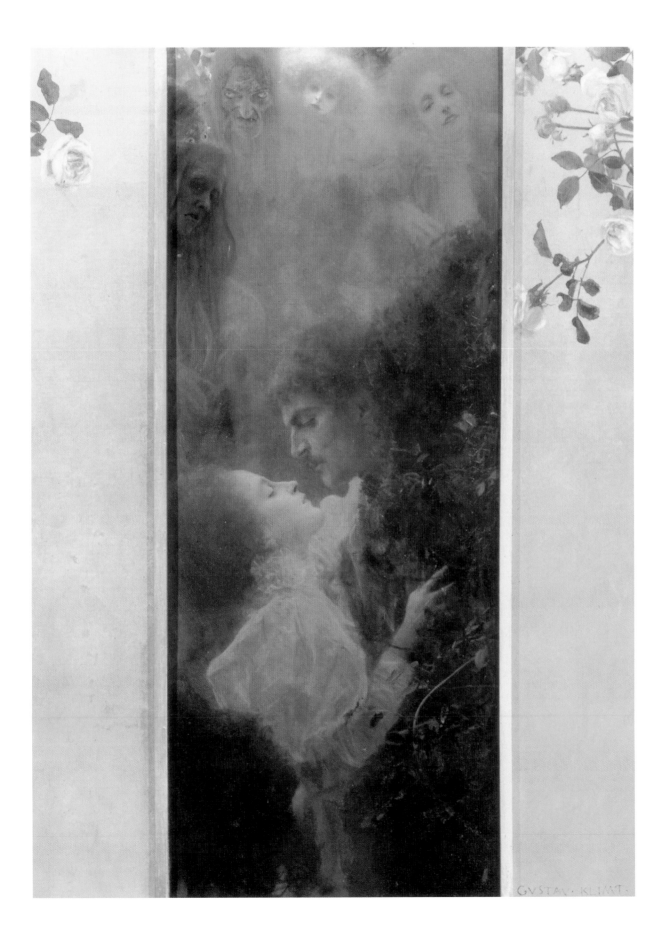

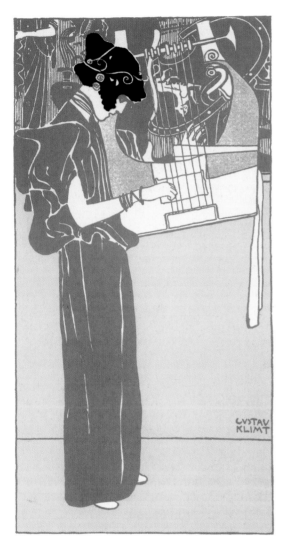

Gustav Klimt, *Music*, illustrated in *Ver Sacrum*, IV, 1901, no. 3, p. 214

female figure (playing the cithara) that will later appear as Poetry in the frieze; alongside this figure, a sphinx dominates the scene, as it will in *Philosophy*. These are the symbols Nietzsche used in his *Birth of Tragedy from the Spirit of Music* to identify the Apollonian and Dionysian aspects of music above all, but also of all creative processes. In *Schubert at the Piano I* (*c.* 1896), the sketch for the other over-door painting for Nikolaus Dumba's music salon, we can already see the motif of the singing maiden, looking directly out of the picture, which is later repeated in the Choir of the Angels of Paradise in the *Beethoven Frieze*.

Klimt shared the enthusiasm of many Viennese for music and the theatre, and attempted to attain an artistic reputation through this interest, seeing that theatre and music-theatre were of particular importance for the liberal bourgeoisie. These were areas in which Viennese society of the period realised and expressed itself. As a member of the Künstlercompagnie (Artists' Company), Klimt, along with his brother Ernst and Franz Matsch, decorated a series of theatres in the provinces, before creating the ceiling paintings for one of the staircases of the Imperial Burgtheater in Vienna, for which Klimt received the highest recognition from the Emperor personally.[41]

In order to give an expression of the meaningful and renewing strength of these actors and musicians, Klimt decorated their portraits with symbols and stylistic motifs from classical antiquity. These include, for example, the masked female figure which was a forerunner of the later *Tragedy*; the censer in *The Court Actor Josef Lewinsky as Carlos in 'Clavigo'* (1895, ill. page 79); and the masks, the cithara player and the large, flat cithara in the *Portrait of Joseph Pembauer*. In both of these portraits, there is the extensive application of gold, which takes on a central importance in the creation of the ornaments in the *Beethoven Frieze*.

Similarly, the cithara, which appears so prominently in the Pembauer portrait, together with the man playing it (possibly Apollo), are further developed in the later paintings *Sappho* and *Music I* (the male musician here becoming female), and receive their ultimate realisation in the female figure in the lithograph *Music*, created for the journal *Ver Sacrum*, a figure Klimt then used as Poetry in the *Beethoven Frieze*.

Klimt's interest in music led to his acquaintanceship with Gustav Mahler, whom he met in 1898 through Alma Schindler (later Alma Mahler), who also, probably, advised him on the creation of the *Beethoven Frieze*.

Gustav Mahler's features have been identified in the Knight in Shining Armour in the *Beethoven Frieze*. A drawing of this armed man exists which Klimt created for the book *Gustav Mahler: A Picture of his Personality in Dedications*, published by Paul Stefan to celebrate Mahler's fiftieth birthday, and where the knight definitely shows Mahler's features.

As a fighter for new music and performing styles, Gustav Mahler was not only admired but also subjected to hostilities that finally forced him to resign from his position as director of the Court Opera in 1907. Mahler and Klimt were, therefore, in a comparable situation.

For this reason, Klimt probably saw his frieze as a personal declaration of war. At this time, he was confronted with the most violent attacks on his art, especially in connection with the faculty paintings *Philosophy* and *Medicine*, which had been shown in the Secession exhibitions in 1900 and 1901. As stated above, the poster depicting the combat of Theseus against the Minotaur was already a clear declaration of the need for new art to wage a just war against the old. Thus the narrow wall of the frieze, depicting the Hostile Forces, can be regarded as a reckoning with the establishment, with politicians as well as the ignorant public and critics.

Positioned centrally, it was the first thing to be seen upon entering the side-hall. Light, open and clear compositions, in which large areas of unpainted plaster contrast with dazzling gold, characterise the side sections, whereas strong colours and figures that almost leap out of the surface dominate the narrow dark wall.

As in his other works, and particularly in the faculty paintings, Klimt wanted in the *Beethoven Frieze* to illustrate the experiences of modern man; and, implicitly, to attack the moralistic and often hypocritical lifestyle of the previous generation. His central aim was to express his belief in the decisive and fundament role of the woman in life, and this finds its culmination in the loving couple at the end — the embrace, as the alleviator of all pain, in which the redeeming strength of the eternal feminine becomes apparent.

Klimt repeatedly used symbols from antiquity to reveal the strength of Eros and to challenge viewers to confront this truth with a new honesty and frankness.[42]

Though many artists praised Klimt's *Beethoven Frieze* enthusiastically, the general public and the contemporary press often reacted to it with head shaking and indignation. Klimt's works, which are so popular today, were regarded by many of his contemporaries as incomprehensible, scandalous and 'obscene.' There was an enormous uproar. Derision was commonplace, and critics outdid themselves in their condemnatory descriptions and expressions of outrage and shock.

The end wall with the Hostile Forces was the main source of indignation: the representations of Sickness, Madness and Death, and the angularly expressive figure of Gnawing Grief, were regarded as "pictures of madness," "pathological scenes" and "shameless caricatures of the noble human form." The lascivious eroticism of the Gorgons and the depictions of Lust and Excess were simply rejected by many as "painted pornography." One report stated: "The representations of lasciviousness on the end wall of the room are among the most extreme ever devised in the field of obscene art. These are the paths Klimt wants to lead us along to Beethoven!"[43]

Another wrote: "With a refined feeling for ornamental effect and with genuine taste ... the most disgusting and repulsive things which were ever produced by a painter's brush are shown here. Sodom and Gomorrah brought up to date, in white tie and tails, and with gardenia buttonholes. A depravity dreamt up in an apocalyptic imagination speaks from these emaciated or bloated figures..."[44]

Klimt was enraged by the ignorant and often malicious criticism that, after *Philosophy* and *Medicine*, now came down with such violence on the *Beethoven Frieze.* He

Gustav Klimt, *Schubert at the Piano I,* c. 1896
Oil on canvas, 30 x 39 cm
Private collection

Gustav Klimt, *Portrait of Joseph Pembauer,* 1890
Oil on canvas, 69 x 55 cm
Tiroler Landesmuseum Ferdinandeum, Innsbruck

was also disappointed that, in spite of the unanimous vote of the professorial staff of the Academy of Fine Arts, he had not been named professor by the Ministry of Education. As a reaction — and against the advice of his friends — he exhibited the painting *Goldfish* (ill. page 22), which he wanted to entitle *To My Critics*, at the eleventh Secession exhibition: it shows the generous rear view of a redhead throwing an ironic glance at the viewer over her shoulder.[45]

It is odd, however, that Klimt was so surprised and hurt by the criticism, seeing that these very public images were so uncompromising. As shown in other contributions to this book, Klimt's disappointment over the public and official misunderstanding of his work ultimately led to the embittered artist renouncing all public commissions and withdrawing into private life.

However, the *Beethoven Frieze* is a key work in Klimt's œuvre and marks the impressive beginning of his 'golden period' in which precious ornamentation took on a decisive role.

The monumentality of the figures in the *Beethoven Frieze* subsequently led to a stylistic change in *Jurisprudence*, the last of the three faculty pictures that Klimt painted, when compared with the previous two. While *Philosophy* was painted mainly in cool blue and green tones, and *Medicine* in warm red and pink, the 'non-colours' black and gold dominate in *Jurisprudence*. There is also a renunciation of multi-figure compositions — in *Jurisprudence*, an old bowed man symbolises humanity, whereas in *Philosophy* it is a tower of people. In the frieze, it is only three people.

The idea of a two-dimensional frieze, developing out of the ornament, which begins with hope (Longing for Happiness) and culminates in an embrace (Fulfilment) found its ultimate realisation in the *Stoclet Frieze* (1905–1909). Klimt himself stated that the *Stoclet Frieze* was "the ultimate consequence of my ornamental development."

Klimt's most famous painting, *The Kiss* (1907/08), which once again deals with the embrace shown at the end of both friezes, can be seen as the end and highpoint of this golden period.

The preservation of the *Beethoven Frieze*

The *Beethoven Frieze* was originally planned to be an ephemeral work of art created for a specific event, the fourteenth Secession exhibition, and — as was the case with the other wall decorations — was to be removed and destroyed after the exhibition.[46] It was only through fortunate circumstances that this did not occur: the Secession intended to hold a major Klimt collective the following year (eighteenth Secession exhibition, 1903) and so it was decided to leave the artwork where it was.

In 1903, the patron and art collector Carl Reininghaus purchased the frieze, which he had sawn into seven sections after it had been taken from the wall, and stored it in a furniture warehouse in Vienna. It was there for twelve years. He then sold the frieze, with Egon Schiele as intermediary, to the industrialist August Lederer, who was one of

Gustav Klimt, *Fulfilment*, 1905–1909 (detail from the cartoon for the *Stoclet Frieze*) Tempera, watercolour, gold paint, silver, bronze, chalk, pencil, white heightening, gold leaf and silver leaf on paper, 194 x 121 cm Österreichisches Museum für angewandte Kunst (MAK), Vienna

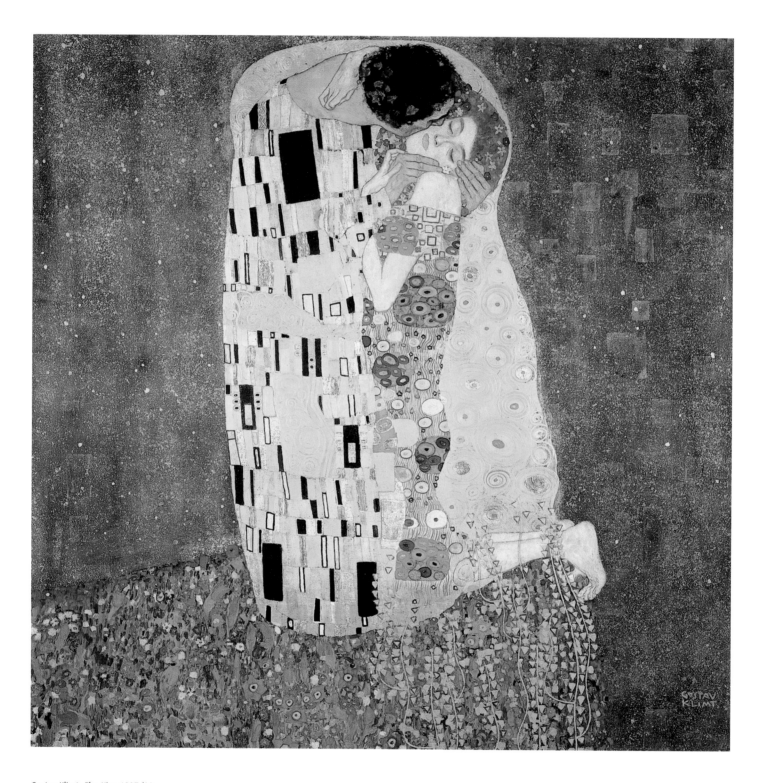

Gustav Klimt, *The Kiss*, 1907/08
Oil with silver and gold leaf on canvas, 180 x 180 cm
Österreichische Galerie Belvedere, Vienna

Klimt's greatest supporters and the owner of the most important private collection of his works.

In 1938, the property of the Lederer family, like that of many other families of Jewish background, was expropriated. The *Beethoven Frieze* came under the supervision of the 'state administration' and, after the end of the Second World War, came into the possession of Erich Lederer's heirs, who had settled in Geneva.

In 1973, the *Beethoven Frieze* was purchased by the Austrian Republic and restored, in less than ten years, under the leadership of Manfred Koller of the Austrian Federal Office for the Care of Monuments. It finally found its place of exhibition in a lower room of the Secession building, where it is now on loan from the Österreichische Galerie Belvedere.

1. *Reichswehr Tageszeitung*, Vienna, 20 April 1902, in: Hermann Bahr, *Gegen Klimt*, Vienna/Leipzig 1903, p. 69.
2. The catalogue gives details of the exhibition committee: "Artistic management and architectural design of the main halls: Josef Hoffmann. Reading room and passages: Leopold Bauer. Poster, catalogue endpapers, invitation: Alfred Roller. Hanging committee: Rudolf Bacher, Adolf Böhm, Josef Hoffmann, Alfred Roller." Cf. *Max Klinger. Beethoven*, in: *XIV. Kunstausstellung der Vereinigung Bildender Künstler Österreichs 'Secession,'* 16 April to 15 June 1902, exh. cat., Vienna, 1902, p. 79. In addition to Klimt's *Beethoven Frieze*, the following artists contributed wall paintings and decorative schemes to the exhibition: Alfred Roller, Adolf Böhm, Ferdinand Andri and Josef Maria Auchentaller. The other participating artists were Rudolf Bacher, Leopold Bauer, Adolf Böhm, Rudolf Jettmar, Josef Hoffmann, Friedrich König, Max Kurzweil, Maximilian Lenz, Wilhelm List, Richard Luksch, Elena Luksch, Kolo Moser, Ernst Stöhr, Felician von Myrbach, Emil Orlik, Othmar Schimkowitz and Leopold Stolba.
3. Christian M. Nebehay, *Gustav Klimt. Dokumentation*, Vienna, 1969, p. 278.
4. Marian Bisanz-Prakken, 'Der Beethoven-Fries von Gustav Klimt in der XIV Ausstellung der Wiener Secession (1902),' in: *Traum und Wirklichkeit, Wien 1870–1930*, exh. cat., Historisches Museums der Stadt Wien, Vienna, 1985, p. 528.

5. *Max Klinger. Beethoven*, exh. cat., see note 2.

6. One of the countries where these ideas originated was Britain, with the Pre-Raphaelites and the Arts and Crafts movement.

7. Bisanz-Prakken, see note 4, p. 528.

8. A list of the artists and techniques used in creating their decorative panels can be found in Joseph August Lux, 'Beethoven und die moderne Raumkunst,' in: *Deutsche Kunst und Dekoration*, vol. 10, April/September 1902, pp. 480f.

9. Paul Kühn, *Max Klinger*, Leipzig, 1907, p. 450.

10 See also: Anselm Wagner, 'Max Klinger's Monumental Painting "Christ on Olympus,"' in: *Belvedere. Zeitschrift für bildende Kunst*, no. 2, 2000, pp. 64–71.

11. Ludwig Hevesi, *Acht Jahre Secession (März 1897–Juni 1905). Kritik–Polemik–Chronik*, Vienna, 1906, p. 101. Undoubtedly the parallel, frieze-like composition of this monumental painting, with its many naked figures, played a role in the creation of the *Beethoven Frieze*.

12. Franz Servaes, *Max Klinger*, Berlin, 1902, p. 39.

13. See *Max Klinger. Beethoven*, exh. cat., see note 2, pp. 15–20.

14. Max Klinger (from *Malerei und Zeichnung*) in: *Max Klinger. Beethoven*, exh. cat., see note 2, p.17.

15. Marian Bisanz-Prakken, *Gustav Klimt. Der Beethovenfries*, Salzburg, 1977, p. 19.

16. *Wiener Allgemeine Zeitung*, 30 March 1902, cited from: Bisanz-Prakken, see note 15, p. 13.

17. Cf. Hevesi, see note 11, p. 283.

18. Peter Gorsen, 'Jugendstil und Symbolismus in Wien um 1900,' in: Maria Marcetti (ed.), *Wien um 1900. Kunst und Kultur*, Vienna/Munich, 1984, pp. 18ff.

19. Nebehay, see note 3, p. 276.

20. Carl E. Schorske, *Fin-de-Siècle Vienna: Politics and Culture*, New York, 1980, p. 254.

21. Christian Huemer, 'Gustav Klimt — The Prophet of Viennese Modernism. Marketing and Cult at the Secession,' in: Stephan Koja (ed.), *Gustav Klimt. Landscapes*, Munich/Berlin/London/New York, 2002, p. 151.

22. Huemer, see note 21, p. 150.

23. Hevesi, see note 11, p. 390.

24. The words of the critic Eduard Ploetzl, cited from Nebehay, see note 3, p. 298, note 41.

25. Hevesi, see note 11, p. 392.

26. Richard Wagner, 'Bericht über die Aufführung der Neunten Symphonie von Beethoven im Jahr 1846 in Dresden nebst Programm dazu' (Notes on the performance of the Ninth Symphony by Beethoven in 1846 in Dresden and the Programme), in: *Gesammelte Schriften und Dichtungen*, Leipzig, 1871, vol. 2, pp. 52ff.

. Marian Bisanz-Prakken has provided a detailed analysis of this influence on the figures in the *Beethoven Frieze*: Bisanz-Prakken, see note 15, pp. 32–34.

27. Peter Vergo, 'Between Modernism and Tradition. The Importance of Klimt's Murals and Figure Paintings,' in: Colin Bailey (ed.), John Collins, *Gustav Klimt. Modernism in the Making*, exh. cat., National Gallery of Canada, Ottawa; Ottawa 2001, p. 30. Werner Hofmann recognised this optimistic expression earlier, in *Gustav Klimt und die Wiener Jahrhundertwende*, Salzburg, 1970, p. 27.

28. Cf. Bisanz-Prakken, see note 15, p. 34.

29. Friedrich Nietzsche, Karl Schlechta (ed.), 'Die Leiden des Genius und ihr Wert,' in: *Menschliches, Allzumenschliches*, part 4: *Aus der Seele der Künstler und Schriftsteller*, vol. 1, no. 157, 1954ff., p. 551.

30. Nietzsche, see note 29, p. 405.

31. Berta Zuckerkandl, 'Klinger's Beethoven in der Wiener Secession,' in: *Die Kunst für Alle*, vol. 17, Munich 1902, p. 386.

32. Reported by Erich Lederer. Cf. Alice Strobl, *Gustav Klimt, Die Zeichnungen. 1878–1903*, vol. 1, Salzburg, 1980, p. 224.

33. Cf. also: Strobl, see note 32, pp. 221–226.

34. Fritz Novotny, Johannes Dobai, *Gustav Klimt*, Salzburg, 1967, p. 328.

35. Marian Bisanz-Prakken, 'Gustav Klimt und die "Stilkunst" Jan Toorops,' in: *Klimt Studien*, Mitteilungen der Österreichischen Galerie, vol. 22/23, 1978/79, Salzburg, 1978, no. 66/67, p. 193. For an account of Toorop's influence on Klimt, see also: Marian Bisanz-Prakken, '"The Distant Spheres of the Totally Feminine." Jan Toorop and Gustav Klimt,' in: *Belvedere. Zeitschrift für bildende Kunst*, vol. 1, 2001, pp. 88–94.

36. And he continues: "This appears to be the latest fashion, *le dernier cri*. [...] However, we do not consider Klimt a poseur; merely a spineless talent without *terra firma* or artistic ethos to hold on to, who despite outstanding technical skills and splendid decorative imagination bends to every external influence without a will of his own." From: *Plein Air*, Vienna, 28 April 1902, cited in: Bahr, see note 1, pp. 71f.

37. Cf. Bisanz-Prakken, see note 15, p. 50.

38. Today, in the Imperial Hunting and Armour Collection, Neue Burg, HJRK inv. no. A62, inv. no. A3. Cf. Strobl, see note 32, p. 222.

39. Cf. Hofmann, see note 27, p. 28.

40. Unfortunately, the sopraporta pictures created for this music salon were lost in the Second World War.

41. In 1890 he was finally awarded the Emperor's Prize for his gouache with the minutely detailed depiction of the auditorium of this theatre and its audience.

42. At the same time, Arthur Schnitzler had begun his literary — and Sigmund Freud his scientific — observations on this subject. Freud, by the way, was similarly fascinated by antiquity.

43. Dr Robert Hirschfeld, Frankfurt, 20 April 1902, in: Bahr, see note 1, p. 69.

44. Unknown newspaper article, Vienna, 26 April 1902, in: Bahr, see note 1, pp. 70f.

45. See the records of the Academy for Fine Arts, Vienna, Z. 633–1901, 4–1902, as well as the article in the daily newspaper *Die Zeit*, 12 April 1902, p. 30. Cf. Strobl, see note 32, p. 227.

46. Jane Kallir feels that another reason for the frieze being so modern is that it anticipated the installation art of the late twentieth century. Jane Kallir, '"High" and "Low" in Imperial Vienna,' in: exhib. cat. *Gustav Klimt. Modernism in the Making*, see note 27, p. 66

Gallery II
The *Beethoven Frieze*

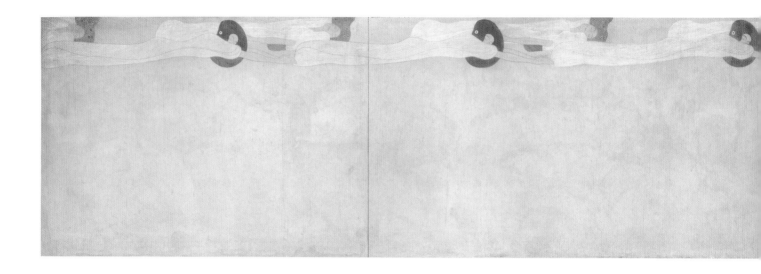

Gustav Klimt, *Beethoven Frieze,* 1902
Casein paint, applications of stucco,
gold and other materials on mortar
Left wall: 217 x 1400 cm
Central wall: 217 x 639 cm
Right wall: 217 x 1403 cm
Österreichische Galerie Belvedere, Vienna
Inv. no. 5987, ND 127

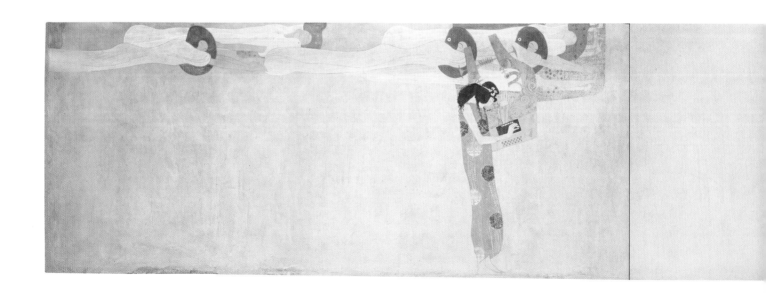

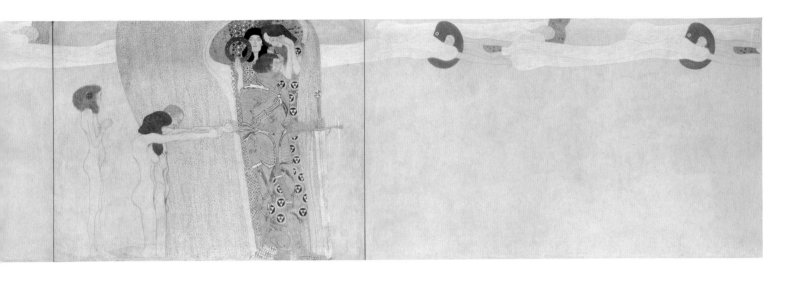

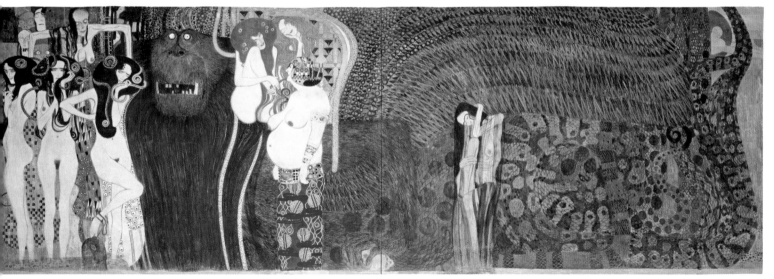

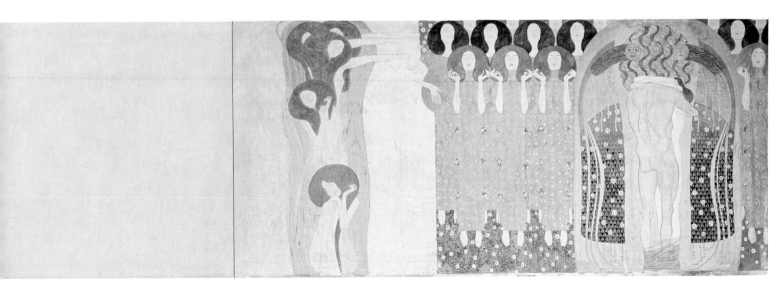

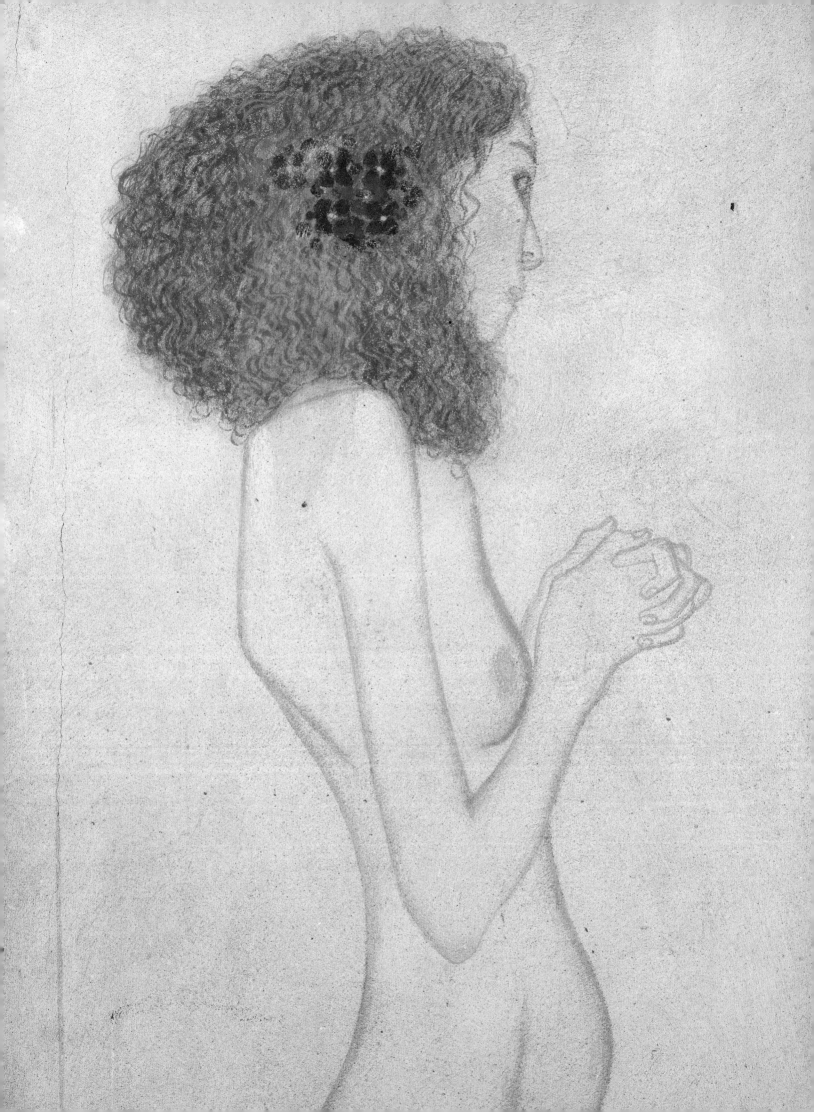

Gustav Klimt, *The Sufferings
of Weak Humanity*
(detail from the *Beethoven Frieze*)

Gustav Klimt, *Young Female Nude, Seen from the Front*, 1902
Blue chalk on paper, 44.8 x 31,6 cm
Wien Museum, Vienna
Inv. no. 74930/62, Strobl no. 753

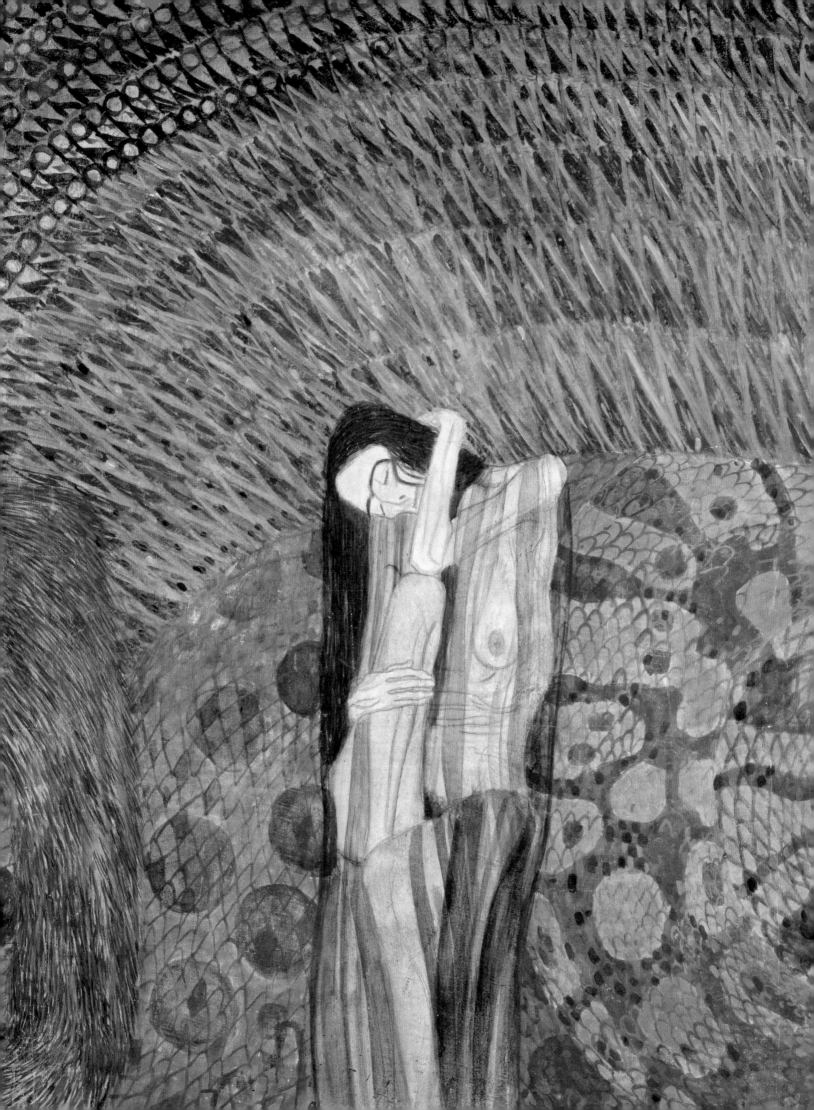

Gustav Klimt, *Two Crouching Nudes; Two Profile Studies,*
Seen from the Left, 1902
Black chalk and pencil on paper, 39.8 x 29.9 cm
Albertina, Vienna
Inv. no. 39319, Strobl no. 824

Gustav Klimt, *Gnawing Grief*
(detail from the *Beethoven Frieze*)

Gustav Klimt, *Standing Female Nude, Seen from the Right,* 1902
Black chalk on paper, 44.9 x 32 cm
Albertina, Vienna
Inv. no. 39316, Strobl no. 776

Gustav Klimt, *The Hostile Forces:*
The Gorgons (Sickness, Madness, Death)
(detail from the *Beethoven Frieze*)

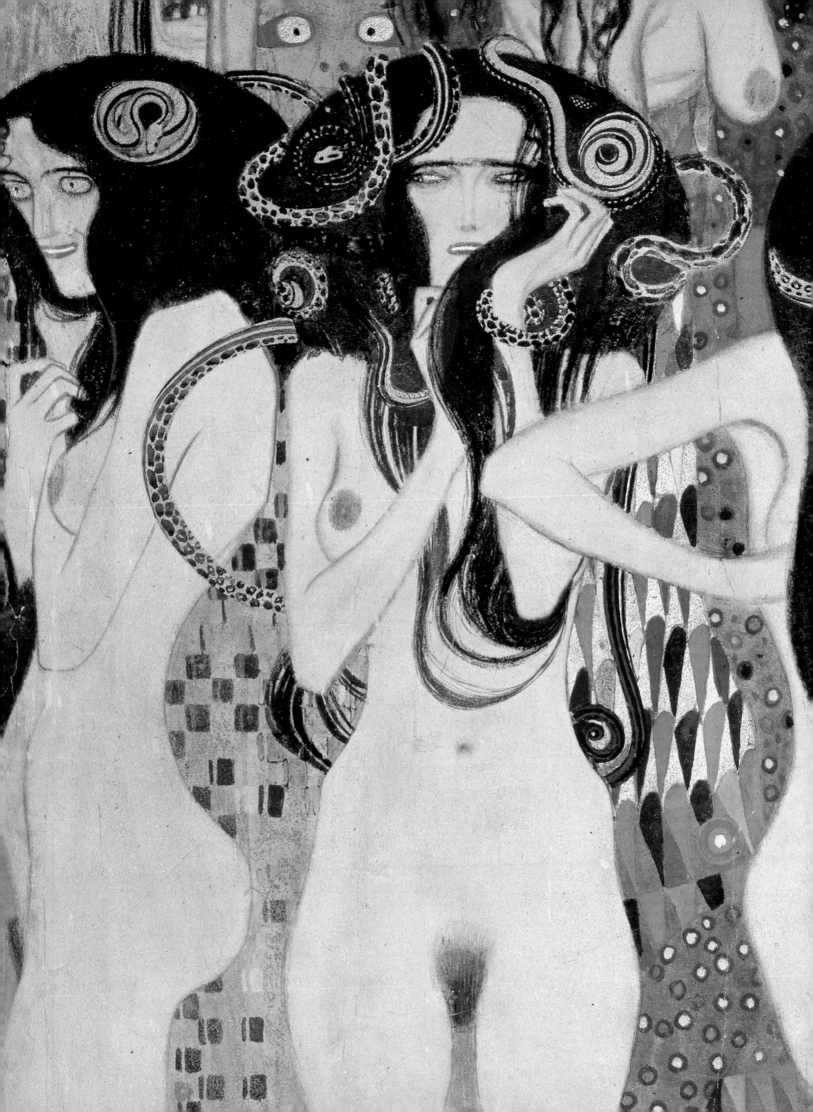

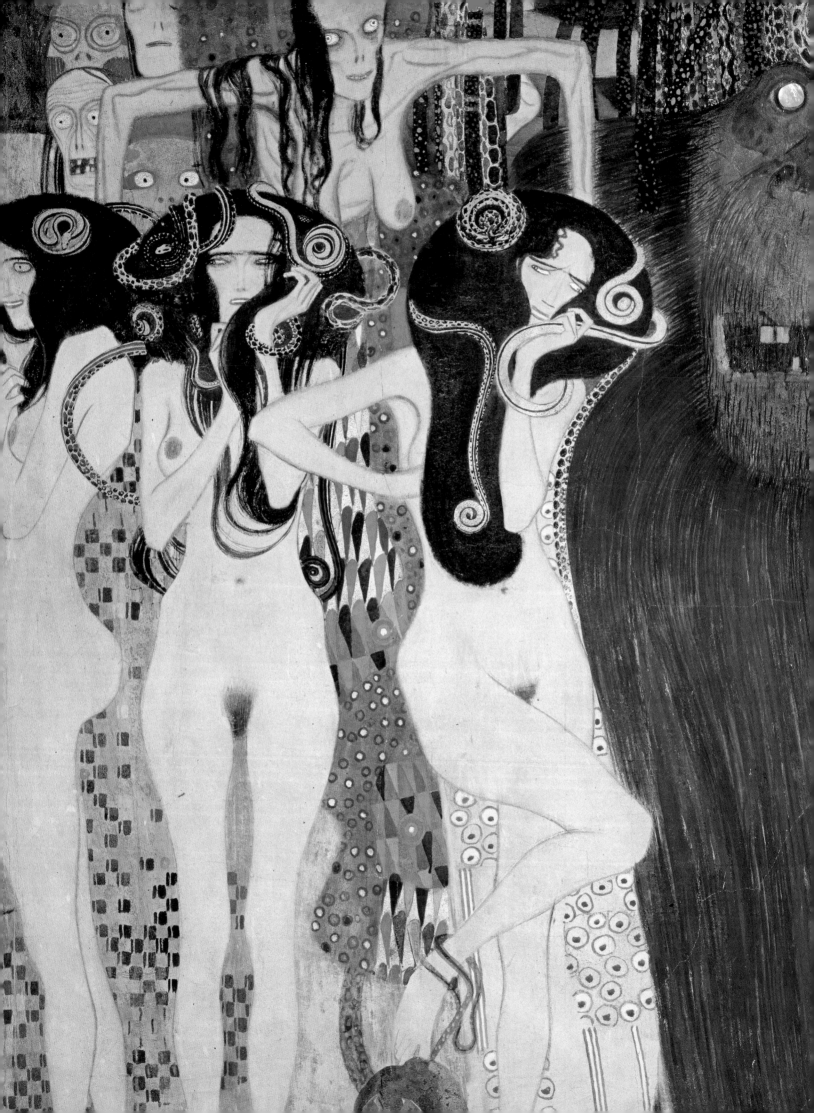

Gustav Klimt, *Standing Nude Young Woman,*
Seen from the Left, 1902
Black chalk on paper, 44 x 30 cm
Albertina, Vienna
Inv. no. 22494, Strobl no. 787

Gustav Klimt, *Standing Female Nude, Seen from the Left;*
Female Nude, Seen from the Front, 1902
Black chalk on paper, 45.3 x 31.4 cm
Wien Museum, Vienna
Inv. no. 74930/69, Strobl no. 805

Gustav Klimt, *The Hostile Forces:*
The Gorgons and Typheus
(detail from the *Beethoven Frieze*)

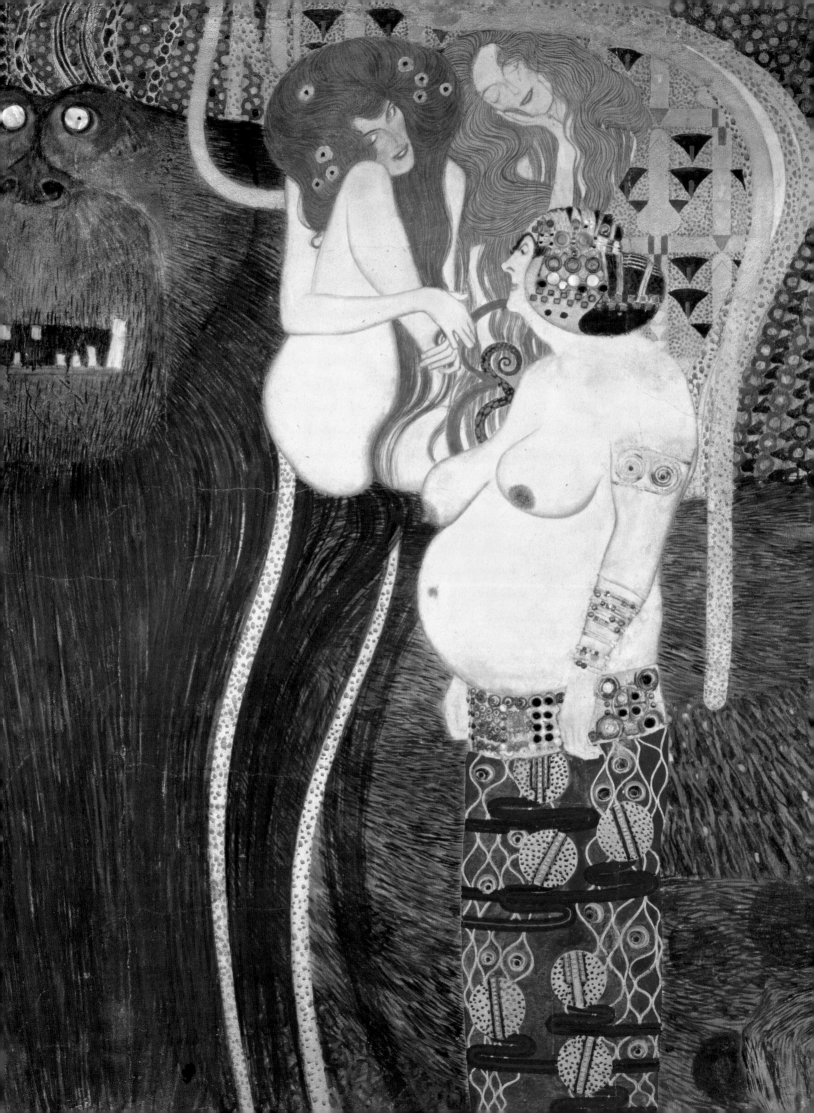

Gustav Klimt, *The Hostile Forces:*
Typheus and *Lasciviousness, Lust, Excess*
(detail from the *Beethoven Frieze*)

Gustav Klimt, *Female Head in Three-quarter Profile,*
Seen from the Left, 1902
Black chalk on paper, 45 x 31.3 cm
Albertina, Vienna
Inv. no. 39323, Strobl no. 810

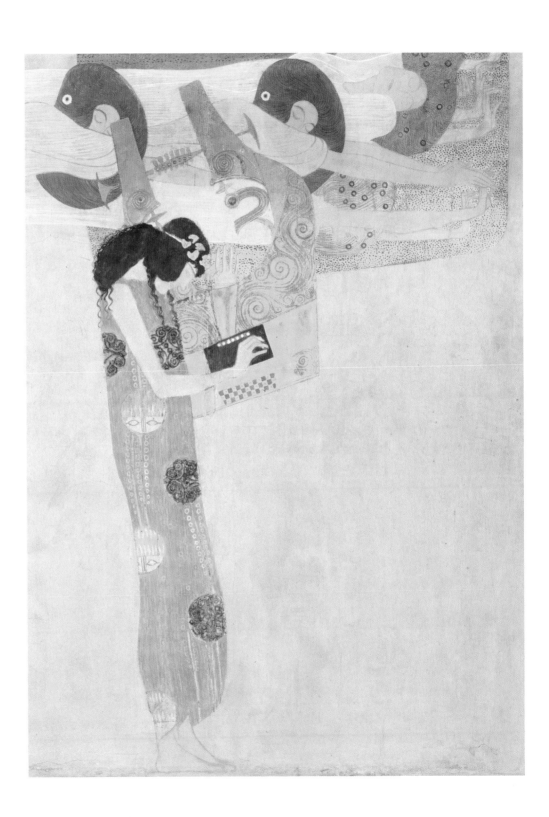

Gustav Klimt, *Standing Female Figure,*
Seen from the Right, 1902
Black chalk on paper, 44.8 x 31.5 cm
Albertina, Vienna
Inv. no. 39318, Strobl no. 835

Gustav Klimt, *Poetry*
(detail from the *Beethoven Frieze*)

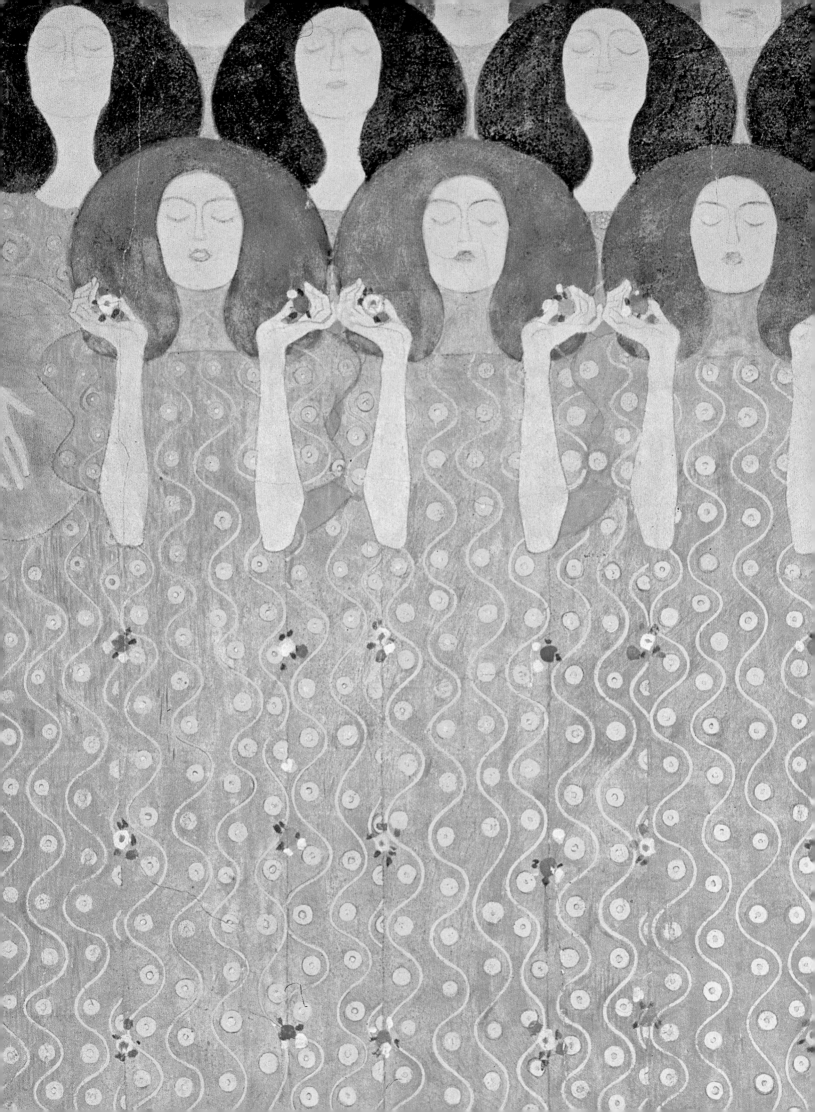

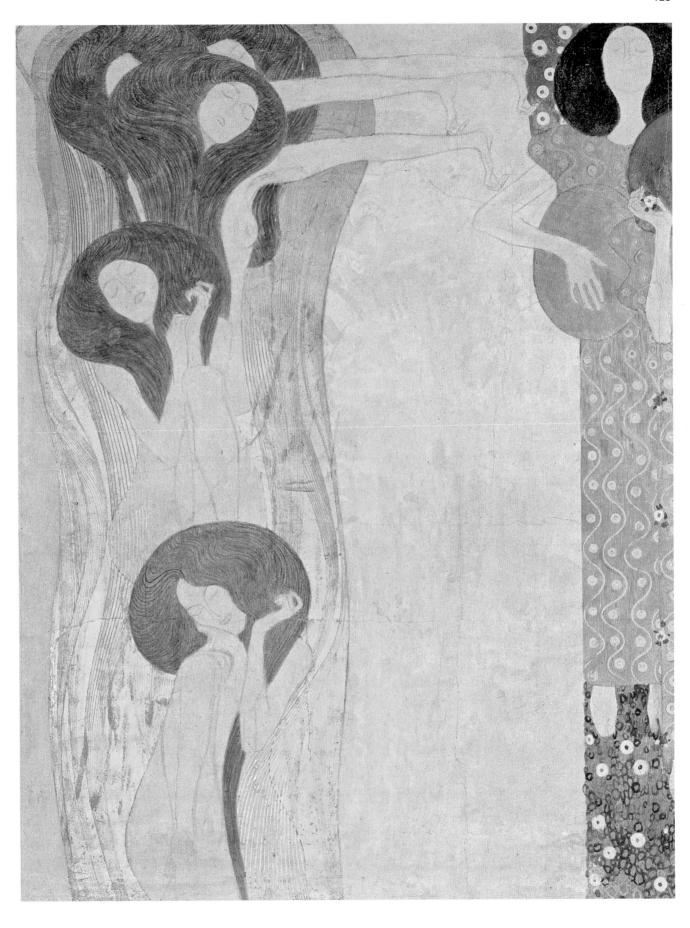

Gustav Klimt, *Choir of the Angels of Paradise*
(detail from the *Beethoven Frieze*)

Gustav Klimt, *The Arts*
(detail from the *Beethoven Frieze*)

Related Works

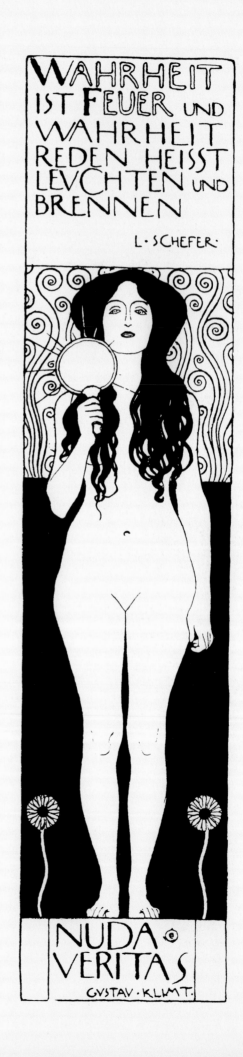

Gustav Klimt, *Nuda Veritas,* 1898
Ver Sacrum, I, 1898, no. 3, p. 12
20 x 4.5 cm (page: 29.5 x 30 cm)
Österreichische Galerie Belvedere, Vienna
Inv. no. (Library) 2576/1

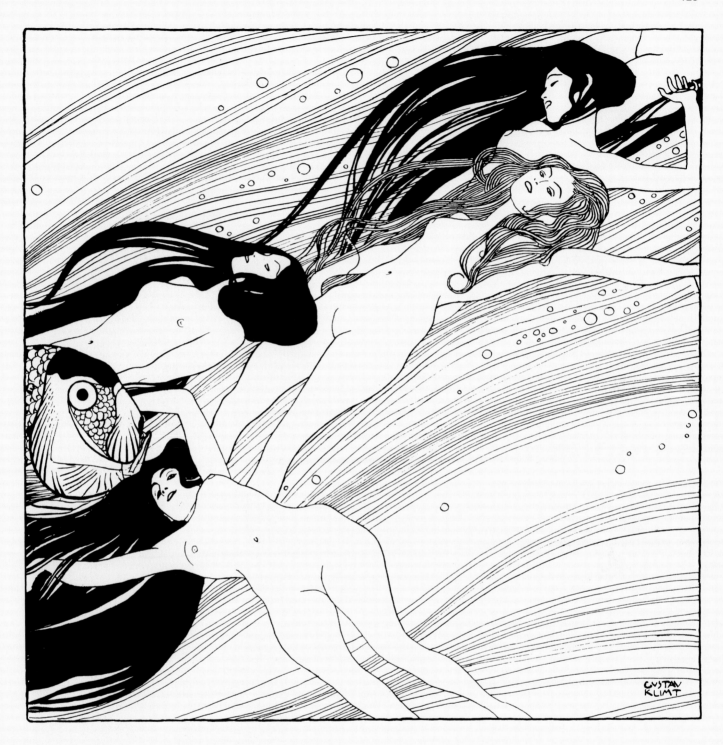

Gustav Klimt, *Fish Blood,* 1898
Ver Sacrum, I, 1898, no. 3, p. 6
18.5 x 18.5 cm (page: 29.5 x 30 cm)
Österreichische Galerie Belvedere, Vienna
Inv. no. (Library) 2576/1

Gustav Klimt, *Music I*, 1895
Oil on canvas, 37 x 44.5 cm
Signed, lower left: GUSTAV KLIMT 95
Bayerische Staatsgemäldesammlungen, Neue Pinakothek, Munich
Inv. no. 8195, ND 69

Gustav Klimt, *Schubert at the Piano I, c.* 1896

Oil on canvas, 30 x 39 cm

Signed, lower right: GUSTAV KLIMT

Private collection

ND 100

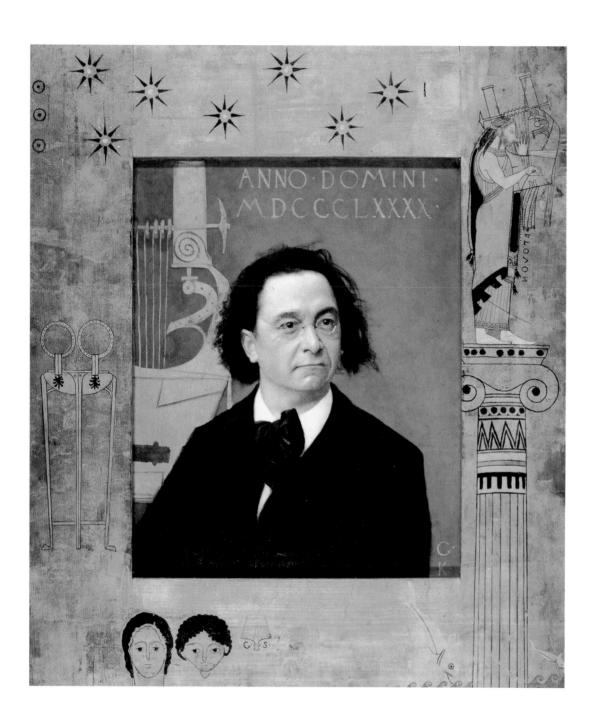

Gustav Klimt, *Portrait of Joseph Pembauer*, 1890

Oil on canvas, 69 x 55 cm

Signed, lower right: GK. Upper inscription: ANNO DOMINI MDCCCLXXXX

Tiroler Landesmuseum Ferdinandeum, Innsbruck

Inv. no. 1213, ND 58

Gustav Klimt, *Farmhouse in Upper Austria*, 1911
Oil on canvas, 110 x 110 cm
Signed, lower right: GUSTAV KLIMT
Österreichische Galerie Belvedere, Vienna
Inv. no. 1370, ND 173

Georges Minne, *Kneeling Youth,* 1898–1900
Marble, height 79 cm
Österreichische Galerie Belvedere, Vienna, Inv. no. 3870

Large Sallet, southern Germany, *c.* 1490–1500
Iron decorated to resemble fabric
Kunsthistorisches Museum, Vienna
Imperial Hunting and Armour Collection
Inv. no. HJRK A3

Lorenz Helmschmid, *Suit of Armour*
Augsburg, *c.* 1485
Probably made for Maximilian I
Iron, brass, leather,
height: 175 cm width: 85 cm; depth: 95 cm
Kunsthistorisches Museum, Vienna
Imperial Hunting and Armour Collection
Inv. no. HJRK A62

Max Klinger, *Beethoven Bust,* between 1902 and 1907
Marble, 102.5 x 56 x 69 cm
Museum of Fine Arts, Boston, Paul Wittgenstein Endowment
Inv. No. 52.204. On permanent loan to the Wien Museum, Vienna

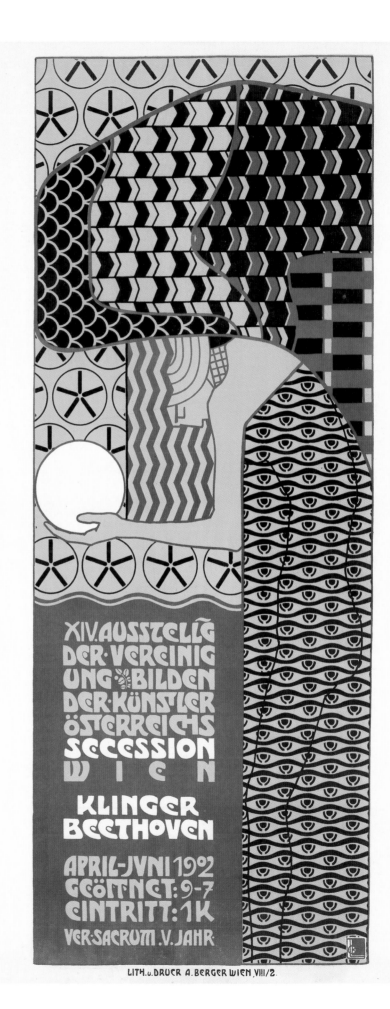

Alfred Roller, Poster for the fourteenth
Secession exhibition, 1902
'XIV. Ausstellung der Vereinigung Bildender
Künstler Österreichs. Secession Wien. Klinger Beethoven'
Lithograph, 95.5 x 62.5 cm
Österreichisches Museum für angewandte
Kunst (MAK), Vienna
Inv. no. Pl 137

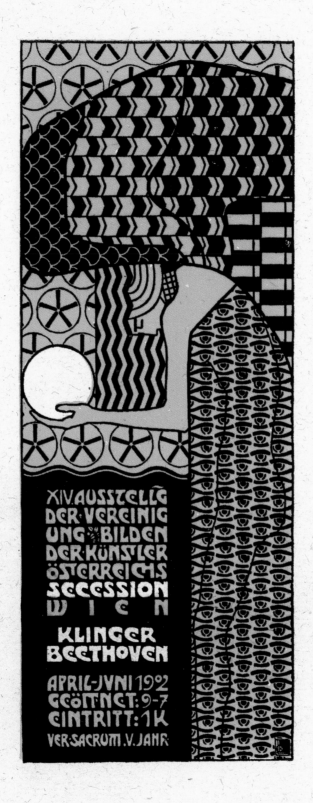

Catalogue of the fourteenth Secession exhibition, 1902
Max Klinger. Beethoven
Original woodcuts
Original format: 17.2 x 15.2 cm
pp. 1, 15, 74, 75
Österreichische Galerie Belvedere, Vienna
Inv. no. (Library) K 28560

AUS KLINGERS SCHRIFT „MALEREI UND ZEICHNUNG".

DIE KÜNSTLERISCHEN, BESser ästhetischen, Anforderungen ändern sich in bezug auf die Einheit des Bildes bei der dekorativen und Raummalerei bedeutend. Bei beiden ist es nicht mehr das einzelne Kunstwerk, welches auf uns Eindruck machen soll, sondern es soll die künstlerische Einheit des Raumes, also der Umgebung des Bildes, zugleich auf uns wirken. In beiden ist der geistige Anschluß des Bildes an die Bestimmung und Bedeutung des Raumes notwendig und da dies ohne wechselseitige Beziehungen, ohne allegorische oder beabsichtigt symbolische Grundlage nicht wohl zu leisten ist, ist von vornherein die geschlossene Einheit der Darstellung aufgehoben — wenn man nicht bloß auf eine landschaftliche oder vedutenhafte Ausschmückung ausging.

15

LEOPOLD BAUER ADOLF BÖHM JOSEF HOFFMANN

GUSTAV KLIMT FRIEDRICH KÖNIG RICHARD LUKSCH

KOLOMAN MOSER ALFRED ROLLER ERNST STÖHR

74

Dieser Gruppe schlossen sich an:

RUDOLF JETTMAR MAX KURZWEIL MAXIMILIAN LENZ

WILHELM LIST ELENA LUKSCH FELIC. FRH. V. MYRBACH

EMIL ORLIK O. SCHIMKOWITZ LEOPOLD STOLBA

75 7*

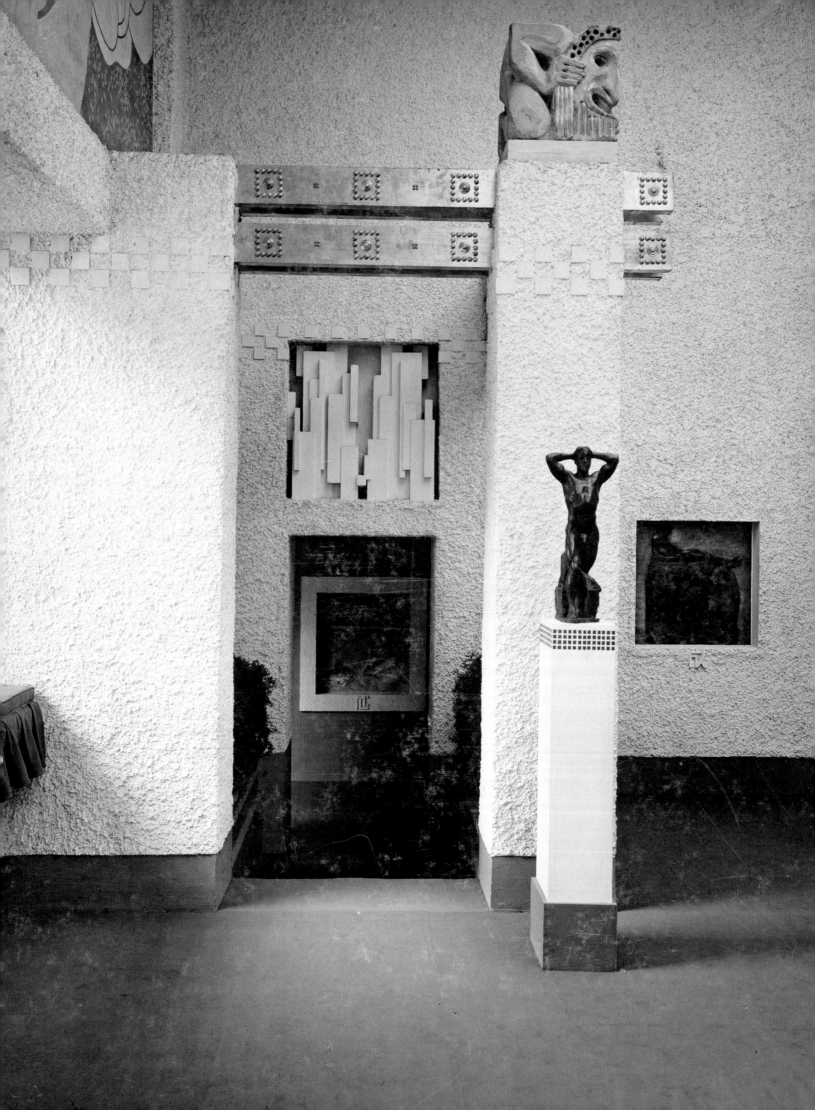

Josef Hoffmann, *Sopraporta*, 1901/02
(reconstruction by Willi Kopf, 1985)
Softwood relief painted white, 94 x 96 x 15 cm
Hummel Collection, Vienna

Beethoven Exhibition 1902, right side-hall
Athlete sculpture by Max Klinger; above this,
a column sculpture by Ferdinand Andri; in the background,
the sopraporta relief by Josef Hoffmann

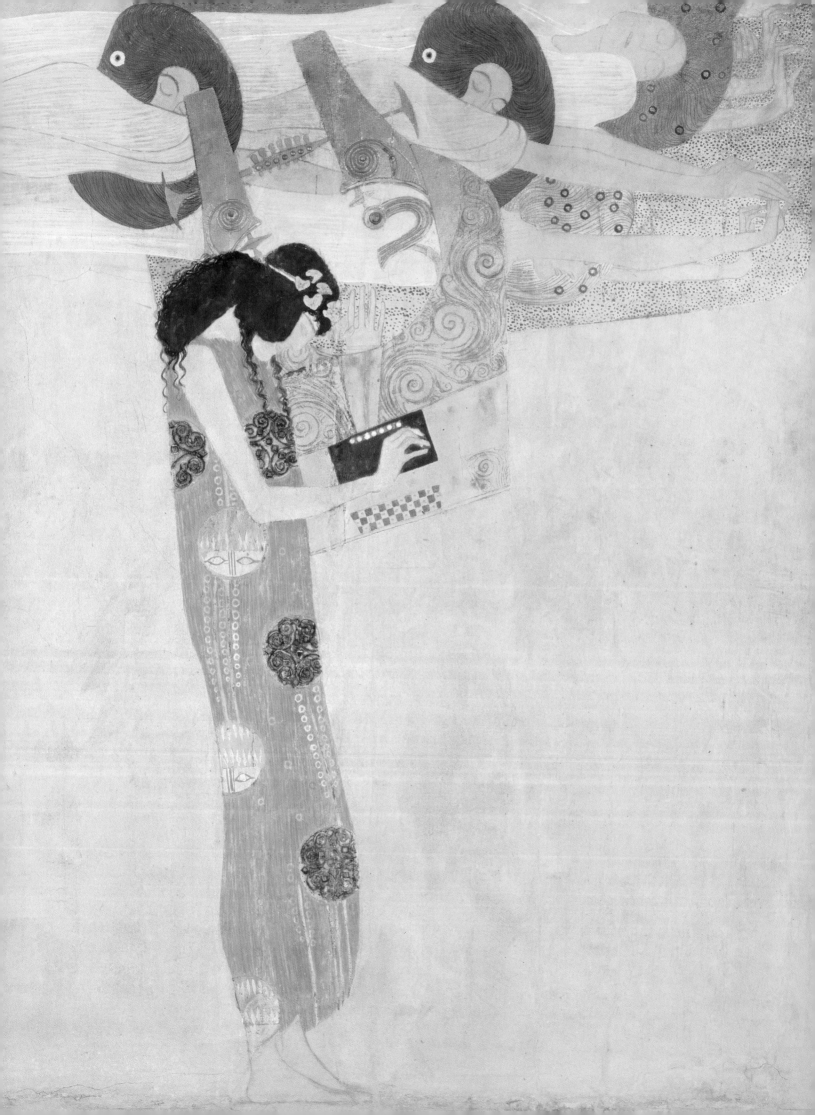

Franz A. J. Szabo

Reflections on the *Beethoven Frieze* and its Relation to the Work of Gustav Klimt

It has now been well over a generation since the Austrian painter, Gustav Klimt, has passed from being a mere central European Symbolist on the periphery of the great currents of Western art to becoming one of the most popular icons of the *fin de siècle*. Gustav Klimt prints of all sizes and description are prominently displayed in print and frame shops, and Gustav Klimt calendars have taken their place right next to Van Gogh and similar first-rank names. But while the bulk of Klimt's œuvre is no longer *terra incognita* and while the famous *Beethoven Frieze*, after not being on public view for decades, was beautifully restored between 1975 and 1985 and has been one of Vienna's main attractions over the past twenty years, it might bear repeating some general comments which have become commonplace since Carl Schorske's seminal 1980 essay on Klimt, in order to put the artist into the historically specific milieu that provided him with his value system and his philosophical focus, as well as what we can call his grammar and vocabulary.[1]

That milieu was the central Europe of the late nineteenth and early twentieth centuries — an area now covered by a dozen different countries, but which at that time was only one large empire: the Austro-Hungarian or Habsburg Monarchy. The Habsburg Monarchy was formed early in the sixteenth century by the dynastic union of the group of duchies that now make up Austria and Slovenia, and the medieval Kingdoms of Bohemia and Hungary. But this polity, which one prominent historian has described as "a complex and subtly balanced organism, which was less a state than a mildly centripetal agglutination of bewilderingly heterogeneous elements" (R. J. W. Evans),[2] did not acquire anything approaching a vaguely coherent common integrating culture until the seventeenth century. When it did so, it did so on the basis of the Baroque Counter-Reformation culture of the seventeenth century.

The Counter-Reformation was the Catholic Church's response to the Protestant Reformation — a response based on an affirmation of the points of difference and friction, rather than on compromise. Validating human action and freedom of choice in the search for salvation, it affirmed the body and sought to harness the senses to strengthen the faith. It was also the basis of a paradigm shift from Renaissance to Baroque art. Baroque art sought to give colour and texture to spiritual experience. It stressed emotion, and explored what we would now call the psychological dimensions of human experience. It was theatrical in manner, and strongly allegorical and exhibitionistic in its style. The culture that grew to dominate and acted as an integrator in the Habsburg Monarchy, in short, was a sensual culture, a culture of images, what Schorske so aptly called "a culture of grace."[3]

Unfortunately, this culture of grace proved uncompetitive in the highly competitive world of emerging national states of the eighteenth century, and during that century a reaction emerged within the Habsburg Monarchy itself.

Gustav Klimt, *Poetry*
(detail from the *Beethoven Frieze*)

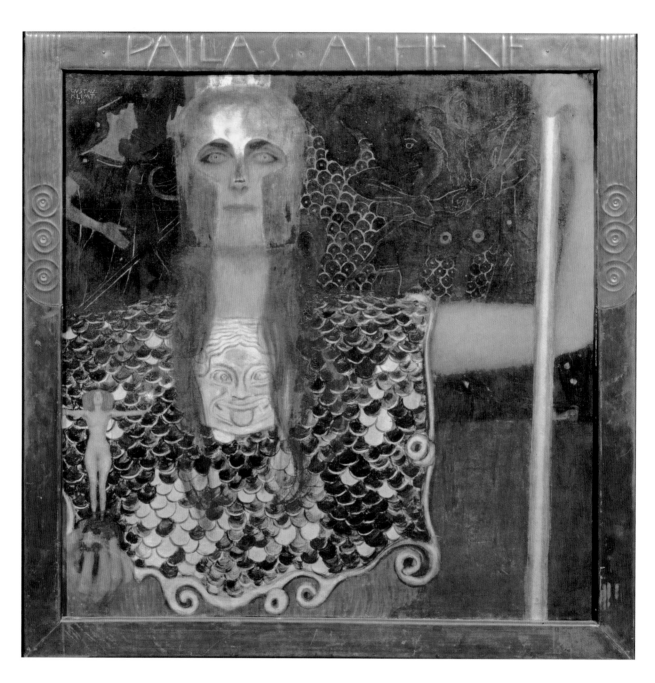

Gustav Klimt, *Pallas Athene*, 1898
Oil on canvas, 75 x 75 cm
Wien Museum, Vienna

It was a reaction that sought to internalise the values and norms of a more modern, production-oriented, dynamic political culture, stressing progress and rationality, and freeing individual energies in the pursuit of a society governed by law, and a culture, in short, focused on the *word*. The triumph of the culture of law was only partial in the eighteenth century, and many aspects of the culture of grace survived well into the nineteenth century. This is important because by the time we can say that the culture of law had finally triumphed politically in the mid-nineteenth century (from the 1850s to the 1870s) with the victory of nineteenth-century liberalism and the institutional-isation of liberal values in the Habsburg Monarchy (that is, guaranteeing the rights of free and rational individuals in a free society governed by law), this was a relatively

belated development by European standards. The older culture, which was displaced, was not one of legendary and distant memory, but one of very recent memory whose elemental sensibilities still had some vitality.

This is the key to understanding how historians have come to discover one of the great paradoxes of Western Civilisation: 'modernism' in its metaphysical sense — that is, the cosmology of modernism — was born not in the technologically and politically more advanced countries of Western Europe, but in the much more conservative and less developed heart of the continent, in the Habsburg Monarchy, and more specifically in its capital, Vienna. It was the classic case of an old tie coming back into fashion, for in the 1870s European liberalism was shaken by a stock-market crash and a depression that was in many ways much worse than the familiar depression of the 1930s, if for no other reason than that it lasted a lot longer. The depression and the crisis in material life that it created shook the comfortable and optimistic verities of liberalism, with its faith in rationality, freedom and law. To their consternation, as Schorske points out, liberals found that the newly emancipated masses in this period of economic crisis tended to vote not for their liberal emancipators and benefactors, but rather for either demagogic conservatives, or a whole new array of other movements that appealed not to the rational but to the emotional and instinctive, movements that pandered to atavistic urges, to mass hysteria, or to wishful thinking. Ironically, this development was not shocking but entirely comprehensible for the younger generation that grew up in the Habsburg Monarchy during this time. And this was so precisely because the Baroque emotional psychology was still a very palpable reality in their country, and it was but a short conceptual leap from there to the world of the subconscious and the instinctual which were to provide the leitmotif for the twentieth century. The process was only underscored by the dominance of the thought of Arthur Schopenhauer, Richard Wagner and Friedrich Nietzsche. Schopenhauer's concept of a single world will was taken up by Wagner, who felt that only through art, and particularly through music, could 'poet-priests' show humanity its basic unity with all living things. This idea was crystallised by Friedrich Nietzsche in his famous book *The Birth of Tragedy from the Spirit of Music*, which argued that the balance between the cerebral Apollonian and the instinctive Dionysian had been upset by scientific rationalism. Nietzsche concluded that myth has to be seen "as Dionysian wisdom made concrete through Apollonian artifice,"[4] and the duty of the individual was "to further the production of the philosopher, of the artist and of the saint within us and outside us, and thereby work at the consummation of nature."[5]

These were messages, as I have suggested, that the relative proximity of the Baroque mentality made much clearer to the younger generation of central Europeans than to people in the more developed West. It was almost as if they were revolting against the values of their parents by reaching back to the conceptual world of their grandparents. In the spirit of Wagner and Nietzsche, artists of this younger generation saw themselves as poet-priests proclaiming a whole new truth. Many great seminal figures of the twentieth-century intellectual world were to be found among this group:

Gustav Klimt, *Pallas Athene* (detail), 1898

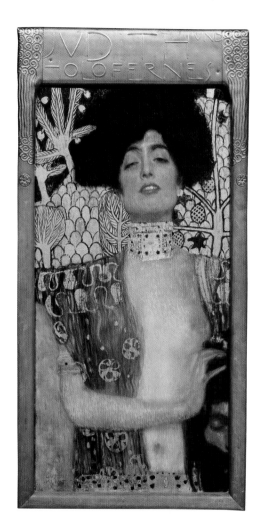

Gustav Klimt, *Judith I*, 1901
Oil on canvas, gold leaf, 84 x 42 cm
Österreichische Galerie Belvedere, Vienna

Schnitzler, Hoffmanstahl and Rilke in literature, Mahler, Schönberg, Webern and Berg in music, Wittgenstein in philosophy, and, of course, the great patriarch himself, Sigmund Freud, to name only the most prominent. In the realm of the visual arts, the revolt of the young was led by the Vienna-born Gustav Klimt.

Son of a goldsmith and, as illustrated by his early works, a talented and promising master of the traditional academic school of painting in Austria, as illustrated by this early work, he suddenly broke with his early style in the late 1890s and led a rebellion of younger artists against the official academic style. The young rebels called themselves the 'Secession' — the secession consisting of not showing their works in the Vienna Academy's exhibition space, but organising their own exhibitions, and eventually building their own exhibition hall. The first Secession exhibition took place in 1898, and Klimt himself designed the poster for it. Within months Klimt now embarked on a wholly new style, marked by such paintings as *Nuda Veritas* (ill. page 18). Naked truth holds up a mirror to humanity to show us our true face. What we see depends on us. The artist poet-priest can confront us with the truth, but we can only recognise it if we shed our old preconceptions. At about this time, Klimt painted the related *Pallas Athene*, in which Vienna's favourite goddess of ordering wisdom proclaims that the ordering wisdom of our lives cannot and should not exclude the Dionysian realities. Most explicit it its Schopenhauer-Nietzschean vision are Klimt's *Music I* and *Music II*, in which music is seen as the tragic muse able to transform buried instincts and mysterious cosmic power into harmony (ill. page 126).

As Klimt's vision was beginning to crystallise in the years leading up to these paintings, he also got an opportunity to perform a public ceremonial function that any self-respecting poet-priest would welcome. He was invited to design three ceiling paintings for the ceremonial hall of the new university of Vienna. The ceiling, whose centrepiece was to proclaim the triumph of light over darkness (embodying the traditional liberal faith in education), would be surrounded by symbolic representations of the time-honoured faculties of European universities: theology, philosophy, law and medicine. The centrepiece and the theology panel were to be painted by the more conventional Franz Matsch, but Klimt was invited to paint philosophy, medicine and law. The first to be completed in 1900 was *Philosophy*, in which 'Wissen' (knowledge or consciousness) was a figure barely visible on the stage of the cosmic drama. The human pillar of life and death on the left, and the mysterious sphinx symbolising the cosmic unknown on the right, dominated the panel and emphasised how little could really be understood by human rationality. If this is not how professors of the social sciences and humanities wished to see their profession, lawyers were even more mortified. In 1907 Klimt completed the final version of the last panel, *Jurisprudence,* in which truth, justice and law are only distant icons before the dominant reality of terror and retribution. In short, Klimt chose to focus on the power of instinct that underlay the political world of law and order rather than to celebrate the triumph of light over darkness.

It was, however, the second panel, *Medicine*, completed in 1901, that in many ways caused the greatest uproar, not only for its message, which showed little respect for

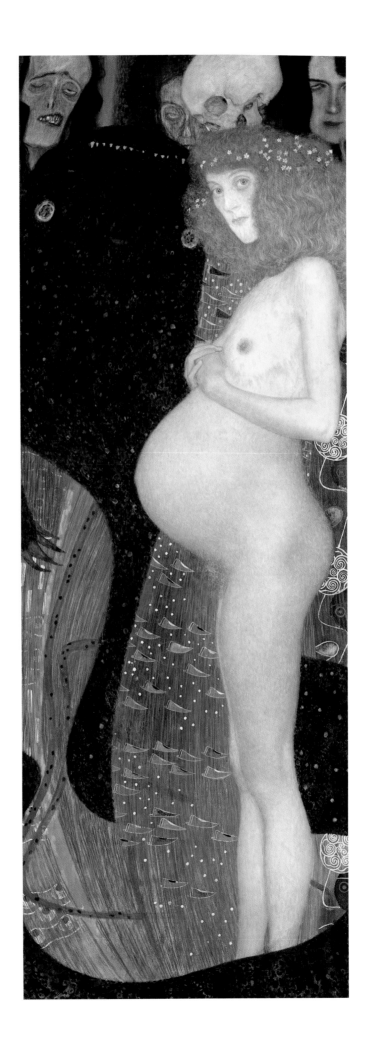

Gustav Klimt, *Hope I*, 1903
Oil on canvas, 189.2 x 67 cm
National Gallery of Canada, Ottawa

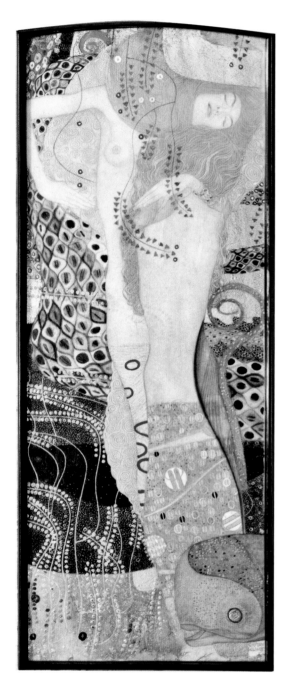

Gustav Klimt, *Water Snakes I*, c. 1904–1907
Mixed technique on parchment, 50 x 20 cm
Österreichische Galerie Belvedere, Vienna

medicine as practitioners like to see it, but also for its putative 'pornographic' elements, which was soundly castigated by Vienna's equivalent of the 'moral majority' (the alliance of the old right and the new left). In this panel, too, rational medicine offered little consolation in the cosmic drama of life and death. If the knot of humanity can reach out to any hope, Klimt seemed to say, then it is not to doctors, but to the eternal feminine — the generative power of woman — which preserves the life of the human chain, studded though it is with pain and death. In the light of what was widely perceived as objectionable both in form and in content, the outcry was, not surprisingly, immense. So great was the storm of protest that Klimt withdrew his three panels and resigned his commission.

In the meantime, a second great public commission had come up, which was less likely to be undermined because it was mounted by the Secession movement itself. The occasion was the 1902 Secession exhibition, which was devoted to a single work: Max Klinger's sculpture *Beethoven*. The entire Secession movement strove to turn the exhibition venue into an integrated artistic environment focused on this single work. In a side room, through which one was obliged to pass to get to the main hall, and from which openings in the wall gave visitors their first glimpse of the Klinger sculpture, Klimt painted a massive frieze on three of the walls, generally called the *Beethoven Frieze* (ills pages 108, 109). The programme of the frieze was based on the famous exegesis of Beethoven's ninth symphony published by Richard Wagner in 1870. In the first half of the first panel, floating figures represent humanity's longing for happiness. The second half of the first panel represents the sufferings of weak humanity, who beseech a hero (the knight in armour) to undertake the struggle for happiness on their behalf. The middle panel shows the hostile forces that the hero must face and overcome. In the first half there are the three Furies; there is sickness, disease, madness and death; there is Typheus (the monster against whom even the gods battle in vain); there is lust, lasciviousness and excess; and finally, in the second half of the panel, there is nagging care. In the first half of the third panel, the human longing for happiness finds repose in poetry, which leads to the kingdom of the ideal, represented in the second half of the third panel, which, with its chorus of angels and its embracing couple, is a visual representation of the celebrated words from the final chorus of Beethoven's ninth symphony:

Freude schöne Götterfunken
Diesen Kuss der ganzen Welt

(Joy, beautiful divine spark;
This kiss for the whole world)

Anyone familiar with Schorske's essay on Klimt will know that he and many other commentators regard this frieze as part of a larger retreat by a Klimt, who had been wounded by his public humiliations over the University paintings. In this view, the

frieze is not only about "the power of art over adversity," but perhaps even more explicitly the first step in Klimt's "withdrawal into the temple of art," after which he putatively "gave up philosophical and allegorical painting almost entirely." What is more, even this *voyage intérieur* into the lofty realms of art had a dark lining to the silver cloud. As Schorske points out: "... the kiss and embrace take place in a womb. The high 'flight' so characteristic of narcissistic omnipotence fantasies terminates in erotic consummation in a womb. Even in that heaven, the woman's hair encircles her lover's ankles in that dangerous way we have come to know so well in Klimt. Even in Arcadia, sex ensnares."[6]

Gustav Klimt, *Fish Blood*, illustrated in *Ver Sacrum*, I, 1898, no. 3, p. 6

This is an interpretation that I feel should be rethought. And in order to do so, I would like to reconsider some of the other paintings executed at the same time, as well as in subsequent years. One of the most well known is *Judith I*. The Judith here is almost invariably seen as a *femme fatale* whose perverse pleasure comes from decapitating her lover — that is, it is suggested that this painting focuses on a castration anxiety, with its fundamental fear of female sexuality. That is why most critics seem to think that 'Salome' is a more appropriate title than Judith. Indeed, it is frequently identified as such in some art books. But this may have more to do with the castration anxiety of the critics than of Klimt. Klimt insisted this was not a picture of Salome the famous *femme fatale*, but of Judith, the famous Old Testament heroine. To emphasise the point, he had the frame made himself, and emblazoned it with the title *Judith and Holofernes*. In other words, what it is important to stress is that the person who has been killed here is a tyrannical Assyrian military figure; it is not female revenge being exacted on a sexually distant John the Baptist! It symbolises the triumph of the erotic feminine principle over the aggressive masculine one, and its only homily is that you cannot conquer nature.

Not every reader will feel entirely persuaded by this interpretation, so allow me to turn to two other paintings which were painted in tandem, in an identical format and size, at the height of the university ceilings scandal. Both isolate and amplify particularly upsetting images contained in the University ceiling paintings, and especially in the *Medicine* panel, where the censorious found several disturbing and two downright unbearable images: bad enough to be breastfeeding in public, as the woman in the top left of the human column does in a way to give maximum exposure to her very ample bosom — there was at least a long tradition in art history of this image — but the forward thrust of the pelvis of the female figure on the far left with its shocking display of pubic hair, and the pregnancy of the nude on the upper right, were certainly well beyond what passed for good taste. Rather than shrink from the controversy, however, Klimt rose defiantly to the occasion with two magnificent responses to his critics. Both paintings were in private hands until the 1960s and then sold to museums. Not only identical in size and shape, but also in iconography and theme, the two were clearly meant to be companion pieces. The first of these, which now hangs in the municipal museum of Solothurn, Switzerland, is entitled *Goldfish* (ill. page 22); and the second, which is now in the National Gallery of Canada, *Hope I* (ill. page 143). Klimt originally

Gustav Klimt, *Flowing Water*, 1898
Oil on canvas, 52 x 65 cm
Private collection

wanted to entitle this *Goldfish* picture *To My Critics*, and his message is accordingly very obvious indeed. But *Goldfish* was not only a comment on the criticism levelled against him, but also yet another affirmation of the primeval generative vitality (the universal Eros) of the feminine, expressed in liquid images to which, as we have seen, he repeatedly turned. The three women portrayed are a blonde, a brunette and a redhead — in a sense, the full gamut of femininity — but, significantly, it is the redhead to whom the aggressive gesture of defiance is reserved. The provocative thrust of her posterior mirrors the provocative thrust of the pelvis of the figure that dominates the left side of the *Medicine* panel.

This is also true of *Hope I*, which evokes the same fluid world and aquatic flow as its companion piece. But the denizens of this world are not the harmless little goldfish that cover the background in *Goldfish*; they are rather creatures we recognise from the Hostile Forces section of the *Beethoven Frieze*. This overtly threatening dimension of *Hope I* has led many observers to conclude that this painting represents a very pessimistic view of life, in which any hope placed in regeneration is doomed in the face of the hostile forces always looming over the horizon. Such critics think of the central female character as vulnerable and fragile. But one careful look at the gaze of defiance in the pregnant woman's face shows immediately that this is not a parable on the theme of hope in vain. Klimt did not paint redheads randomly or coincidentally, but very deliberately. The 'red' colour of the hair (including even the defiantly obvious pubic hair) evokes the relationship to the primary colour red — in this case tellingly underscored by the blaze of red that permeates the river of life in the background (a none too subtle evocation of menstrual blood) — and this red, for Klimt, was also an explicit reference to eroticism. Here the Eros of the central character is every bit the match for the forces threatening her. In short, Klimt does not suggest her hope is in vain, rather he asserts that the generative forces of nature are *the* hope of life in the face of pain and death! This, too, is reflected in the placement of two offending nude figures in the *Medicine* panel. The pregnant and the breast-feeding figures, by flanking icons of sickness and death, in a sense out-flank, contain and transcend them. What is more, by standing outside the human column on the right, the nude on the left of the panel assumes a dominant position as the mediating figure that animates the dynamic of the river of life. A male hand symbolically reaches out to her in hope, while her hand reaches back to the human column directly into the pubis of another nude.

In a similar vein we have two paintings entitled *Water Snakes* (ill. page 144), which are also frequently interpreted as being animated by male anxiety in the face of putative female sexual self-sufficiency and inexhaustibility (another reason why overly zealous interpreters have chosen to translate 'Wasserschlangen' into 'the female friends' or even 'lesbians' in other languages). In my view, these paintings intended to evoke the willowy, perpetually self-renewing currents of nature, a watery world of liquefaction, the flowing river of life. It was a recurring theme in Klimt, seen as early as his 1898 illustration for *Ver Sacrum* entitled *Fish Blood,* his *Flowing Water* of the same year or his *Water Nymphs (Mermaids)* of *c.* 1899 (ills pages 145, 146). It was

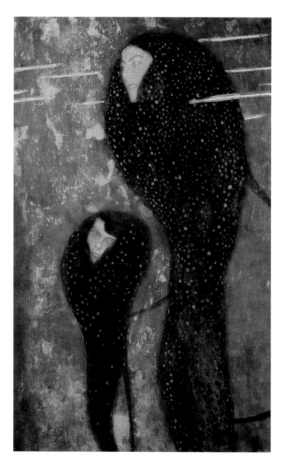

Gustav Klimt, *Water Nymphs (Mermaids)*, *c.* 1899
Oil on canvas, 82 x 52 cm
Bank Austria Creditanstalt, Vienna

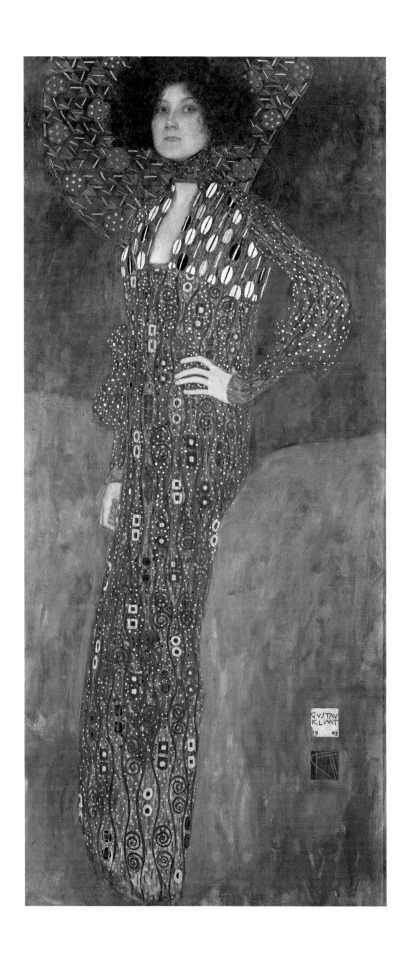

Gustav Klimt, *Portrait of Emilie Flöge*, 1902
Oil on canvas, 181 x 84 cm
Wien Museum, Vienna

also a theme to which the Wagnerian milieu of the Secession movement provides an instructive clue. Anyone familiar with the operas of Richard Wagner will know of his use of identifying musical 'leitmotifs' — and especially how in his four-part nineteen-hour extravaganza *Ring of the Nibelungen* such leitmotifs are integrally connected and tie the whole work together. What not every listener might have noticed is that the opening E-flat chord of *Das Rheingold*, which Wagner presents as the elemental nature motif, when doubled in speed becomes the motif of Erda, the Mother Earth goddess, and this in turn doubled becomes the motif of the River Rhine (to which, incidentally, after nineteen hours of a truly cosmic drama, everything again returns in a redemptive apotheosis). The recurring aquatic vision of Klimt, again, is thus *not* a threatening vision, where women overwhelm men with a sense of inadequacy in the face of their seemingly inexhaustible capacity for carnal bliss. It is, rather, a vision of hope — and even redemption. These women are not *femmes fatales*, but Dionysian embodiments of elemental Eros — what Goethe called 'the eternal feminine.' The menacing dimension that is often (and quite rightly) perceived is not that of the castrating bitch or the inexhaustible sensualist, but rather elemental atavistic instinct always threatening to break unpredictably through the surface. For confirmation of Klimt's own lack of castration anxiety, one need only consider his portrait of his mistress, Emilie Flöge. Despite the fluid evocation of her dress (designed, incidentally by Klimt), no hint of sexual anxiety informs his brush.

In some of the most famous and well-known works of Klimt, which he painted in subsequent years, this theme is only amplified. So, for example, in the luxuriant *Danae* (ill. page 149), the male principle, reduced to a single black rectangle, must find its place in the ample warmth of an essentially feminised cosmos, with its evocatively fluid round lines — the sperm and egg analogy being too obvious to belabour. In *The Kiss* (ill. page 104) we see the male (with the same aggressive male symbols of black rectangles) embraced by a female. Note that her dress is more organically integrated with the flower garden on which they kneel. Indeed, it can be regarded as a harmonic continuum of that garden. He seems to dominate, but if we focus on the placement of her hand, it is really she who is pulling him down into the garden. Similarly, in the dining room frieze of the Belgian banker and industrialist Adolphe Stoclet, executed on Klimt's design in gold, marble and semi-precious stones, the dominant image is the 'Tree of Life,' which completely engulfs the human figures. Here, too, the female is a harmonious element of nature whose embrace in the Fulfilment portion of the frieze draws the male into the integrated whole, and in a word, *redeems* him.

The similar focus on the embrace and redemptive power of nature are evident in Klimt's landscapes. From the beginning, Klimt strove for a kind of overwhelming immediacy to embrace the viewer and to draw him into a fundamental harmony with nature. He did this by the device of placing his horizon high on the canvass (something which Ferdinand Georg Waldmüller had made famous). In time the horizon became higher and higher, and just as Klimt had focused on the luxuriant fecundity of the

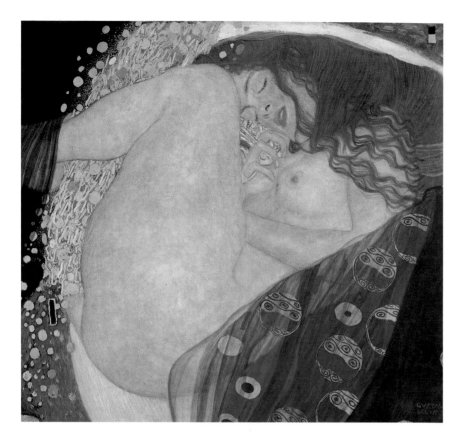

Gustav Klimt, *Danae*, c. 1907/08
Oil on canvas, 77 x 83 cm
Private collection

female, so too his landscapes become more and more fecund as he went on until the horizon disappeared altogether and we are drawn completely into the natural world in all its prolific plenitude — in effect, integrating the viewer him- or herself into this cosmos of feminised nature, as can be seen in *Bauerngarten mit Sonnenblumen* (*Farm Garden with Sunflowers*) of around 1907. Similarly, in Klimt's society portraits, which have often been interpreted as manifestations of his withdrawal from philosophical painting to become a mere decorator for Vienna's refined *haut monde* with (as Schorske observes) a "static [and] crystalline ornamentalism,"[7] I would agree with the argument that the very contrast between the naturalism of the face and hands, and the ornamentation of the clothing and background in these portraits, actually frees the 'persona' from gravity, and elevates and intensifies the fragile individuality of the sitters in the mystery play of existence. For all the introversion, sadness and tragedy apparent in many of these portraits, what stands out even more about Klimt's women is that they are inflexible, proud and unconquerable.

If we can return to the *Beethoven Frieze* with this in mind, a different sense of its messages and implications emerges, one which departs from traditional interpretations. I believe that Schorske's interpretation about the final kiss and embrace taking place in a womb is not only correct but is also the key image that ties all three walls of the *Beethoven Frieze* together, for there is one critical 'womb' image in each of them, with each representing a significant stage of a process. If we begin with the 'hero' on the left wall — this knight of the super-ego (Klimt, by the way, gave him the face of his contemporary, the composer Gustav Mahler; see ill. page 92), who dares to confront the Hostile Forces — we see that his determination is nurtured (and here the first the womb-like image surrounding the grouping is particularly apt) by Pity and Ambition in a way that ordinary humans, naked and cowed, are not capable. In his determination to face reality, the knight is already a Nietzschean 'Übermensch,' even

Gustav Klimt, *Farm Garden
with Sunflowers, c.* 1907
Oil on canvas, 110 x 110 cm
Österreichische Galerie Belvedere, Vienna

if he is animated by false confidence about the outcome. The armour is a symbol of this confidence, but it is also a symbol of man as he who masters nature, of the military hero, of, in fact, a man not far removed from the unfortunate Holofernes.

In the central panel we encounter the fundamental realities of life: the Furies (or, as the Greeks said, 'the grim ones') who acquaint us with the world of pain, disease, sickness, madness and death, as they cosy up to Typheus, the winged monster, the son of the Mother Earth (representing the elemental fury of Mother Earth). In this elemental world governed by instinct, we now encounter a second womb-like image that is in reality the core of the whole frieze (ill. page 153). This womb represents the elemental world of the senses (the elemental aspect is stressed here by the use of the three primary colours). There is, of course, a menacing dimension here (as in *Water Snakes I* and *II* (ill. page 34) the Dionysian is not placid), but there is also an unmis-00takable focus on what I would call the 'generative imperative' through the stylised representation of erect penises and red-mouthed vulvas. The sensual and physical is here stressed in all its variants: sex, food, and narcissistic luxuriating in the body. With

particular reference to the figure of Lust one might recall, for example, that the central figure of *Hope I* was also a redhead with the identical sprigs of blue cornflowers in her hair, and that Lust here is holding a red band not unlike the blazing red line running through *Hope I*. For me, Klimt conceived this 'womb' within the Hostile Forces panel essentially as a 'feminine principle' to which even the most aggressive super-hero must submit — to recognise sensuality, and especially sexuality, with all its frightening dimensions, as the driving force of the world. The knight cannot subdue this world with the traditional Judeo-Christian perspective of man as the master of nature. Rather he must integrate himself *into* it. Symbolically, he must shed his armour and instead submit to an Eros that shares affinities with what the Greeks called *philía*, a universal power that opens the way to the divine. The human spirit cannot just float over or transcend the so-called 'hostile forces,' it must go through the tragedies of life where the only eye of the hurricane is precisely this womb — the womb of solace but also the womb of self-recognition, the womb that gives birth to a new sensibility, which can take us past the nagging care of our little existence to the golden and redemptive world of art.

If the first half of the right wall then unmistakably proclaims that art is an Apollonian force, which has access to instinctual energies and can lead us to a higher bliss, it also suggests that the redemptive power of art is not accessible to would-be conquerors of nature, but only to those who submit to the transformative power of Eros. This is clearly represented in the final panel. Through art the hero completes his quest in a third womb-like image: in the embrace of a woman, stripped of all his useless armour, yes, but his feet not ensnared in a dangerous way by the woman's hair, but immersed in stylised watery waves, which unite him with his companion (ill. page 153). Woman is thus the true dominating figure of the *Beethoven Frieze*, because woman alone is in close union with the harmony of the world. Only by feminising his sensibilities, by succumbing to the embrace of the eternal feminine, can man aspire to a fulfilment of his longings.

Now, what I have tried to stress here is what I see as the common denominator in Gustav Klimt's complex metaphysical universe. That common denominator is an organic conception of the cosmos, emphasising the integration of the individual human life in the great chain of being, stressing the creative, the generative, the eternal feminine underpinnings of human existence, and it is precisely this feminised cosmos that speaks so forcefully to us today. The sudden popularity of Klimt after half a century of neglect is therefore, in my view, a symptom of a momentous development in which we are participating: the transition of our culture from one style or one cosmology to another. Like the Age of Mannerism, which moved from Renaissance optimism to Baroque sensuality, ours too is a transitional age. What I mean to suggest is that the period we have become accustomed to calling 'modernist,' the style we have come to call 'avant-garde,' which have dominated our age since the First World War, has come to an end. We may not have found our new style, our new language yet, but what is increasingly clear is that many of the intellectual premises of twentieth-century mod-

ernism are no longer valid. The present-day failure of modernity (the Cartesian modernity of Paris and New York) seems patent all around us, from the crumbling tower blocks of the 1960s to the failures of social engineering manifest by the collapse of communism. Now we can appreciate what turn-of-the-century Vienna had to say to us. Now, not only the false optimism of modernity but also its headlong nihilism stands unmasked.

It seems to me that while artists generally reflect and refract their society in sensitive and telling aesthetic form, they are not necessarily always conscious or aware of what it is that they are reflecting because they tend not to have the advantage of historical perspective. But if we look at the political, social and intellectual framework within which avant-garde modernism developed from, say, 1910 to the 1970s, we see first of all the long shadow cast by the First World War ("the seminal catastrophe of our century," as George Kennan[8] put it) with all its dehumanisation. We see the intoxication with the so-called 'second industrial revolution,' with its optimistic, functional and utilitarian view of technology. And we see, above all, the reign of the science of physics: from the relativity theory of Einstein, through Heisenberg's uncertainty principle, to the atomic nightmares of the 1950s, 60s and 70s. That all this evoked a fragmented, abstract minimalist style is hardly surprising. The question that should be asked, above all of artists, is whether this language is adequate to express the human dilemma in the new context that is daily being established. Now we live under the shadow of the destruction of our planet's organic infrastructure and ecosystem. We seek to humanise technology, and the queen of the sciences is no longer physics, but biology. Our new ecological, organic view of the universe, our desperate search for roots, for continuities, in short our emphasis on the integrative rather than the fragmentative, all these are signs of a world on the brink of a fundamental change of cosmologies. Suddenly Gustav Klimt, who was on a quest for a new cosmology in his own lifetime, uncannily speaks to us again today. We could do worse than be informed by his vision.

1. Carl E. Schorske, *Fin-de-siècle Vienna: Politics and Culture*, New York 1981 (originally published New York, 1980), pp. 208–278.
2. R. J. W. Evans, *The Making of the Habsburg Monarchy, 1550 –1700: An Interpretation*, Oxford 1979, p. 447.
3. Schorske, see note 1, p. 7.
4. Friedrich Nietzsche, *Die Geburt der Tragödie aus dem Geist der Musik*, in: *Werke in drei Bänden*, Munich,1954, vol. I, p. 121.
5. Friedrich Nietzsche, *Schopenhauer als Erzieher, in. Unzeitgemässe Betrachtungen*, in: *Werke in drei Bänden*, Munich, 1954, vol. 1, p. 326. See also William J. McGrath, *Dionysian Art and Populist Politics in Austria*, New Haven, London 1974, pp. 53–83.
6. Schorske, see note 1, pp. 259–260.
7. Schorske, see note 1, p. 264.
8. George Kennan, *The Decline of Bismarck's European Order: Franco-Russian Relations 1875–1890*, Princeton 1979, p. 3.

Gustav Klimt, *'This Kiss for the Entire World'*
(detail from the *Beethoven Frieze*)

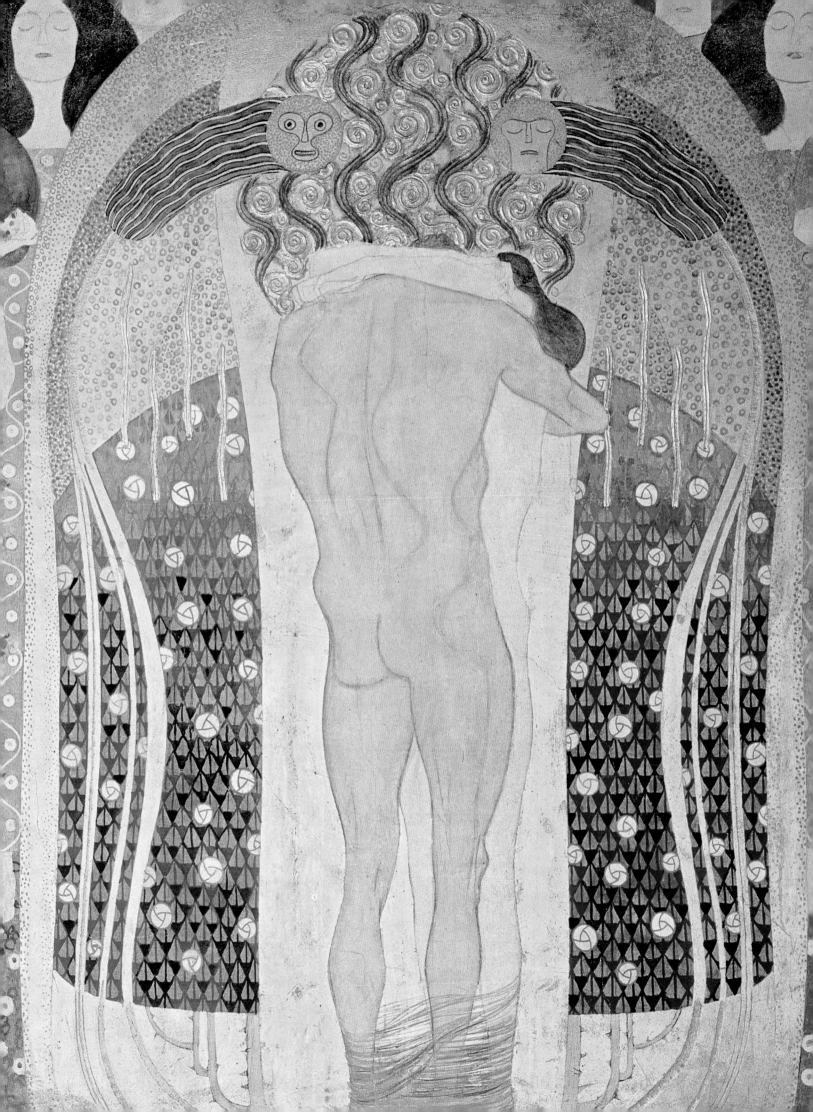

Manfred Koller

The technique and conservation
of the *Beethoven Frieze*

With their fourteenth exhibition in 1902, the members of the Viennese Secession definitively liberated them-
selves from the historicism of salon art by creating an ephemeral work that combined architecture, painting and
sculpture, and that was animated by a desire to reform art and life.[1] Similar ideas of a *Gesamtkunstwerk*, or 'total
work of art,' were also developed in other European centres around this time.

The preconditions for new monumental painting around 1900

Since ancient times, mural painting, as a site-specific form of art directly linked with architecture, has had a spe-
cial status because of its very public character. The Enlightenment of the eighteenth century, with its turning
towards ancient classical artistic ideals, resulted in the abandonment of illusionary wall painting (fresco) for inter-
iors and façades. The renewal of the interest in fresco painting in the nineteenth century was originally due to
the religious and artistic ideals of the Nazarenes, who based themselves on the painters of the early Florentine
Renaissance. This renewal was encouraged by the almost simultaneous publication of the first Italian edition of
Cennini's art manual *Trattato della pittura* in 1821 (new edition in 1859),[2] which was translated into English in
1844, into French in 1858 and, as late as 1871, into German.[3] The view that existed thereafter, that the prime
period of fresco painting occurred in the Trecento and Quattrocento and continued into the Baroque era, has in
many ways been qualified in recent studies. The technique of 'fresco' painting on wet plaster — which Cennino
Cennini was the first to describe around 1400 — later became a synonym for all types of wall paintings, though
in fact it corresponds only to a limited extent to the techniques actually employed, for which marked regional and
personal developments can be identified.[4]

Parallel to the religious-romantics' enthusiasm for frescos, secular decoration in the Age of Goethe succumbed
to a fascination with the Pompeian wall paintings that had come to light in the rediscovered cities of the Cam-
pania after 1783. Their dazzlingly preserved colours were misidentified as the products of a wax technique simi-
lar to the encaustic method described by Pliny and Vitruvius.[5]

After the Congress of Vienna in 1812, the newly consolidated monarchies of Europe felt the need for a "public
art in which emphasis is to be placed on its visual and educational role." This led to Peter Cornelius, in a
letter to Joseph Görres in 1814, recommending the "reintroduction of fresco painting."[6] Cornelius had seen the
Nazarenes' fresco paintings in the Casa Bartholdy in Rome in 1816/17,[7] and in the 1820s had executed, in Munich

Gustav Klimt,
The Sufferings of Weak Humanity
(detail from the *Beethoven Frieze*)

and Bonn, the first large-scale fresco paintings in Germany, with the assistance of chemists such as Johann Nepomuk Fuchs. In Vienna, Joseph von Führich and his pupils, followed a generation later by Carl Rahl, were the first to proceed in a similar direction.[8] As a result of the Paris World Fair of 1867, the interior decoration of the Viennese Ringstrasse was implemented using two much simpler techniques: that of applying oil paint directly on to a wall, and that of applying the oil paint to fabric that is then glued to a wall (a technique known as marouflage). Through the influence of his teacher, Ferdinand Laufberger, and his knowledge of the neo-Baroque visual richness of the Makart era, Gustav Klimt grew up knowing these techniques well. His early ceiling paintings in the Hermes Villa, alongside Makart, and the paintings he created jointly with Franz Matsch for the lunettes of the staircases in the Burgtheater and Kunsthistorisches Museum, are examples of oil paints applied directly to the dry plaster of the walls. On the other hand, the two large ceiling paintings Klimt and Matsch created for the Burgtheater staircases were painted on canvas, in the studio, and then applied as marouflage, using an oil and white-lead adhesive.[9] The latter method had previously been used in Vienna for similarly large-scale works by Anselm Feuerbach (hall of the Academy, up to 1892); Hans Canon (ceiling of the staircase in the Museum of Natural History, 1884/85); and Mihaly Munkácsy (ceiling of the staircase of the Kunsthistorisches Museum, 1890).[10] The young Klimt appropriated all the most important formal and technical methods provided by tradition, so that the list of works produced by the Klimt and Matsch painters' co-operative at Sandwirtgasse in the Mariahilf district of Vienna up to the year 1885 includes everything from the 'glue-painting' of theatre curtains in Carlsbad, Reichenberg and Fiume, 'tempera backdrops' and ceilings painted in oils to look like Gobelin tapestries, to the *sgraffito* work in the courtyards of the Kunsthistorisches Museum modelled on Laufberger's cartoons.[11] According to Franz Matsch, he and Gustav Klimt originally proposed painting the Great Hall of the University in fresco technique.[12] In the event, however, Klimt painted his faculty paintings in oil on canvas, doubtless with the aim of attaching these to the ceiling at a later date.

These individual approaches to the historical traditions of mural painting came together again towards the end of the nineteenth century in the desire to create a new form of monumental painting. The previous crisis in painting technique, which had led to the preference for using oil paint, usually in the form of paintings completed in the studio and then glued to a wall or vault (marouflage), is clearly illustrated by John Ruskin's misjudgment, made in 1871, which is precisely in line with the British Pre-Raphaelites' preference for oil painting. Ruskin considered oil painting as "absolutely permanent," and fresco, on the other hand, as inferior because "marble discolours, fresco fades ... of his splendid art Michel Angelo understood nothing; he understood even fresco imperfectly."[13] The close examination of the frescos in the Sistine Chapel during the latest restoration, however, has shown Michelangelo to be a technically unsurpassed fresco painter. Due to the lack of experience in mural techniques for historical painting in standard academic art education, German painters including Alfred Rethel (town hall in Aix-en-Chapelle, after 1840), Arnold Böcklin (Basel Museum,

1868/69) and Hans von Marèes (zoological station, Naples, 1873) had great difficulties in achieving their goals; whereas Moritz von Schwind, who was born in Vienna, was able to adopt the Nazarene fresco tradition of Führich and Kupelwieser (Wartburg, 1855).[14]

The only new discovery in connection with wall-painting techniques during the nineteenth century was silicate painting (also known as stereochromy and mineral painting), for which Adolf Wilhelm Keim, who was attempting a "reform in painting techniques," was granted patents in Augsburg in 1878 and 1881. In 1882, he founded the Versuchsanstalt für Maltechnik (Research Institute for Painting Techniques) in Munich. Its second chairman was Franz von Lenbach. From 1884 it published the influential journal *Chemisch-technischen Mitteilungen für Malerei* (Chemical-technical Information on Painting).[15] In 1894, the first Congress on Painting Techniques took place in Munich, at which historical fresco techniques were discussed.[16] Sadly, there has been only limited study of the role of Ernst Berger as a painting technologist during his Viennese period. He became prominent only after his entry into the Research Institute for Painting Techniques in Munich and the publication of his pioneering studies on historic painting techniques.[17]

The interest in fresco painting was omnipresent in the last decade of the nineteenth century. In 1890 in Berlin, a sponsor offered prizes for frescos, on various themes, done in private houses. In 1895, the National Society of Mural Painters was founded in the United States and, from Boston to Chicago, provided the 'American Renaissance' with many commissions. Twenty artists took part in the competition which was organised in Zürich in 1896 for the decoration of the Swiss National Museum, which was finally won by Ferdinand Hodler.

This was carried out using full-size colour cartoons (only partially preserved) on a fresco worked on daily, with *sgraffito* and numerous areas of *secco* utilised in the application of plaster and colour.[18] The general move towards monumental art is also apparent in the great increase in the number of restorations of medieval murals in Austria between 1890 and 1910. Alois Riegl, the General Conservator, placed particular emphasis on this work after 1902.[19] The active role played by the Secession in preventing the 'cleaning' of the giant door of St. Stephan's Cathedral in 1900 is proof of the receptiveness of the young group of artists to new aspects of the preservation of monuments.[20]

Gustav Klimt, *Theatre in Taormina*, 1886–1888
Oil on stucco ground, *c.* 750 x 400 cm
Ceiling painting in the northern staircase
of the Burgtheater, Vienna

The renaissance of the figural frieze

Along with the contemporary interest in a new kind of monumental painting, in accordance with the ideals of historical fresco techniques, which could be observed starting in the early nineteenth century, there was also a renaissance of figural friezes based on ancient models that continued into the twentieth century. As we know today, the entirely or partially polychrome relief friezes below the roof of Greek temples showed

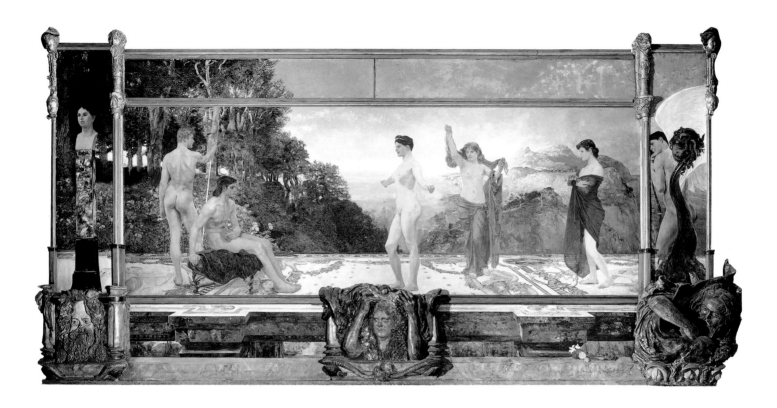

Max Klinger, *The Judgment of Paris*, 1885–1887
Oil on canvas, 370 x 720 cm
Österreichische Galerie Belvedere, Vienna

epic narrative series.[21] The later adaptation of such pictorial friezes in Byzantine mosaics, medieval basilicas and, later, in secular Italian Renaissance art, provides a bridge to this tradition. In the sixteenth century, this type of frieze was introduced into northern Europe: it can be seen in the galleries of Fontainebleau in France, and in the Spanish Hall in Schloss Ambras and the wall paintings in Weyerburg, both near Innsbruck.[22] In Schloss Ambras, the painting of the frieze is combined with white and polychrome stucco relief; in Weyerburg, painting is predominant. This kind of frieze art increased in importance during the Age of Goethe, particularly with the advent of the revival of historical styles. Such friezes can be found in Theophil Hansen's work: the University of Athens and the cast of the Parthenon Frieze in the hall of the Academy of Fine Arts in Vienna (opened 1877), as well as in the mosaic friezes for the portico, vestibule, and columned hall of the Viennese Parliament, in the form of painted strips pasted to the wall (marouflage again). [23]

Max Klinger's *The Judgment of Paris* in the Österreichische Galerie Belvedere unites the frieze form with elements of panorama painting. His multipart, large-scale frieze composition *Christ on Olympus*, which was completed in 1897, was the focal point of the third Secessionist exhibition in Vienna. Klinger's ideal of 'polychrome sculpture,' which he demonstrated by painting the plaster model of the Beethoven group, had precursors, principally in England and Holland, a fact brought vividly to mind by the exhibition *The Colour of Sculpture* (1996).[24] According to Ludwig Hevesi, the relief of the dancing figures (no longer in existence), highlighted in gold, on the rear façade of the Vienna Secession building, was a "happy idea of [Kolo] Moser's."[25] In Vienna, the 'relief paintings' by Gerald Moira (with Lynn Jenkins as technician), who had great success with his coloured relief friezes for public buildings (for example, the Library, Liver-

pool) and restaurants (Trocadero, London), had been followed with particular interest.[26] A sophisticated *pastiglia* frieze by Charles Rennie Mackintosh and his wife dominated the Scottish Room at the eighth Viennese Secessionist Exhibition in November and December 1900. In 1906, Margaret Macdonald Mackintosh created an even larger and denser frieze for the music salon in the villa of the industrialist and financial backer of the Wiener Werkstätte, Fritz Waerndorfer, in Döbling, a suburb of Vienna. This can be seen today in the Museum for Applied Art.[27]

Experiments with materials at the Beethoven Exhibition

According to Berta Zuckerkandl, the members of the Secession had planned a "fresco exhibition" for 1901, but this had to be postponed until Klinger's Beethoven sculpture was completed. The term 'fresco' was in fact a terms that here covered many wall-painting techniques used in monumental painting. The wall paintings by Klimt, Alfred Roller, Adolf Böhm and Josef Maria Auchentaller exhibited in the fourteenth Secession exhibition were merely *a secco* paintings (the pigment painted on dry plaster), placed at frieze height below the ceiling. The catalogue clearly shows that particular attention was paid to painting techniques: "As for ... painting ... its appeal depends exclusively on the mastery of its superb medium, so capable of development, this medium able to capture the entire visual world, which it can reproduce in all its forms, with absolute clarity and depth."[28] The small, movable compositions at eye-level illustrated experiments with various materials and techniques, such as plaster and cement carving, glass and ceramic mosaics, coloured marble, the combination of wood, marble and metal, and casein and silicate colours — but there was only a single "fresco with casein painting," by Rudolf Jettmar. The mother-of-pearl inlay work, and golden lacquer pieces in the Sino-Japanese tradition were indicative of those models from overseas which had become popular following the world fairs and the new influence of Japonism. These were a continuation of the adaptation of foreign techniques such as had been employed in Vienna since the Rococo period (for example in the Vieux Lacque Room, Schloss Schönbrunn). In 1900, the Secession itself organised an exhibition of old and modern Japanese art.[29]

The experiments with silicate painting were the only really new technical development, as this technique had been in use only since its development in the 1880s in Munich. After this time, it was occasionally used in Austria for the restoration of historic murals (for example in 1903 in the Sgraffito House, Eggenburg). A silicate coating had already been applied to the plaster façade of the Secession building in 1898.[30] In addition, there was structural plaster (pedestal zone), ornamental carved plaster (frieze zone), and glass mosaics (facings of the vases) in the entrance areas of the Secession building.[31]

Josef Hoffmann's pre-Cubist over-door reliefs in the side-hall, on the left beneath the *Beethoven Frieze*, are much too plastic to be 'mortar carvings' and were probably cast

Ferdinand Andri, *St. Sebastian*, 1902
Lime wood relief, partially gilded and painted,
prepared for the fourteenth Secession exhibition, 1902
80 x 80 cm
Private collection

Ferdinand Andri, *In Tyrannos*, 1902
Lime wood relief, partially gilded and painted,
prepared for the fourteenth Secession exhibition, 1902
80 x 80 cm
Private collection

in plaster and worked before the material hardened. They are therefore plaster reliefs which, according to Hevesi, Hoffmann himself described as "crystallised plaster."[32] Hoffmann's wall decoration — which was described in the catalogue as simulating "roughcast" — and the cubic installations continue the building tradition of the Austrian Baroque period, whereas during the nineteenth century an increasingly coarse form of plaster had come into use (Vienna Hofburg, Michaelertrakt, 1892). This was already used for the surface of the ashlars of Theophil Hansen's buildings on the Ringstrasse (Palais Epstein, Academy of Fine Arts, originally unpainted). Hoffmann contrasted this form of plaster with flat 'chessboard' stripes, with gilded wooden beams as supports. In this way, the plaster structures of external walls, such as can be seen in cottages around Döbling from around 1870, were in effect transported indoors, thereby monumentalising the impression of the interiors.[33] The overall white coating provided not only a neutral connection between the rooms and openings, but also underlined the solemn, sacral atmosphere, and so stands in a long, historical tradition. Palladio described *bianchezza* as the most appropriate colour for sacral rooms, and this played no minor role in creating the cultic character of the Beethoven Exhibition.[34] The sacral purity of the white colour is, however, aesthetically broken by the rustic character of the plaster, which serves as an effective contrast.

Gustav Klimt, *The Hostile Forces: The Gorgons*
(detail from the *Beethoven Frieze*, after cleaning and securing the breaks on the edge, with retouching tests)

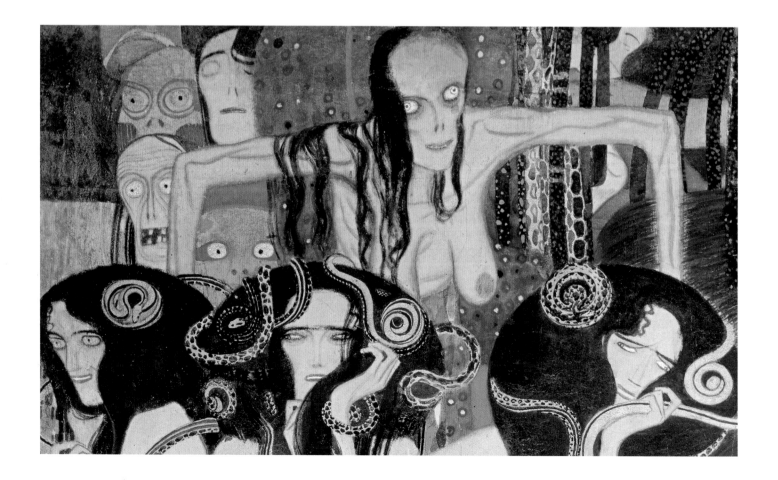

Klimt's technique for the *Beethoven Frieze*

In 1901, provisional wooden walls were erected in the main hall of the Secession for the *Beethoven Frieze* and the other (now lost) wall paintings. The simple construction consisted of unplaned crossbars attached to vertical slats on which reed mats — which actually held the plaster — were nailed. It was the lower areas of these wooden walls that were covered with plaster. The slightly recessed continuous frieze area received a light grey plastering, applied with a mortarboard, to form the actual painting surface.[35] The height of the frieze zone available for painting was 2.17 metres (7 feet 2 inches), which permitted the depiction of life-size figures — similar to those in Lebietzky's *Parliament Frieze* of 1912.[36] This wood-and-plaster construction technique is reminiscent of those ancient building techniques which had been in use until the Baroque. In this respect, the *Beethoven Frieze* can be compared with the wall frescos that Tiepolo had created for the Palazzo Labia in Venice around 1750, where the wood and reed walls are hidden from the viewer behind the illusionist painting. This simple and inexpensive wall-building technique is indicative of the temporary character of the exhibition, but later proved itself to be strong enough for the removal and preservation of the frieze. A similar point can be made about the light-grey lime plaster with a small portion of gypsum that was applied directly to the newly erected walls and smoothed out using a mortarboard. The light traces of scraping provide a lively texture typical of a traditional, crafted structure. This confirms the heavy demands the Secessionists placed on authenticity of materials, and on the precise techniques used, and so accords with the artistic programme set out in the catalogue. The theories of the British Arts and Crafts movement, based on the writings of William Morris, with which Klimt and others had became acquainted during their time at the School of Arts and Crafts in Vienna, stands behind this concern with materials and techniques. So it is particularly noteworthy that, although the Beethoven Exhibition was aimed at 'modern' forms and content, the materials and execution were typical of 'classic' traditions, and, in spite of the short-term purpose, were employed with the utmost care.

The preparations for the *Beethoven Frieze* are documented in hundreds of drawings and graphic studies. On the other hand, the paper cartoons used for the *spolvero* (pricking) transfer of the intentionally uniform heads of the yearning figures and the choral group were probably destroyed during the work. The transfer of the compositions, using a lattice grid of charcoal lines about 11 cm (4.5 inches) apart coincides with a geometric method reintroduced in the early Renaissance (with roots in ancient Egypt) and, more immediately, was a continuation of the practice used for the decorations created for the Ringstrasse. The method by which the cartoons for Klimt's early ceiling paintings were prepared is evident from the conserved ground of his 'Globe Theatre' ceiling painting of 1897 for the staircase of the Burgtheater.[37] In contrast to the interior decoration characteristic of historicism, more than half of the sixty square metres (645 square feet) of the plaster surface of the *Beethoven Frieze* was left unpainted. The 'rough' effect of the material thus deliberately stressed the two-dimensional nature of the wall.

Josef Hoffmann, *Sopraporta*, 1901/02
(reconstruction by Willi Kopf, 1985)
Softwood painted white, 94 x 96 x 15 cm
Hummel Collection, Vienna

Gustav Klimt, *Gnawing Grief*
(detail from the *Beethoven Frieze* after cleaning)

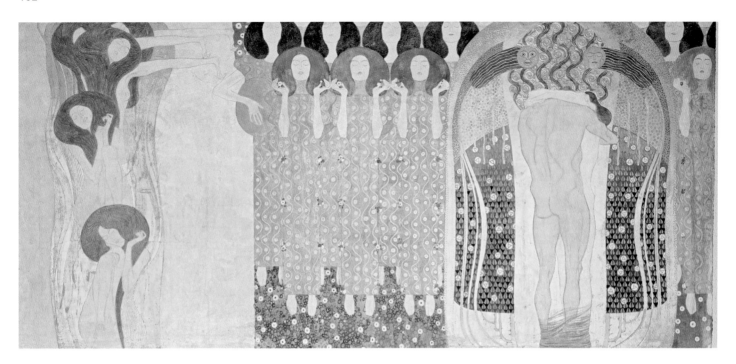

Gustav Klimt, *The Arts, Choir of the Angels of Paradise,*
'This Kiss for the Entire World'
(detail from the *Beethoven Frieze*)

Gustav Klimt, *The Knight in Shining Armour*
(detail from the *Beethoven Frieze*)
Applications on the armour. Here it is possible to see
the grained structure of the plaster with the oil gilding,
pastiglia applications, and darkened contours

That the actual painting was carried out in two or three separate phases can be seen
in the various stages of the work's development. The female heads in the Choir of the
Angels of Paradise, for example, are painted in the same flat, preparatory style of
painting used for their hair and clothing. Here, Klimt did not complete the sensitive and
ornamental lines, using a coloured brush-drawing technique, as he did in the case of
the figures in the Longing for Happiness, or the Hostile Powers. Even the contouring of
the faces and other physical features — usually carried out in the two complementary
tones, light blue and light red — is missing in this case. The rejection of the additional
flesh tones underlines the graphic abstraction of Klimt's visual language. Only the
naked male back, in the final chorus, is modelled as a genuine 'representative' of the
basic theme of the frieze: mankind redeemed through art and music.

The technique used in painting the *Beethoven Frieze* — matt casein colours on dry
plaster — corresponds exactly with the *a secco* painting technique. In works produced
for the Ringstrasse, this type of lime and casein painting was used only for decorative
purposes, whereas thick or thin oil paints were used for wall paintings. This watery
emulsion permitted a thin, matt application of colour and a precise drawing of lines.
The garments of the floating figures, which, with their white and bluish parallel lines
appear as if clothed in antique, filmy fabrics, were finally drawn with graphite. Even
though we can see no definite evidence for the use of colour pencils in the coloration
of this work, the painting style is reminiscent of a coloured drawing and, with this in
mind, Marian Bisanz-Prakken was led to make comparisons with the linear art of Jan
Toorop.[38]

There are also close, contemporary parallels in respect to the painting technique
used. Colour etchings by Jean-François Raffaelli were exhibited at the third Secession
exhibition, in 1899. Following his example, (oil) colour pencils called 'Raffaelli pencils'
were produced. In addition, in 1904 Wilhelm Ostwald, professor of physical chemistry
in Leipzig and Nobel laureate in 1909, published articles on the theory of colour and
painting techniques. Paul Klee was fascinated by these in their year of publication.[39]
In 1905, Ostwald published in a daily newspaper his ideas on a new kind of wall paint-

ing which he called "monumental pastel," arguing that frescos carried out using the old techniques were now adversely affected by the corrosive effects of the sulphuric acid in the atmosphere. His new, dry technique on rough lime plaster (if necessary mixed with pumice) involved painting and drawing with pastels in a tragacanth bond, to be smeared on with the finger. This was then fixed with a borax-casein solution, with an aluminium acetate solution used to waterproof the casein, producing a result similar to that which Klimt had already developed for himself in 1902. However, Klimt's painting was particularly sensitive to dampness and wear. Ostwald recommended that exterior paintings be rubbed with paraffin wax, and between 1905 and 1910 gained practical experience with artists working in Jena, Berlin, Mannheim and Schaffhausen.

Gustav Klimt, *Typheus*
(detail from the *Beethoven Frieze*)
Applications: the mother-of-pearl eyes after cleaning

Another important technique in the creation of the *Beethoven Frieze* was the use of surface structure in line with the motif depicted. The first long wall was roughly rubbed down (Sufferings of Weak Humanity); the narrow wall was left rough in places (Typheus), but elsewhere was smooth (female figures); the second long wall (Fulfilment) is for the most part smooth. The variations in the thickness of the coats of paint applied were intentional in most cases, though towards the end of the frieze (floating figures) the reason why the work remained unfinished was undoubtedly lack of time. The thinness of the paint has the effect of rendering clearly visible the technique Klimt used for transferring his drawings onto the wall. As noted above, he transferred his sketches with the aid of a grid, and his cartoon tracings of recurrent motifs with the aid of the *spolvero* method. The cartoon figures for Longing for Happiness, for example, are repeated no fewer than nine times in the final chorus and their outstretched arms above Poetry reproduced a total of four times. A mirror-image cartoon tracing was used for the faces of the two arts at the top.

Klimt was able to achieve still more graphic and plastic effects by making cuts in the plaster and scoring the mortar, usually in combination with *pastiglia* technique plaster,[40] and material applications too (e.g. the golden armour of the knight in the Sufferings of Weak Humanity, the head of Excess). Among the other items applied are wall tacks, buttons, mother-of-pearl (for the eyes of the monster Typheus), curtain rings and fragments of mirror (Poetry, Excess), as well as costume jewellery made of coloured glass (for the hilt of the knight's sword and the belt of Excess). Klimt's use of gold leaf, meanwhile, was either justified by the object to which it is applied (hair ornaments, armour and such like) or was used for give emphasis to certain symbols and patterns. The gold leaf areas vary significantly in terms of their glazing or the drawings scored into them (using a graphite pencil or a brush).

Only at first glance does Klimt's *Beethoven Frieze* seem to be a hastily produced, purely decorative work. What is most fascinating about it on closer inspection is the artistic dexterity and attention to detail evident in the execution. Klimt filled whole areas with casein paint only when he needed a coloured ground, as was the case with the hair of the figures Longing for Happiness, for example. The rest of the frieze is executed more like a brush drawing, though the artist makes liberal use of charcoal,

Gustav Klimt, *Poetry*
(detail from the *Beethoven Frieze*)
The split which occurred during the removal
at the end of 1903/beginning of 1904 and
the transport protection provided at the end of 1977

Left side-hall of the Secession Building during construction work for the Beethoven Exhibition, 1901

Conservation of the split upper edge
of the *Beethoven Frieze*

graphite pencils and pastel crayons too. The sparkling metal inserts and applications make for an effective contrast with the rather matt appearance of the painted areas. The possibilities of mural painting and of painting onto plaster become a vehicle of stylistic expression, whilst alternations of rough-smooth, matt-glossy, empty-full, sketchy-fleshed out, polychrome-monochrome and light-dark make for an exquisitely decorative impact, in some cases combined with patterns engraved in the still moist plaster to create mosaic-like effects. For the Vienna of 1900 was enamoured not only of fresco, but also of mosaic techniques too (one has only to think of Leopold Forstner, for example).[41]

The survival and restoration of the *Beethoven Frieze*: A 100-year history

Initially, the *Beethoven Frieze* remained in its original location until the eighteenth Secession exhibition — Klimt's first collective exhibition — in November and December 1903. Afterwards, through the intervention of Egon Schiele, it was bought by Carl Reininghaus and stored in a provisional storehouse. It was removed in seven irregular sections totalling approximately thirty meters (98.5 feet) in length, and obtained by sawing through both the layer of plaster and the wooden supports. The removal of the four-meter (13-foot) unpainted section of plaster above the opening providing a view into the main hall was dispensed with. In 1907, Klimt made the collector an offer in which he agreed "to carry out the repairs necessary when the work reaches its final location, free of charge."[42] Probably while being taken down, a long crack formed in Poetry, due to there being a join in the wooden construction behind it. Still more cracks resulted from the strains placed on the work during transportation, and — at least according to Arpad Weixgärtner in 1912 — from the vibrations caused by tramlines.[43] In 1915, during the First World War, August Lederer bought the entire work. After the confiscation of the Lederer collection in 1939, the Klimt paintings in the collection were initially stored in Schloss Thürnthal, before being transferred to Schloss Immendorf in 1943, where the collection was destroyed by a fire in 1945. By that time, the *Beethoven Frieze* had been "taken into safekeeping" in the depot of a Viennese transport company, where it would likewise have been destroyed in a bombing raid in 1944 had it not been transferred to Schloss Thürnthal in December 1943 after an exhibition of several sections in honour of the eightieth anniversary of Klimt's birth. Fortunately, therefore, it survived the war, and although the Schloss Thürnthal storeroom was closed in 1948, the frieze must have remained there for some years.[44] Not until 1956 was it removed to the Altenburg Monastery, pending the conclusion of restitution proceedings, and from there, in 1961, to the Österreichische Galerie Belvedere in Vienna for safekeeping.

The former stables of Prince Eugene in the Lower Belvedere served as a provisional storeroom for the frieze from 1961 to 1977. In these rooms, the sections of the frieze, which had been strengthened with wooden diagonals on the back and supports on

either side, were stored upright, with just a little space between them so that the painted surfaces were not visible. Having been moved so many times, the edges of the frieze — especially along the top and sides — had crumbled away in places and were therefore in need of repair. This was done with plaster as far as possible, just as the holes in the frieze were refilled with plaster plugs.

In June 1967, the official workshops, under the leadership of Dr Gertrude Tripp, received a commission from the Ministry of Education to investigate the possibilities of a restoration of the frieze in the light of the proposed purchase by the Republic.[45]

In 1971, after receiving a positive assessment from the Austrian Federal Office for the Care of Monuments that a restoration was technically and economically feasible, Federal Chancellor Bruno Kreisky personally discussed the possibility of a purchase by the state with the owner Erich Lederer. After several evaluations by various experts (including Dr Gerbert Frodl), the frieze was eventually purchased by the Republic of Austria for fifteen million Schillings.

Storage in the Ceremonial Stables of the Lower Belvedere, Vienna, c. 1970, before restoration

There were no comparable models for a restoration project of this kind in Europe or indeed in the rest of the world. It therefore took almost ten years to develop basic test procedures and to analyse thoroughly the methods to be employed. The author (who has been head of the studio since 1980), and Dr Hammer, who was chief advisor and head restorer, together with a team consisting of many, mostly young, mural restorers from Austria and overseas, were involved in this work.[46]

In view of the extensive preliminary work done, it was decided that the original, tried-and-tested wooden-and-plaster construction should be preserved in its entirety. The only step to be taken was to give it support from the back using a stabilisation method that would have as little impact on the frieze as possible. A full-size copy of the left half Vices and Hostile Powers exactly reproducing the original techniques was produced in order to come to grips with these problems. After trying several variants, it was clear that the best solution would be to maintain and conserve the frieze construction in its present condition, and to adjust the suspension of each section using a steel frame with flexible elements fitted with adjustable clamps made of cast aluminium.

The spring of 1984 saw the completion of the restoration work on those sections that were to be shown to the public for the first time at the now celebrated exhibition *Dream and Reality* that took place the following year. In 1984, during the final phase of the restoration, the Österreichische Galerie Belvedere took the initiative of having the participating restorers produce an full-size copy of the entire frieze on light-weight, plastered synthetic boards for use in future exhibitions.

Following the exhibition, the frieze was taken back to the Secession building, where a new ground floor room had been created specifically for it, based on the very same plans that were used for the construction of the original frieze room in 1902. The government having given its approval, albeit subject to the fulfilment of various technical preconditions, the plan to reinstall the frieze in the Secession could at last be seen through to completion. The individual sections attached to a new steel frame were then

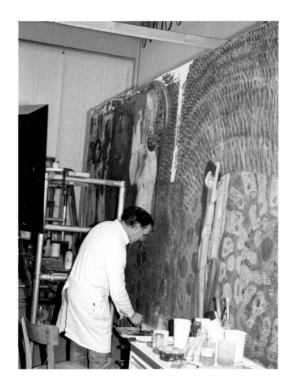

mounted on the fixed wall pedestals prepared for them and firmly anchored in place at their original height. Responsibility for the conservation and supervision of the frieze was assigned to the Österreichische Galerie Belvedere.

There can be no doubt that the successful return in 1986 of Gustav Klimt's *Beethoven Frieze* to the site of its creation was a most worthwhile addition to the many cultural attractions of Vienna.

Preparation of a full-sized copy of the *Beethoven Frieze* in the workshops of the Austrian Federal Office for the Care of Monuments, the Arsenal in Vienna

1. *XIV. Ausstellung der Vereinigung bildender Künstler Österreichs Sezession Wien. Klinger, Beethoven*, exh. cat., Vienna, April–June 1902; Fritz Novotny, Johannes Dobai, *Gustav Klimt*, Salzburg, 1967, pp. 29ff., 325ff.; Christian M. Nebehay, *Gustav Klimt. Eine Dokumentation*, Vienna, 1969 (DTV ed., Munich, 1976), pp. 283ff.; Robert Waissenberger, *Die Wiener Sezession*, Vienna, 1971, pp. 79ff.; Peter Vergo, 'Gustav Klimt's Beethoven Frieze,' in: *The Burlington Magazine*, CXV, 1973, pp. 109–113; Marian Bisanz-Prakken, *Der Beethovenfries. Geschichte, Funktion, Bedeutung*, Salzburg, 1977 (DTV ed., Munich, 1980); Manfred Koller, 'Monumentale Kunst um 1900 und heute. Der Beethovenfries von Gustav Klimt–Entstehung und Schicksal,' in: *Parnass* May/June 1984, pp. 19–29; Nicole Dey, *Gustav Klimt. Der Beethovenfries*, unpublished thesis, University of Münster, 1998.

2. Paolo Bensi, 'Metodi e procedimenti della pittura italiana fra Otto- e Novecento,' in: *Ricerche di storia dell'arte* 24, 1984, pp. 75ff

3. Manfred Koller, 'Die Wandmalereitechniken der Neuzeit,' in: *Reclams Handbuch der künstlerischen Techniken*, vol. 2, Stuttgart, 1990, pp. 346ff. Contains all those not specially cited entries included in the following text.

4. Manfred Koller, 'Material und Technik in der Wandmalerei des Quattrocento. Tagungsbericht,' in: *Kunsthistoriker aktuell*, 19, 2/2002, p. 8.
 International Colloquium on Baroque Wall-Painting, Vienna 2002 (contributions in preparation for the Salzburger Barockberichte 2003).

5. Peter Werner, *Pompeji und die Dekorationsmalerei der Goethezeit*, Munich, 1970; H. Schmid, *Enkaustik und Fresko auf antiker Grundlage*, Munich, 1926.

6. Frank Büttner, *Peter Cornelius. Fresken und Freskenprojekte*, vol. 1, Wiesbaden, 1980, pp. 70ff; Gisold Lammel, *Peter Cornelius' Beitrag zur Neurenaissancemalerei*, in: Karl-Heinz Klingenburg (ed.), *Historismus-Aspekte zur Kunst im 19. Jahrhundert*, Leipzig, 1985, pp. 123–140.

7. *I Nazareni a Roma*, exh. cat., Nazionale d'Arte Moderna, Rome, 1981. Casa Bartholdy 1816/17, Casino Massimo 1817–1829.

8. Werner Kitlitschka, *Die Malerei der Wiener Ringstraße*, Wiesbaden, 1981, pp. 6ff., pp. 54ff. From the series *Die Wiener Ringstraße. Bild einer Epoche*, vol. 10, Renate Wagner-Rieger (ed.).

9. Gerbert Frodl, 'Begegnung im Theater. Hans Makart und Gustav Klimt,' in: *Klimt-Studien,* Mitteilungen der Österreichischen Galerie 22/23, 1978/79, pp. 9–36; Ivo Hammer, Manfred Koller, 'Zur Technik und Restaurierung von Klimts Beethovenfries,' in: *Traum und Wirklichkeit*, exh. cat., Vienna, 1985, pp. 544–557.

10. Werner Kitlitschka, see note 8, pp. 140, 177; Vinzenz Oberhammer, 'Michael von Munkácys Deckengemälde im Stiegenhaus des Kunsthistorischen Museums in Wien,' in: *Jahrbuch der kunsthistorischen Sammlungen in Wien*, 70, 1974, pp. 221–337.

11. Mitteilungen des k.k. Museums für Kunst und Industrie, vol. 20, 1885, p. 308.

12 Herbert Giese, 'Matsch und die Brüder Klimt,' in: *Klimt-Studien*, Mitteilungen der Österreichischen Galerie, vol. 66/67 (year 22/23), Salzburg 1978/79, p. 64

13. John Ruskin, 'The relation between Michel Angelo and Tintoret,' 1871, in: *Collected Works*, XXII, 1903–1912, p. 77. Cited from Joan Evans (ed.), *The Lamp of Beauty. Writings by John Ruskin*, Oxford 1959, p. 121. Cf. Clare Willsdon, *Mural Painting in Britain 1840–1940*, Oxford, 1993.

14. Jürgen Pursche, 'Schwinds Fresko-Projekt auf der Wartburg. Beobachtungen zur Entwicklung seiner Maltechnik,' in: Rudolf Zießler (ed.), *Die Schwind-Fresken auf der Wartburg*, 14, Arbeitsheft des Thüringischen Landesamtes für Denkmalpflege, Eisenach, 1998, pp. 23–44.

15. Adolf Wilhelm Keim, 'Über Freskomalerei,' in: *Technische Mitteilungen für Malerei*, 5, Munich, 1888, pp. 124–131; Adolf Wilhelm Keim, *Über Mal-Technik*, Leipzig, 1903; Marion Wohlleben, '"Wetterfest, lichtecht, waschbar." Adolf Wilhelm Keim und seine Erfindung die "Keim'schen Mineralfarben." Zur Geschichte eines Produkts,' in: *Mineralfarben*, Zürich, 1998, pp. 13–48 (Schriften des ETH-Institut für Denkmalpflege, vol. 19).

16. Alfons Siber, 'Bericht über die Restaurierungstechnik in Pellizano mit besonderer Berücksichtigung des Freskos,' in: *Mitteilungen der k. und k. Zentralkommission*, new series 14, 1898, pp. 199–202.

17. Ernst Berger, *Fresko- und Sgraffitotechnk nach älteren und neueren Quellen*, Munich, 1909.

18. Thomas Becker, Christoph Herm, Paul Müller, 'Vom Karton zum Wandbild. Ferdinand Hodlers "Rückzug von Marignano," Technologische Untersuchung zum Entstehungsprozess,' in *Zeitschrift für Schweizerische Archäologie und Kunstgeschichte*, 57, pamphlet 3, Zürich, 2000.

19. See Manfred Koller, 'Mittelalterliche Wandmalereien in Österreich–150 Jahre Restaurierung,' in: Matthias Exner, Ursula Schädler-Saub (eds.), *Die Restaurierung der Restaurierung? Zum Umgang mit Wandmalerei und Architekturfassungen des Mittelalters im 19. und 20. Jahrhundert*, ICOMOS Conference, Hildesheim, 2001; Munich, 2002.

20. Ludwig Hevesi, 'Die Sezession und das Riesentor,' in: Ludwig Hevesi, *Acht Jahre Sezession (März 1897–Juni 1905). Kritit –Polemik –Chronik*, Vienna 1906; new edition by Otto Breicha, Klagenfurt, 1986, pp. 361f.

21. For information on the so-called polychromy debate in the nineteenth century, see Patrick Reutersward, *Studien zur Polychromie der Plastik II, Griechenland und Rom*, Stockholm, 1960. For the impact on contemporary sculpture up to Max Klinger, Andreas Blühm and others, see *The Colour of Sculpture 1840–1910*, exh. cat., Van Gogh Museum Amsterdam/Henry Moore Institute Leeds 1996/97, Leeds 1996.

22. Manfred Koller, 'Zur Technikgeschichte der Dekorationsmalerei,' in: *Maltechnik Restauro*, 86, 3, 1984, pp. 18–32.

23. The allegorical, figurative frieze planned by Hansen for the central hall was only completed in 1912 by Eduard Lebietzky. See Eva-Maria Höhle, Manfred Koller, Josef Bartl, Hubert Roithner, Karin Troschke, 'Der Gemäldefries in der Säulenhalle des Parlaments in Wien,' in: *Österr. Zeitschrift für Kunst und Denkmalpflege*, XLIX, 1995, pp. 173–184.

24. *The Colour of Sculpture* (see note 21), ill. 64 (Lawrence Alma-Tadema, *Phidias*

Showing the Frieze of the Parthenon to his Friends, 1868), p. 107 (Max Klinger).

25. Ludwig Hevesi, 'Weiteres vom Haus der Sezession', see note 20, pp. 68–74, here p. 69.

26. P. C. Konody, 'Moira's Reliefmalerei,' in: *Kunst und Kunsthandwerk*, 4, Vienna, 1901, pp. 174ff.; G. C. Williamsen, 'Gerald Moira and his decorative work,' in: *The Artist*, 1902, pp. 267ff.

27. Peter Vergo and others, *Ein moderner Nachmittag. Margaret Macdonald Mackintosh und der Salon Waerndorfer in Wien*, Vienna, 2000.

28. Catalogue 1902, see note 1, p. 18.

29. Ludwig Hevesi, 'Japan in Wien' (see note 20), pp. 216–229.

30. Ludwig Hevesi, see note 20, p. 69.

31. Otto Kapfinger, Adolf Krischanitz, *Die Wiener Sezession. Das Haus: Entstehung, Geschichte, Erneuerung*, Vienna, 1986.

32. Marian Bisanz-Prakken, see note 1, ill. 45; Eduard F. Sekler, *Josef Hoffmann. Das architektonische Werk*, Salzburg, 1982, pp. 58ff., ill. 65.

33. Manfred Koller, 'Die Fassaden der Wiener Hofburg. Erforschung und Restaurierung 1987–1997,' in: *Österr. Zeitschrift für Kunst und Denkmalpflege*, 51, 1997, pp. 494–536, ill. 663. Eduard F. Sekler, see note 32, p. 60, draws attention to the motif of garden architecture (pergola).

34. Andrea Palladio, *I quattro libri dell'architettura ...*, Venice, 1570 (reprint Milan, 1951), book 4: "Tra tutti i colori niuno è, che si convenga più ai tempij, della bianchezza: con cosiache la purità del colore, e della vita sia sommamente grata à Dio."

35. See Manfred Koller, 'Klimts Beethovenfries. Zur Technolgie und Erhaltung,' in: *Klimt-Studien*, 1978/79, Salzburg, pp. 215–240.

36. See Eva-Maria Höhle and others, see note 23, p. 174.

37. Sigrid Eyb-Green, 'Gustav Klimts Karton für das Deckengemälde "Globetheatre" im Wiener Burgtheater 1897,' in: *Restauratorenblätter*, 21/2001.

38. Most recently, Marian Bisanz-Prakken, '"Die fernliegenden Sphären des Allweiblichen." Jan Toroop und Gustav Klimt,' in: *Belvedere. Zeitschrift für bildende Kunst*, 1, 2001, pp. 34–47.

39. Wilhelm Ostwald, *Malerbriefe*, Leipzig, 1904; Wilhelm Ostwald, *Monumentales und dekoratives Pastell*, Leipzig, 1912 (reprint Munich, 1988); Albrecht Pohlmann, Helmut Materna, Wilhelm Ostwald, 'Farbenlehre, Maltechnik, Gemäldeuntersuchung,' in: *Beiträge zur Erhaltung von Kunstwerken*, 8, Restauratoren Fachverband (ed.), Berlin, 1999, pp. 44–60.

40. This technique, commonly used since the Middle Ages, was also employed by Margaret Macdonald Mackintosh to an even greater extent in her frieze for the Salon Waerndorfer in 1906.
See Manfred Koller, 'Zur Technologie der Pastiglia vom 13. bis 20. Jahrhundert,' in: *Restauratorenblätter*, vol. 21, 2000, pp.121–125. Egger/Robertson/Trummer/Vergo, see note 27.

41. Wilhelm Mrazek, *Leopold Forstner–ein Maler und Materialkünstler des Wiener Jugendstils*, Vienna, 1981.

42. Christian M. Nebehay, see note 1, p. 299, note 8.

43. Christian M. Nebehay, see note 1, p. 295, note 3.

44. Theodor Brückler (ed.), *Kunstraub, Kunstbergung und Restitution in Österreich 1938 bis heute*, Vienna, 1999, pp. 224, 252. From the series *Studien zu Denkmalschutz und Denkmalpflege*, vol. XIX.

45. In addition, the official restorer Manfred Koller and the freelance wall-painting restorers August Kicker and Emmerich Mohapp were members of the examination team. A written report was not provided until 1971.

46. Additional information can be found in Manfred Koller, 1984, see note 1; and Koller and Hammer, 'Zu Technik und Restaurierung von Klimts Beethovenfries,' in: *Traum und Wirklichkeit*, exh. cat., Vienna, 1985, pp. 544–557.

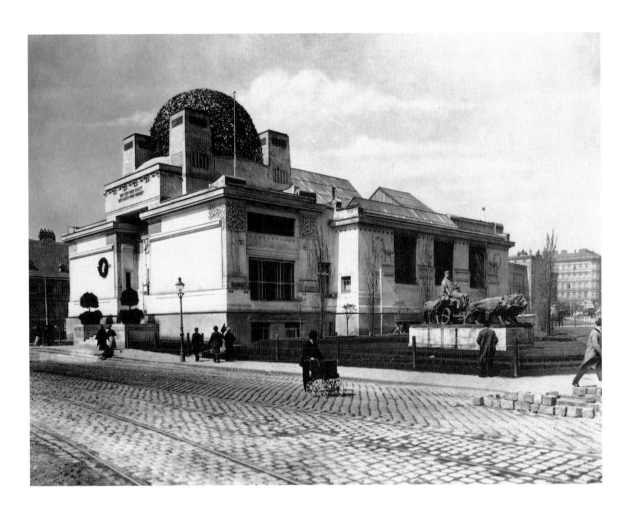

Secession Building (architect Joseph Maria Olbrich, 1897/98)

Photograph *c.* 1900

Verena Perlhefter

Biography

1862

Gustav Klimt is born on 14 July at Linzerstrasse 247 in Vienna, the second child of Ernst and Anna Klimt, to be followed by five more children. His father, who is an engraver by profession, is without an income from 1873 onwards, meaning that the family is very poor.

Gustav Klimt's place of birth, Linzerstrasse 247, 14th district of Vienna, photograph *c.* 1900

1876–1883

After eight years of schooling, Gustav enrols at the Vienna School of Arts and Crafts (now the University of Applied Arts), as do his brothers Ernst (1864–1892) and Georg (1867–1931). As an engraver and sculptor, Georg will later make some of the frames for Gustav's works. Klimt attends a two-year foundation course taught by Michael Rieser, Ludwig Minnigerode and Karl Hrachowina. The painting class he attends later is taught by Ferdinand Laufberger (1829–1881) and, following Laufberger's death, by Julius Victor Berger (1850–1902). Although the Klimt brothers receive stipends enabling them to attend college, the family's financial distress is such that they are under pressure to earn a living as soon as possible. They do this by painting watercolour miniatures based on portrait photographs, and by producing technical drawings for an otologist.

Gustav Klimt, *Allegory of Sculpture*, 1896
Black chalk, graphite and gold leaf, 41.8 x 31.3 cm
Wien Museum, Vienna

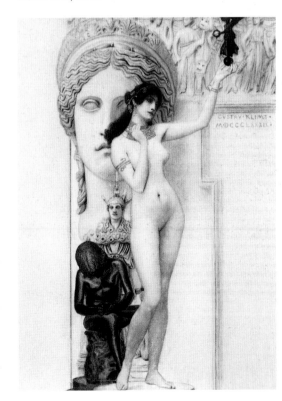

In 1880, the Klimt brothers and fellow student Franz Matsch receive their first commission as decorators: they are to paint murals depicting Poetry, Music, Dance and Theatre at the home of the architect Johann Sturany.

1883–1885

Franz Matsch, Ernst and Gustav Klimt set up in business together as the Künstlercompagnie (Artists' Company) and move into a studio on Sandwirtgasse 8 in the Mariahilf district of Vienna. One of their main sources of work is Fellner & Helmer, a Vienna-based firm of theatre architects for which they paint sets, ceilings, curtains and so on. Between 1872 and 1914, Fellner & Helmer build numerous theatres in Austro-Hungary, Germany, Switzerland and the Balkans.

Franz Matsch, Ernst and Gustav Klimt are also asked to work on a pattern book published by Martin Gerlach called *Allegories and Emblems* (1882–1884).

Gustav Klimt, *Auditorium of the Old Burgtheater*, 1888
Gouache on paper, 82 x 93 cm
Wien Museum, Vienna

1886–1888

The Court Buildings Committee in 1886 awards the Künstlercompagnie its first big contract, which is to decorate the two staircases of the New Burgtheater, designed by Gottfried Semper and Karl Hasenauer, with murals on the history of theatre. At the opening ceremony, the Künstlercompagnie comes in for high praise from no less a person than Emperor Franz Josef I.

In 1887, the City of Vienna commissions two paintings of the Old Burgtheater: while Gustav Klimt paints the view from the stage into the auditorium, Franz Matsch is responsible for the view from the entrance looking towards the stage. The two artists people their paintings with more than two hundred meticulously detailed portraits of well-known members of Viennese society.

1890

Gustav Klimt is awarded the lucrative Emperor's Prize in recognition of his Burgtheater painting, exhibited at the Künstlerhaus.

During the summer, Klimt visits Venice with his brother Ernst and Franz Matsch.

1891

The Künstlercompagnie is awarded the contract for the spandrel and intercolumniation paintings of the Great Staircase in the new Museum of Art History, again designed by Gottfried Semper and Karl Hasenauer. Whereas both Matsch and Ernst Klimt remain committed to the traditional style of painting promoted by the Academy, in the section

devoted to Ancient Greece, Gustav depicts Glykene, lover of the painter Pausias, in modern dress.

Gustav joins the Künstlerhaus (Co-operative Society of Austrian Artist).

1892

The Künstlercompagnie moves into a studio at Josefstädterstrasse 21 in the Josefstadt district of Vienna, in which Klimt will continue to work until 1914.

Klimt's father dies on 13 July, and on 9 December his brother, Ernst. Having assumed the role of guardian to Helene Klimt, Ernst's daughter from his brief marriage to Helene Flöge, Gustav now has to provide not only for his mother and his sisters, but also for his sister-in-law and his niece.

The death of Ernst marks the end of the Künstlercompagnie. Franz Matsch embarks on what is to be a very successful career as a society portrait painter.

Studio in Josefstädterstrasse 21, 8th district of Vienna
Photograph taken between 1910 and 1914

1893

Klimt is awarded the Künstlerhaus silver medal for his painting *The Auditorium of the Theatre in Schloss Eszterhazy*, painted in Hungary earlier that year.

He is among those nominated for a professorship at the special school of history painting at Vienna's Academy of Fine Arts, but in the end is not appointed.

1894

On 4 September, the senate of Vienna University commissions Franz Matsch and Gustav Klimt to decorate the ceiling of the University's ceremonial hall, designed by Heinrich von Ferstel.

1895

Klimt's *Auditorium of the Theatre in Schloss Eszterhazy* wins the Grand Prix in Antwerp. Klimt begins work on the music room of Nikolaus Dumba's house in Vienna.

1896

Klimt is made a member of the board of trustees of the Graphic Arts Society, which one year earlier had commissioned his *The Court Actor Josef Lewinsky as Carlos in 'Clavigo.'*

Gustav Klimt, *Lady at the Fireplace*, c. 1897/98
Oil on canvas, 41 x 67 cm
Österreichische Galerie Belvedere, Vienna

1897

On 3 April, Klimt informs the board of the Künstlerhaus of his intention to found a new association to be headed by himself as chairman and Rudolf von Alt as honorary chairman. The aim of the Vienna Secession, as the new association is called, is to reform artistic practice in Vienna and bring Austrian art into line with international developments. On 24 May, Klimt rejects a motion of censure passed by the Künstlerhaus just a few days previously and tenders his resignation, as do several others like him. The first meeting of the breakaway association takes place on 21 June. Klimt, together with Josef Hoffmann and Carl Moll, will remain responsible for its exhibitions until 1905.

1898

In January, the first number of the Secessionists' magazine, *Ver Sacrum* (Sacred Spring), is published. To facilitate his work on the faculty paintings for the ceremonial hall of the University, Klimt takes on an additional studio at Florianigasse 54 in the Josefstadt district, which he will retain until 1906.

On 26 May, the Education Ministry's fine arts committee denounces as obscene the female figure symbolising Suffering Humanity in the painting for the Faculty of Medicine, and suggests that she be replaced by the figure of a boy.

Klimt becomes a member of the International Association of Painters, Sculptors and Engravers chaired by James Abbott McNeill Whistler.

The second Secessionist exhibition opens on 12 November in the new Secession building designed by Josef Maria Olbrich, the entrance to which bears the Secessionists' guiding maxim: 'For the time, its art. For art, its freedom.'

1899

Included in the fourth Secessionist exhibition from 18 March to 31 May are Klimt's *Nuda Veritas* and *Schubert at the Piano*, a sopraporta (over-door painting) from the music room of the Palais Dumba.

During the spring, Klimt travels to Florence, Genoa, Verona and Venice in the company of Carl Moll and his family.

1900

The sixth Secessionist exhibition from 8 March to 6 June features the first of Klimt's faculty paintings, *Philosophy*. Opinions are divided and the work triggers a heated debate in the press. Among the work's champions is the art critic Ludwig Hevesi, who defends the work in the following terms: "Klimt's *Philosophy* is a great vision, invested with what can indeed be called cosmic fantasy. The chaos out of which philosophy has had to — and must forever — wrest itself is apparent in the entire scene as forever fluid, constantly coalescing and fragmenting life [...] The most diverse blues, purples, greens and greys intermingle, shot through with a shimmering yellow that is intensified even to the point at which it metamorphoses into pure gold. The impression is one of cosmic dust, of swirling atoms and elementary forces that search for things in order to make them palpable. Myriad sparks fly around, each one of them a star — a red, blue, green, orangey yellow, sparkling gold star. But in its entirety the chaos is a symphony whose colours are mixed intuitively by the sensitive soul of the artist."[1]

Writing in *Die Fackel*, meanwhile, Karl Kraus pokes fun at Klimt's work, derisively advising the painter "to have his ideas for *Jurisprudence* and *Medicine* checked in good time by such men as can advise him better than those he turned to this time."[2]

The professor of art history Franz Wickhoff, however, defends *Philosophy* in both a published article and a lecture, asserting that "once his picture for *Medicine* is placed alongside it, the decorative impact of the sea-green shimmer of the first work will make complete sense and no one will omit to commend the artist who has given us such

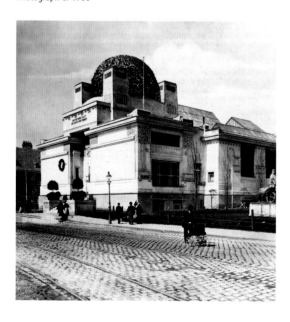

Secession Building (architect Joseph Maria Olbrich, 1897/98)
Photograph *c.* 1900

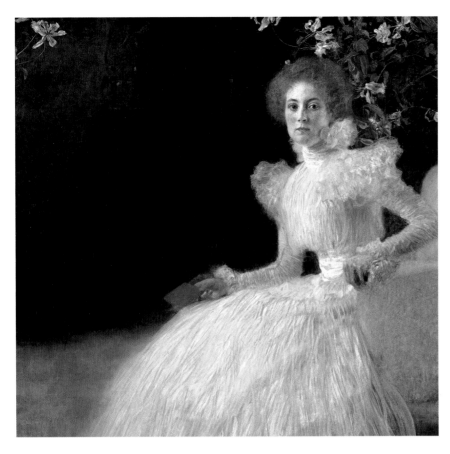

Gustav Klimt, *Portrait of Sonja Knips*, 1898
Oil on canvas, 141 x 141 cm
Österreichische Galerie Belvedere, Vienna

splendid works."[3] No fewer than eighty-seven university professors nevertheless sign a petition protesting against the installation of Klimt's works in the great hall, many of them motivated by their dislike of modern art in general. "The university professors have now taken a stance against Klimt's *Philosophy*," writes one commentator, adding that "the only response that is right in this instance, however, is to stand with one's back to the work."[4]

The board of the Vienna Secession appeals the professors' petition, and on 12 May the ministry's fine arts committee dismisses the petition on the grounds that the petitioners should first wait and see what effect the picture has once installed. Besides, the committee argues, the work's inclusion in the International Fair in Paris would soon give everyone an opportunity to judge it without prejudice on the basis of its artistic merits alone.

At the World Fair in Paris (15 April to 12 November), *Philosophy* wins the gold medal. Two other works by Klimt, namely *Pallas Athene* and *Sonja Knips*, are also exhibited at the fair.

Gustav Klimt in his painting smock, *c.* 1909
Silver bromide print by Pauline Hamilton

1901

The second faculty painting, *Medicine*, is unveiled at the tenth Secessionist exhibition from 15 March to 12 May, and is instantly controversial on account of Klimt's portrayal of a pregnant nude. Hevesi again goes into raptures over the colours: "It is dawn, a reddish tinge on the mist heralds the breath of opening day, and the first sparks of the sun flash over the horizon. But in the midst of this harmony full of tenderness and power a surprising dissonance is heard — the searing blue of the veil flowing down the skeleton of Death. It blows across like a breath, but with all the sharper, bluer accents of edges and rents. And, on the other side of the picture, the blue tone rings out once more, for

Gustav Klimt and Emilie Flöge in a rowing boat in front of the embankment wall of the Villa Paulick on Lake Atter, 1909

Gustav Klimt, *Portrait of Adele Bloch-Bauer I*, 1907
Oil, silver and gold leaf on canvas, 138 x 138 cm
Neue Galerie, New York

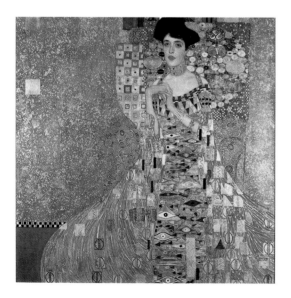

a blue arabesque of this kind also encircles the naked body of an infant floating away from the swarm."[5]

Karl Kraus is customarily derisive and "cannot help but admire the originality of this modern symbolist who, though he has not advanced beyond the depiction of Death as a skeleton, has at least used the time-honoured snake Hygeia as an ornamental — and serpentine — appendage of the Secessionist toilette."[6]

The Imperial Council holds a special meeting concerning the purchase of Klimt's paintings. Not only is Klimt refused a chair at the Academy of Fine Arts, but the public prosecutor calls for the confiscation of an edition of *Ver Sacrum* containing some of the preliminary studies for *Medicine*. The regional court in Vienna dismisses this call on the grounds that the drawings are merely artistic studies of human movement.

The Historical Museum of the City of Vienna purchases Klimt's contributions to *Allegories and Emblems*, while the state of Bavaria purchases the study for *Music I* for the state art collection.

1902

In the eyes of the Secessionists, Max Klinger's sculpture of Beethoven is superior to anything as yet produced by Auguste Rodin. The fourteenth Secessionist exhibition from 16 April to 27 June is therefore devoted to Klinger's sculpture, effectively providing it with a triumphal entry into Vienna. The Secessionists themselves are asked to each contribute one work, free.

Klimt contributes his *Beethoven Frieze*, created specifically with this exhibition in mind. At a meeting of the Herrenhaus, Klimt, the frieze and the Vienna Secession all come in for criticism, and the press is equally damning: "Klimt has once again produced art that could only ever please three people — namely a physician and two attendants."[7] And: "These paintings may be all very well for some subterranean house of pleasure in which pagan orgies are celebrated, but not for such galleries as those to which artists would make so bold as to invite honourable ladies and young girls."[8] And: "Surely we have had enough of this degenerate genius's courtesans, both those that are rickety and consumptive and the plumper, more voluptuous examples."[9]

Klimt's response to these contemptuous reactions is *Goldfish*, a painting that he allegedly wanted to call *To My Critics*, and that is first shown at the thirteenth Secessionist exhibition in February 1902.

On a visit to Vienna in June, Rodin expresses his deep admiration for Klimt's *Beethoven Frieze*, while ignoring Klinger's Beethoven sculpture altogether.

1903

Ferdinand Hodler visits Vienna, where he befriends Klimt and later buys *Judith I*.

May sees Klimt in Venice and Ravenna, cities he returns to in December, when his itinerary also takes in Padua, Florence and Pisa.

In May, Josef Hoffmann, Kolo Moser and Fritz Waerndorfer found the Wiener Werkstätte (Vienna Workshop), in which they exhibit some of Klimt's paintings.

The Education Ministry's fine arts committee views the faculty paintings on 11 November and returns a positive verdict, though it is critical of Matsch's work. Owing to the discrepancy in quality, it suggests exhibiting Klimt's paintings in the Moderne Galerie instead of in the great hall of the University.

From 14 November to 6 January 1904, the Vienna Secession stages a Klimt collective in which all three faculty paintings can for the first time be viewed together. As always, Hevesi is extremely impressed and acknowledges the new style evident in *Jurisprudence*: "A newly fashioned style, after all the painterly orgies of the last decades. A more solemn, more religious approach to form and colour [...] Just look at the two works on either side, *Philosophy* and *Medicine*: a mystic symphony in green and a magnificent overture in red, both of them purely decorative patterns of colour. While in *Jurisprudence*, black and gold dominate, in other words not real colours, but against such a background line acquires a greater significance, and form becomes what one has to call monumental."[10]

Karl Kraus is still unmoved: "Gustav Klimt, having twice employed the brightest of colours in an attempt to disguise the dullness of his ideas, set out to paint Jurisprudence, but in fact symbolised only penal law. The atmosphere is that of a students' prank — a criminal and a polyp-like creature rearing up menacingly are shown together at the bar. [...] Seeing this colour-drunk painter staggering through our modern life, one is either inclined to ridicule or, depending on mood and character, to be moved to pity."[11]

The end of the year sees the publication of the last edition of *Ver Sacrum*.

Gustav Klimt, *Poppy Field*, 1907
Oil on canvas, 110 x 110 cm
Österreichische Galerie Belvedere, Vienna

1904

The Galerie Miethke is taken over by the gold- and silversmith Paul Bacher, with Carl Moll as artistic director; from now on, this is the gallery that will represent Klimt in Vienna.

The only works the Secessionists wish to send to the World Fair in St. Louis are Klimt's *Philosophy* and *Jurisprudence*, together with two landscapes. On 26 January, however, the Education Ministry turns down their proposal and Austria eventually decides not to take part in this international fair at all.

The Belgian industrialist Adolphe Stoclet commissions Josef Hoffmann to build a new mansion in Brussels that he wants decorated with a frieze by Klimt (*Stoclet Frieze*).

Klimt's *Goldfish* and *The Golden Knight* are exhibited at the Great Art Exhibition in Dresden and his *Procession of the Dead* at the first Exhibition of the German Artists' Association in Munich.

1905

On 3 April, Klimt decides to forfeit the fee for the faculty paintings. After an animated exchange of letters and a newspaper interview of Klimt by Berta Zuckerkandl, the ministry on 27 April returns the paintings to Klimt, despite having until then insisted that they were already state property. In this interview, Klimt explains his reasons for taking back the pictures as follows: "The main reasons for my decision to take back the ceiling paintings ordered by the Education Ministry have nothing to do with the dismay

Gustav Klimt, *The Three Ages of Woman*, 1905
Oil on canvas, 173 x 171 cm
Galleria Nazionale d'Arte Moderna, Rome

that various attacks from the most diverse quarters could easily have induced in me [...] I am unaffected by such attacks as a rule, but then all the more sensitive the moment I sense that my patron is dissatisfied with my work, as is the case with the ceiling paintings. The minister's response to every attack has been to insist on a standpoint that barely touches on the artistic factors that are at issue here [...] The ministry has hinted in countless communiqués that I have become an embarrassment for them [...] I want to regain my freedom, away from all these pointless absurdities that hold up my work. I reject all state support, I don't want any of it. But what I've told you here is secondary. The main thing I want to confront is the way art is treated in the Austrian state and at the Ministry of Education. Whenever there's an opportunity, genuine art and genuine artist are under attack. They sponsor only what's feeble and false. [...] I'm not handing over my pictures because I want nothing more to do with clients who have no connection with real art and real artists."[12] On 25 May, Klimt repays the fee he received for this commission.

Klimt's professorship at the Academy of Fine Arts is rejected with final effect.

From 19 to 21 of May, Klimt is in Berlin, where fifteen of his works have been included in an exhibition of the German Artists' Association, among them his *The Three Ages of Woman* and *Hope I*. Klimt, together with Ferdinand Hodler and Ulrich Hübner, is awarded the Villa Romana Prize, but turns it down in favour of Max Kurzweil.

In June 1905, the Klimt group, to which Josef Hoffmann, Otto Wagner and Carl Moll also belong, and which has consistently emphasised the importance of craftsmanship, resigns from the Vienna Secession in protest at the intention of the remaining artists to confine all future exhibitions to pictures only.

1906

On 12 March, Klimt is made an honorary member of the Bavarian Royal Academy of Art in Munich.

In May Klimt visits Brussels and London, where he attends the private viewing of an exhibition involving the Wiener Werkstätte and meets the Scottish artist Charles Rennie Mackintosh.

In December he visits Florence.

1907

Franz Blei's translation of Lucian's *Dialogues of the Courtesans* containing drawings by Klimt is published in the spring.

In February and March, the Galerie Keller und Reiner of Berlin exhibits Klimt's faculty paintings, which, however, are not well received in Germany. Klimt takes part in an exhibition of Viennese art at the Galerie Arnold in Dresden and in the International Art Exhibition in Mannheim.

During the summer, he makes the acquaintance of Egon Schiele, on whose work he will for a long time have a formative influence.

1908

In May and June, Klimt's breakaway group of Secessionists stages its first exclusively Austrian Kunstschau, or art show, the highlight of which are sixteen works by Klimt, including *The Kiss*. Thanks to Klimt's mediation, the show gives Oskar Kokoschka his first chance of exhibiting his works without prior vetting by a jury. The Education Ministry buys Klimt's *The Kiss* for the Moderne Galerie, while in early July, Vienna's Historical Museum buys his *Portrait of Emilie Flöge*.

In spring, a number of Klimt's works, including his *Jurisprudence*, go on show in Prague.

The Galerie Miethke publishes *The Works of Gustav Klimt*, for which Klimt himself designs a different emblem for each plate.

Emilie Flöge in her Viennese fashion salon, 1910
Photograph by Madame d'Ora

1909

The second Kunstschau in July is devoted to contemporary European painting and includes Klimt's *Hope I* and *Hope II*, as well as one entire room containing works by Kokoschka. Egon Schiele also has a room of his own, the five portraits exhibited there marking his breakthrough as an artist.

Klimt takes part in the tenth International Art Exhibition in Munich and the eighteenth exhibition of the Berlin Secession.

In October, he travels to Paris and from there to Madrid, where he studies works by Velázquez and El Greco.

1910

Klimt takes part in the ninth Venice Biennale from 23 April to 31 October. The Venetian Galleria Internazionale d'Arte Moderna buys his *Judith I*.

He also takes part in an exhibition by the German Artists' Association in Prague and in the Berlin Secession's Graphic Arts exhibition.

The National Gallery in Prague buys his *Farm Garden with Sunflowers* and *Schloss Kammer on Lake Atter*.

1911

Klimt visits London and Brussels, where work on the *Stoclet Frieze* is nearing completion.

In March he is in Rome, where at the International Art Show he wins first prize for his painting *Death and Life*.

1912

Klimt takes part in the Great Art Exhibition in Dresden, whereupon the Moderne Galerie Dresden buys his *Beech Forest I*.

He becomes chairman of the Austrian Artists' Union.

1913

Klimt sends ten paintings and ten drawings to an exhibition organised by the Austrian Artists' Union in Budapest. He also takes part in the ninth International Art Exhibition in Munich and the third Exhibition of the German Artists' Association in Mannheim.

Gustav Klimt, *c.* 1910, photograph by Moriz Nähr

Gustav Klimt in the garden of his studio,
Josefstädterstrasse 21, *c.* 1910
Photograph by Moriz Nähr

1914

Klimt moves into his last studio, at Feldmühlgasse 11 in Hietzing.

He takes part in an exhibition of the German Artists' Association in Prague. The National Gallery in Prague buys his *Virgin*, while from February to June his *Portrait of Mäda Primavesi* goes on show at the second Secession in Rome.

By May, Klimt is back in Brussels, where he is fascinated by the sculptures on show in the Musée du Congo Belge.

1915

Klimt's mother dies on 6 February.

Three of his paintings and twenty-two of his drawings are included in an exhibition called *Viennese Artists* at the Kunsthaus Zürich from 4 to 22 August. Together with Schiele and Kokoschka, Klimt also takes part in an exhibition by the Austrian Artists' Union in Berlin.

1916

On 25 May, Klimt is made a member of the Saxon Academy of Fine Arts in Dresden.

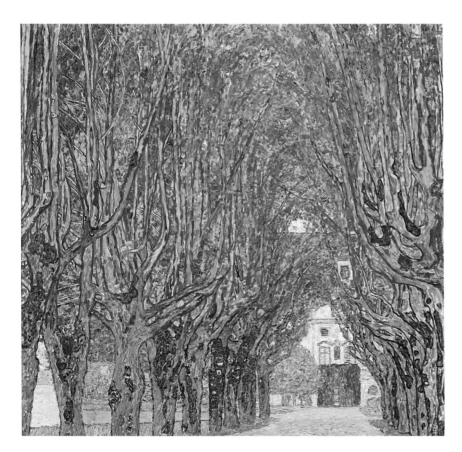

Gustav Klimt, *Avenue at
Schloss Kammer,* 1912
Oil on canvas, 110 x 110 cm
Österreichische Galerie Belvedere, Vienna

Ante-room of Klimt's studio at Feldmühlgasse 11
Photograph by Moriz Nähr, 1914

1917

Klimt submits thirteen paintings and twenty drawings to the Österrikiska Konstutställ-ningen in Stockholm.

On 26 October he is made an honorary member of Vienna's Academy of Fine Arts.

1918

On 11 January, while at home at Westbahnstrasse 36 in the Neubau district of Vienna, Klimt suffers a stroke that leaves him paralysed down one side. He dies 6 February and three days later is interred in Hietzing Cemetery.

Gustav Klimt, *Litzlberg on Lake Atter*, c. 1910–1912
Oil on canvas, 110 x 110 cm
Museum der Moderne Rupertinum, Salzburg

1. Ludwig Hevesi, *Acht Jahre Secession (März 1897–Juni 1905). Kritit –Polemik –Chronik*, Vienna, 1906, pp. 233f.
2. *Die Fackel*, no. 36, Vienna, March 1900.
3. Franz Wickhoff, 'Was ist häßlich?' *Fremdenblatt*, Vienna, 15 May 1900.
4. 28 March 1900, quoted without further details by Christian M. Nebehay, *Gustav Klimt. Dokumentation*, Vienna, 1969, p. 227.
5. Hevesi, see note 1, pp. 317f.
6. *Die Fackel*, no. 73, Vienna, April 1901.
7. Dr Robert Hirschfeld, quoted by Nebehay, see note 4, p. 297.
8. S.G., quoted by Nebehay, see note 4, p. 297.
9. *Salzburger Volksblatt*, quoted by Nebehay, see note 4, p. 297.
10. Hevesi, see note 1, pp. 444ff.
11. *Die Fackel*, Vienna, 21 November 1903.
12. Berta Zuckerkandl, *Zeitkunst, Wien 1901–1907*, Vienna, 1908, pp. 163ff.

Gustav Klimt, *Portrait of Ria Munk*, 1917/18
Oil on canvas, 180 x 90 cm
Lentos Kunstmuseum Linz

Egon Schiele, *Gustav Klimt on his Deathbed*, 1918
Black chalk on paper, 47.3 x 30.5 cm
Private collection

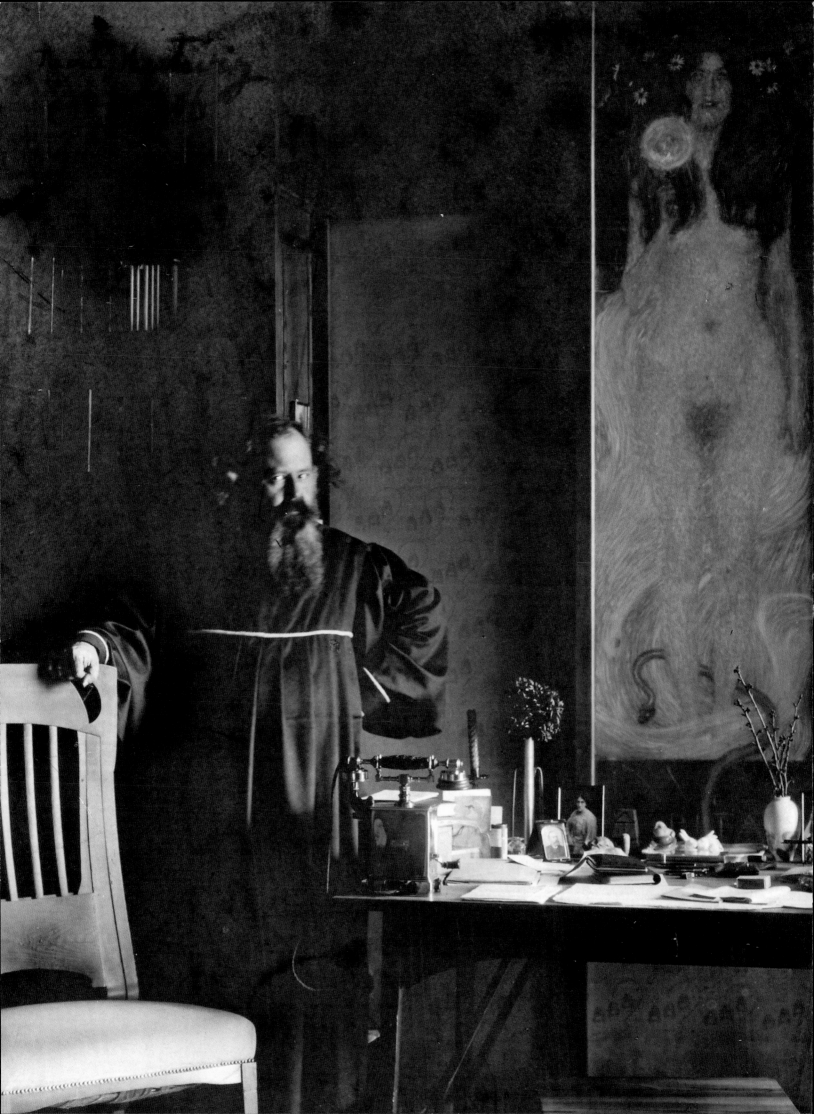

The Klimt controversy in contemporary documents

Gustav Klimt

What I am and what I am not.

On a non-existent self-portrait*

I can paint and draw. I myself believe that, and some others say they believe it too. But I'm not sure if it's true. Only two things are certain:

1. There is no self-portrait of me. I'm not interested in myself as the 'subject of a picture,' more so in other people, especially women, but still more in other phenomena. I'm not sure I'm very interesting as a person. There isn't anything particularly special about me, anyhow. I'm a painter who paints from morning till night, day after day. Figurative pictures and landscapes, portraits more rarely.

2. I have no gift for either speech or the written word, especially when I'm supposed to say something about myself or my work. Even if I have to write a simple letter, I get anxious and upset as if I were feeling seasick. That's why people will have to do without an artistic or literary self-portrait. Which is no matter for regret. Anyone wanting to know something about me — as an artist, which is the only noteworthy thing — should look closely at my pictures and make out from them what I am and what I want to do.

* Original manuscript in the possession of the Wienbibliothek im Rathaus, formerly in Wiener Stadt- und Landesbibliothek.

Hermann Bahr

Speech on Klimt*

Ladies and gentlemen:

[...] Let me first explain the situation. There's a young artist who quickly makes a name for himself, gains the respect of artists, experts and the public, and wins commissions (for example, for the new Burgtheater, and the museums), and so is on his way, as they say, to 'making it.' A wonderful future awaits him. In a few years he will be a professor — and then he can retire.

But that doesn't appeal to him. He is discontent. He feels he's capable of more. He feels that so far he has never been himself, that he has always been painting in a foreign language, as it were. He's no longer willing to accept that. Now he understands the one thing that can make an artist — the strength to show his own, unique inner world, the one which never existed before him and will never exist again. That's what he wants — he wants to be his own

Hermann Bahr in the study of his villa in Ober Sankt Veit c. 1905. On the wall next to him, *Nuda Veritas* by Gustav Klimt

man. He goes through an deep crisis until eventually he has purged everything alien, acquired all the resources he needs to express himself, and finally becomes the artist he is. We greet the signs of it with delight — the Schubert picture, *Truth*, the landscapes — and please note admiringly how he is continually striving for freedom, for great things. Finally he is right up there — and gives us *Philosophy*. Of course, he is not understood at first. We are not surprised by that — but 'they' will be duly won over, just as they were won over to Böcklin and Richard Wagner, whom they did not understand at first either. They just need time. Then something unexpected happens — not just that he is not understood. No, the non-comprehending, Folly, takes to the street and rants and stirs things up against him, and the crudest forms of political agitation are turned on him — an artist! He is denounced, suspected and personally slandered, and every base instinct is stirred up against him. He has only one answer to that — he sends the picture to Paris, where it wins the highest honour for our country that the artists of Europe have to award. And meantime he has already sat down to begin his new picture, *Medicine*. We're all a bit worried about it, though: Will he keep it up? Will it be as good? But it is not only as good — it surpasses it. *Medicine* is still greater, still purer, still freer. And what happens? The same hounding begins, only more violent, still wilder, even more infamous.

So far there has been nothing about the case that is not in fact quite routine. It's a typical case that is repeated time and again when a great artist appears. He is initially not understood by the multitude. For the life of them, they cannot help being unjust to him due to their inferior nature. He blinds, disconcerts and confuses them. You cannot look straight at the sun. They turn away. Those are the artist's decent opponents. But there are others. [...] Schopenhauer describes them superbly — but you need to hear it in his own words. I have brought the text with me, because it really seem specially written for us only yesterday, pro the Secession and contra its enemies. "Nothing less than lack of judgment," he says, "stands in the way of the fame of the highest merit but envy. Envy is in fact the soul of the omnipresent, tacit, spontaneous alliance of all mediocre people against outstanding individuals in every field. Thus, immediately an eminent talent shows up in any discipline, all the mediocrities in the subject hastily endeavour to bury it, remove any opportunity for it to become known and in every way prevent it from showing itself and coming to light; just as if it were high treason against their incompetence, dullness and crudeness."

No, I must confess, I found all that quite normal. It would of course be nice if people were different, but that's how they are. I'm not surprised that people rush out into public places, into the street, and adopt the crude tone of politics in their debate. That had to happen, it's a part of our entire development that no one has ever seriously resisted! But that no one seriously resists the mob shooting its mouth off here, that educated people are intimidated into crawling away, is what I don't understand. [...] Thousands and thousands of people among us think as I do, and feel the same as I do in this matter. But it has become the custom among us for educated people to say nothing. Educated people regret the situation, but say nothing. Educated people are sorry about it, but say nothing. Educated people cringe, but say nothing. Educated people 'don't get involved.' Initially, that's probably due to petty for being stronger for us than the general interest. Everyone is annoyed by someone else and wants to do him down; no one thinks of the whole. Last year, when there was uproar because of *Philosophy*, I said to friends at the Secession on the first day: "I'm willing to bet, Weyr will come to you tomorrow — he was president of the Genossenschaft at the time — and he will declare we're opponents, we think you're heading in the wrong direction, we're fighting you — but this is not about a style or school or a view of art, this is about art itself, art is threatened. It could happen to any one of us tomorrow, it concerns everyone — here's my hand, we're behind you!" But it's just as well I didn't bet. He didn't come. The rancour against the individual was once again stronger than the feeling for the whole. And then we have to take into account how very 'distinguished' and 'superior' our educated people are — much too 'distinguished' and much too 'superior' ever to get mixed up in a dispute about such old and long-established truths. 'Really, that all goes without saying,' they declare superciliously. 'That's really all

too absurd even to refute.' Yes, but what are educated people for, with their superior education? When experience shows nothing goes without saying any more and nothing is too absurd any more? [...]

No state or nation can exist if it lacks the necessary hierarchy of education. Thinkers and artists are only one part of culture. They create. But educated people have to take care of the other part. It is up to them to spread what has been created in the way of thoughts or emotions and make them effective and fruitful among the populace. If this mediating activity by educated people is lacking, the artists and thinkers work in a void, and then — what would happen then if our artists discover one day that they are wasting their efforts here, and that the necessary conditions for art and culture are absent? [...]

None of them need to stay here. None of them are materially tied down here by their interest. All of them could go tomorrow, and there would be nothing more pleasing to the young Grand Duke of Hessen, whose ambition is to make his little Darmstadt the Athens of modernism. If they nonetheless stay, that will only happen from a very rigorous sense of duty and a very high, very fine kind of patriotism. But the moment they realise it is being made effectively impossible for them to be artists because that mediating activity by the educated is absent, this sense of duty would have no meaning any more. Then they have the right to leave and look for a better county. [...]

And the conclusion? You may draw your own conclusions. My view is that anyone who says nothing about such attacks on art makes himself an accomplice in them. My view is that the mob of mediocrities would never have become so despicable here if educated people had not been so cowardly. My view is that, if there is to be freedom for art and protection for artists, every single person has the obligation to stand up and be counted. I've now done that. Now it's your turn!

<div align="right">(1901)</div>

* Hermann Bahr, *Rede auf Klimt*, Vienna, 1901, pp. 79–84.

The controversy over *Philosophy*

Ludwig Hevesi

The iconoclasts of Vienna*

Ah, the iconoclasts of Vienna! At the very beginning of the twentieth century it has become possible for professors at the University of Vienna to retard their thoughts by a millennium and mob a picture formally commissioned from one of Vienna's leading artists for the ceiling of their university's main hall. They can't bear Gustav Klimt's *Philosophy*, they couldn't possibly sit beneath it, and some of them are convinced that their green baize would blush bright scarlet at it. [...] The picture doesn't sit comfortably with the Renaissance-style building by Ferstel, they say. All these excellent surgeons, gynaecologists, philosophers, theologians, astronomers and whatever suddenly feel a new common vocation calling them: they have to protect the Viennese Renaissance Revival building from being stylistically impaired by Secessionist painting. [...]

If the Künstlergenossenschaft or Secession wanted to interfere in the work of the astronomers or anatomists, they would be well and truly trumped and told to crawl back to the mire of their dark ignorance. But it's fine the

other way round; art still isn't considered a real 'subject,' even by these academic experts, but simply as a fit diversion for any old dilettante. Everyone thinks he knows something about art — after all, he 'knows what a person looks like,' or a tree or the sea. And everyone's seen allegorical ceiling paintings, and so knows how anything like that 'ought' to look. All these scholars who keep up to the minute with the state of knowledge in their own subjects, and don't miss even the slightest advance in scholarship, are totally oblivious of the immense changes that have taken place in art. [...]

I discussed Klimt's picture in detail here around a fortnight ago and paid tribute to its total significance. I shall therefore mention only briefly that it depicts a cosmic fantasy. The sombreness of space, resplendent in all shades of blue and violet, is shot through with sparkling stars of every colour. Half visible in a green cloud is a dark sphinx, and floating past it is a long train of human figures, at all stages of life, from child to dotard, as a symbol of genesis, growth and passing away. And below, at the side, we see a bright head staring ahead with wide-open eyes. That is Philosophy, whose vision comes from space. One of the learned gentlemen complained in an interview that Klimt depicted Philosophy as "a nebulous fantasy entity, an enigmatic sphinx," whereas Philosophy these days endeavours to be "precise." Obviously he did not look at the picture closely enough, because Philosophy is rendered as a bright, luminous head. It is only the processes in the cosmos that are nebulous and fantastic. And that is what, in fact, they are. Indeed, all the signatories of the protest taken together can no more explain them than the unscholarly painter. That's why there wouldn't have been any point in the artist soliciting the various faculties beforehand, as the academic suggested. The painter's job is to paint something painterly, not scholarly. [...]

Everyone claims to be on the side of the Secession, of modern art, and of free art. They detest any 'restriction on art, by whatever side.' But, apparently, art must be allowed to be limited by their side. And it should be modern — but also the same as they've been used to all their lives. And it should be free — but with the 'freedom I'm thinking of,' in other words it can be told what's what and will adapt obediently to the taste of Professor X and the habits of Professor Y. Where does all this leave the Secession, whose principal motif is 'artists' art, not the general public's art'? The really remarkable thing is how little these learned gentlemen know about the nature of the new art.

(30 March 1900)

* Ludwig Hevesi, *Acht Jahre Secession (März 1897–Juni 1905). Kritik–Polemik–Chronik,* Vienna, 1906, pp. 250–254.

Hermann Bahr

Contra Klimt (*Philosophy*)*

Vienna, March 1900
The Difficulty of Solving the Riddle of the Universe

Though there may be many really good pictures to be seen at the Secession Exhibition, works that display the same artistic merit as the best items in the Co-operative Exhibition open at the same time, one eventually comes to the conclusion that the bizarre creations on show presumably owe their genesis solely to the effervescent humour of a number of artists. Convincing proof thereof is the large allegorical wall painting by Gustav Klimt called *Philosophy*. This painter in particular, long reckoned one of the most brilliant of today's rising stars, shows us in a

number of smaller works in a room alongside what he is capable of when he wants to be taken seriously. *Philosophy*, however, he approached simply in jocular vein, decidedly the most sensible thing to be done with it. Depicted in the sprawling painting we see primeval matter, how it coagulates as a result a mysterious force and adopts the shape of a blurred countenance. That is the riddle of the universe. The disastrous effect of taxing your brains with this riddle too long is shown in a group of figures on the left. A naked old codger stands there at his wits' end and buries his face in his hands with an expression of profound regret, obviously at having fouled up his life with a chair of Philosophy. Perhaps the distressing lack of clothing also hints that in the end this sad old fogey was given a cold douche to treat his chronic philosophising. We also see a young lady, whose pleasant exterior shows us more welcome barenesses than those of the old gent, also hiding her face. Clearly this young miss is ashamed and annoyed at having read Schopenhauer, particularly the nasty things that that unchivalrous philosopher says about the fair sex. However, a third unclothed girl has come to a thoroughly sensble decision. She prinks her hair with a look at the riddle that obviously says, "What do I care about it? If you've got looks, then the whole world's yours for the taking, or half of it anyway." This behaviour prompts a doting father who fears his little boy could be corrupted by such feckless company to take to his heels with his child in his arms. If we also mention that a choleric figure that can't be identified more closely is more or less lashing the world with its strawberry blond hair, no doubt in a strop at not being able to solve the riddle, we have just about exhausted the witty contents of the picture. Oh yes, on the extreme right a newborn babe can be seen and at the bottom edge a glaringly lit head called 'Knowledge.' As such, we hope it will know what the poor abandoned waif above is all about. That will set our minds at rest as we say goodbye to the picture, because it's more than we do.

Ed. Pötzl

Vienna, 28 March 1900

We can't call this a work of art

[...] Professor Jodl expressed his views on this matter to our reporter in the following terms: "I don't think this picture is suitable for hanging in the University. I think it's just a bad picture. For us, it's not at all about ignoring the mood of the times. The painting would have to be an ornament to the university for the long term. The consensus of opinion is that the style and attitude of the picture do not consort well with the style of the hall where it is supposed to hang. As is clearly shown by the list of names of eminent people who have signed, and who belong to various parties and opinions though united in voicing opposition to the picture, it is purely artistic and aesthetic considerations that are being expressed. They relate principally to the artistic merit of the picture. It's not in the least about the kind of thing described in the *Lex Heinze*. We are contesting not the nudity in the picture but its ugliness. We are also of the view that the obscure, unclear symbolism of the picture, which is and could only ever be understood by a small minority, is contrary to the true purpose of the painting. It's true that the ceiling of the hall is crying out for decoration. But why has this job been entrusted specifically to Klimt, who has hitherto not distinguished himself with large monumental works, whereas there are many artists in Vienna who could have come up with a much more estimable picture? If the state wants to buy pictures of this sort, there are plenty of museums where they can offload examples of the remarkable development of art at the beginning of the twentieth century. But the university is not a suitable place for the picture. We are fighting not nudity nor free art, but ugly art." [...]

"Our action," said Professor Exner, "is not directed against the Secession at all, or against the modern art movement. We can admire even Klimt as an artist, but we can't call this picture a work of art. We do not consider this kind of symbolic representation artistic, regardless of the fact that the picture does not even suit the architectural character of the University building."

<div align="right">Neue Freie Presse</div>

Vienna, 30 March 1900
The Professors' Defence

[...] On 24 March, a private communication was sent out by us and eight colleagues (Chrobak, Gussenbauer, Lieben, Lammasch, v. Lang, Neumann, Toldt and Weiss), the initial purpose being merely to invite our other colleagues to look at and assess the picture. Through a regrettable indiscretion, this circular was made public in distorted form and so became the subject of premature debate by a section of the press. Before our precise reasons had been made known, assertions of the most extraordinary nature were imputed to us by those whose intentions we will refrain from explaining. We have been accused of wanting to stage a coup against the freedom of art, so that the whole vocabulary with which the Lex Heinze was challenged in recent weeks was used against us a second time in the wrong place.

We trust that no one who is not a complete stranger to the nature and objectives of university teaching will seriously entertain the notion that representatives of academic freedom could ever intend a curtailment of the freedom of art in any form. But as with the freedom of art, we wish to safeguard the freedom to criticise as well, and consider those who want to deprive our artists of the benefits of honest criticism to be dubious defenders of the freedom of art. The claim that works of art can only be judged by artists is questionable, not only because those who propose it would like to restrict the term artist to adherents of a particular movement, but mainly because art that wishes to be understood and admired only by artists would exclude itself from gracing all rooms intended for those who are not artists.

It has also been imputed to the signatories of the petition that the protest against the Klimt picture is directed against modernism and the Secession. In a Vienna cleft by party factions, art, unfortunately, is also treated by many as a partisan issue. If some feel obliged out of ignorant naivety to think everything new is good, it is the habit of others to declare everything traditional sacrosanct. The name Secession or Künstlergenossenschaft becomes a kind of rubber stamp that grants individual work the mark of approval by the relevant group of 'artistic experts.' It then appears to be a duty of solidarity to regard criticism of an individual picture as an attack on the group of artists concerned, on the whole movement, or even on art itself.

Nothing is further from our thoughts than intervening in such factional disputes, of course. The struggle between different artistic outlooks is not settled by declarations and counter-declarations. We have no occasion to allow ourselves to be bounced towards one side or the other by the bullying of party phrases. Our sole concern is a single picture and the issue of whether the artist has or has not carried out in a satisfactory fashion the task assigned to him. We have no general verdict to give on the style of art the picture is attributed to, nor do we wish to touch on Klimt's total *œuvre* or artistic personality.

Among the signatories of the petition there are equally representatives of conservative art outlooks as well as adherents of movements that several years ago led to the very establishment of the Secession. But precisely because, though starting from different theoretical standpoints, we have come together in the practical assessment

of an individual case, we believe we have found a warranty that our judgment has not been unilaterally influenced by love or hatred of this or that specific art movement. [...]

The fact that seventy supporting declarations for the intended petition were forthcoming within a few days has confirmed our expectation that a large number of our colleagues do not share the view that the matter should simply be ignored. [...]

Dr Franz Wickhoff, Professor of Art History at the University of Vienna, has sent the Rector, Dr Wilhelm Neumann, a sharply worded telegram disapproving of the agitation against Klimt's picture and holding the Rector personally responsible for it.

Neue Freie Presse

* Herman Bahr, *Gegen Klimt*, Leipzig/Vienna 1903, pp. 15f., 22–27.

The controversy over *Medicine*

Ludwig Hevesi

Secession: New paintings by Klimt*

[...] *Hygeia* is one of the most terrific things in modern decorative painting. And the most original. The idea, vision and painterly design are thoroughly Klimt. No borrowing or stylistic dependence spoils the impression that we are seeing a youthful creative force gaining free momentum upwards as God builds up its wings and it is summoned by stars that we cannot see, but that it alone senses overhead.

The scene is intended as a continuation of *Philosophy*, which it will be separated from by rather more than the width of a picture. That pale stream of human figures reminiscent of the Milky Way in a dark firmament continues here as a throng of humanity in all conceivable forms. A tangle of life and death, suffering and pleasure, of struggling, longing, hoping and despairing gestures. From the infant to the old man, from love and fertility to drying up and withering, all humanity like a cloud of figures rushing along, all with their eyes closed towards an uncertain fate. And in the midst of them, tall and erect, is pale, bony Death. He is carried along with them, unavoidable, inescapable, surrounded by all his horrors, by disease, ugliness and want. But even in this desolation of Death there shines a star of consolation. Just as the gleaming head of Philosophy rose from the depths of infinity in the first painting, so the shining figure of Hygeia rears from the twilight of the abyss. A lofty, grave head crowned with laurels of gold, sublime peace in her features, the consciousness of miraculous power. A gold-embroidered crimson robe descends in long folds around her (still incomplete) half-length figure, her neck and arms decorated with golden jewellery. Around her right arm curls the golden snake of Asclepius, inclining its head in a great arc towards the wonder-working bowl offered to it by the left hand of the goddess.

Klimt's decorative concept for the ceiling of the hall is becoming steadily clearer. [...] Whereas in *Philosophy*, green and blue tones formed a cooler harmony, here a complementary warmer coloration rings out, ranging from pink to bright, blazoning crimson. The human bodies run through the whole symphony of flesh

tones with the subtlest of nuances and an infinity of contrasts and highlights. The aerial dimension where all the action is taking place follows suit. It is dawn, a reddish tinge on the mist heralds the breath of opening day, and the first sparks of the sun flash over the horizon. But in the midst of this harmony full of tenderness and power a surprising dissonance is heard — the searing blue of the veil flowing down the skeleton of Death. It blows across like a breath, but with all the sharper, bluer accents of edges and rents. And, on the other side of the picture, the blue tone rings out once more, for a blue arabesque of this kind also encircles the naked body of an infant floating away from the swarm. He is not alone. Over him circles a splendid female figure in all the opulence of her female charm, a relaxed, sweeping shape of the utmost melodiousness. With one arm she holds up her golden brown hair that streams around her head in a great line, while the other arm she stretches out towards the jostling throng, which almost touches her. As she does this, the arm cuts through a stream of cold white misty light that pours through the scene from above. And this strip of light is crossed by another arm below, a darker one belonging to one of the colossal male figures with his back to us. It is actually impossible to describe the decorative effect of this vertical white column of light, crossed by the two arms and bordered in between by other dark profiles. That is an invention such as only a painter of great genius could devise. [...]

And yet it is all only a vision. As in *Philosophy*, this is not a mere collection of humanity but an individual etherisation of the physical. One can feel its breath and pulse. But it is also something else, an eidolon, an allegory of life. The modern painting technique that does not lay down fixed, glazed surfaces, but allows forms to grow out of a *fouetté* of individual brushstrokes and dabs, proves itself brilliantly here. At the height the ceiling picture will be seen at, it will inevitably form an entirely airy, freely pulsing mass of colour.

(16 March 1901)

* Ludwig Hevesi, *Acht Jahre Secession (März 1897–Juni 1905). Kritik–Polemik–Chronik*, Vienna, 1906, pp. 316–319.

Hermann Bahr

Contra Klimt (*Medicine*)*

Vienna, 29 March 1901
'Freedom of Art' — The Easy Excuse

Klimt's *Medicine* is a very bitter brew, though it may taste sweet to those incurably ill with Secessionism. Others don't like it much, or don't enjoy it at all. We are among the latter. *Medicine* is actually no more than an translation of *Philosophy* into other keys. The basic tonality of *Philosophy* is blue, that of *Medicine* violet with a touch of pink. A clump of humanity floating on the left, one floating on the right; over there, the head of the lady personifying Philosophy appears upper centre; over here, Lady Medicine emerges almost full figure, though her facial features and hair-do proclaim a close relationship with her colleague. We won't go into the details of the work because it's not worth the trouble. We don't take the picture seriously, nor the defence of it by literary Secessionists. Many of them come up with the silliest reasons to 'retrieve the picture's honour.' Somewhere it says, for example, in a roundabout way, that one must not condemn the work as it was carried out as a commissioned work after the sketch had been approved. Others come up with the ridiculous old chestnut that people are offended by the nudities in the picture — certainly the most serious charge, for the poor in spirit. Prudery in art has long been

a thing of the past, but there is however a 'thus far and no further.' Klimt's boldness in depicting the absolutely human goes beyond all limits. He dares to depict things as no one has ever done before, and we are convinced he would venture even further except he would thereby come into conflict with a certain article of the law. In the case of such heinous artistic deeds, the 'modernists' — writers as well as artists — have the easy excuse of 'the freedom of art.' They think they can indulge in all possible sins under this euphemistic disguise, and drivel on in a tone of utter conviction that they are only guided by the gravity of the matter, while the main reason lies in the satisfaction of their own pleasure in the rendering of risqué subjects. They then think up new forms of expression in language or painting techniques, the more outrageous and exaggerated the better, and throw sand in the eyes of a gullible public. Unfortunately, many people allow themselves to be blinded thereby, without seeing through the humbug being carried on in the holy name of 'art.' Klimt failed to solve his tasks of rendering Philosophy and Medicine in visual terms satisfactorily. In departing from traditional forms of allegory as a 'new man,' he set off down the road of incomprehensibility. But nothing is worse for a work of art than not being understood by the general public.

Karl Schreder

* Hermann Bahr, *Gegen Klimt*, Leipzig/Vienna 1903, pp. 56f.

The controversy over *Jurisprudence*

Ludwig Hevesi

Secession: On the Klimt exhibition[*]

I first saw *Jurisprudence* in the dog days. In the master's larger studio way out in Josefstadt, on the very top floor of Schmidt's Furniture Factory. An iron door led up, with the letters *G. K.* written on it and a notice saying *Knock loudly*. I hammered with my fist loud enough to awaken the dead, but the master was very much alive and immediately at the door. [...] Never was the painter more fantastic and at the same time truer-to-life. How often he has portrayed the poor sinner who appears as the accused in *Jurisprudence*. That emaciated, naked old man with the sunken head, bowed back and convulsively twisted bundles of muscles. He stood there with the most *perdu* of *profils perdus*, already branded thereby as a condemned man beyond saving. [...]

The day before yesterday I saw *Jurisprudence* again. It was, as a friend remarked to me, Friday 13 November, and the weather to go with it. A day of mega-atmosphere. Foggy rain fell slowly and steadily on a dark, damp city. There was profound gloom in every parlour. And I only got to Klimt and the Secession at three p.m. He was still painting; hope of his finishing his painting had been abandoned. I glanced at it in the chancel-like twilight in which golden objects sparkled at me appealingly. All the colours could be seen in their full richness, every one of them, and I could still make out objects and their parts. But a veil of evening air hung over them, and the gold glistened that much more goldenly. And then I suddenly realised something, with Klimtish suddenness.

I'd returned from Sicily only four days earlier. I was still reeling from the sensations one brings back from seeing the mosaics in the Cappella Palatina and King Roger's chamber, in Monreale and Cefalú. [...] That's the old gold-

background world of the Middle Ages, the world of glistening and gleaming, and poured over it was the gilded smile of the mystic rose. When I was standing beneath the gleaming vaults of the Palatina, I sensed the time-encrusted gold lustre from all the Arabian honeycomb cells in the vaulting trickling down on my head like 'chlorine-coloured' honey or scented chrism. Beneath these noble stone canopies resides the headiness of a dream of a fairy-tale world of jewels, where precious and holy mean the same thing. [...]

That is what suddenly occurred to me as I stood in front of Klimt's picture in the twilight. It shone at me out of its gold, and whispered to me from the gestures in which passionate forces swell or slumber. That is what lies, quite unknown to him, in his *Jurisprudence*. A newly fashioned style, after all the painterly orgies of the last decades. A more solemn, more religious form and colour, a liturgical art, as if a purer faith had overcome a variegated, vital paganism once more. Just look at the two works on either side, *Philosophy* and *Medicine*: a mystic symphony in green and a magnificent overture in red, both of them purely decorative patterns of colour. While in *Jurisprudence* black and gold dominate, in other words not real colours, but against such a background line acquires a greater significance, and form becomes what one has to call monumental.

(15 November 1903)

* Ludwig Hevesi, *Acht Jahre Secession (März 1897–Juni 1905). Kritik–Polemik–Chronik*, Vienna, 1906, pp. 444–448.

Karl Kraus

On *Jurisprudence**

Gustav Klimt, having twice employed the brightest of colours in an attempt to disguise the dullness of his ideas, set out to paint Jurisprudence, but in fact symbolised only penal law. The atmosphere is that of a students' prank — a criminal and a polyp-like creature rearing up menacingly are shown together at the bar. Tipsy academics sentenced to a fine of ten crowns if they call a policeman a 'polyp' will envy of Mr Klimt's impunity after having painted this insult to the constabulary. Under the powerful impact of the colours, they will enjoy the joke made by this artist who has put the harmony of the colours black-red-gold, which is usually so strongly disapproved of by the authorities, to such good use in this painting of Jurisprudence, which was commissioned by the Ministry of Education. However, should serious men make jokes when an exceedingly talented colourist, who has been elevated to the level of a Titan of modern thought by a group of literary parasites, scoffs at the warning "Paint, painter, don't get smart!" until he collapses miserably under the limitations of a talent which, when observing life, is only capable of extracting ever-new nuances of colour?

At the opening of the twentieth century, there is no symbol which can provide a thinking person with a richer field of associations than jurisprudence. Omnipresent in all political, social and economic struggles, arbitrating between those in power and those who want to seize power, between the noble and the lowly, the rich and the poor, man and woman, capital and labour, production and consumption — jurisprudence is all of this to us, and even more: wherever two of you come together, it will call out to you: I am among you!

However, for Mr Klimt the notion of jurisprudence is limited to crime and punishment, the administration of justice merely a matter of 'Derwischen und Abkragln' (Viennese for 'catch'em and wring their necks'), and he presents the warning picture of the criminal to those happy if they 'can avoid having anything to do with the courts, no matter what.' Not even the intellectual world of those whose horizons are defined by the crime stories in the

Extrablatt newspaper should be so narrow-minded at a time when that branch of jurisprudence we call the administration of law is becoming increasingly restricted; at a time when it is becoming clear that future generations might well disavow the mystical concept of punishment, and that a the theory of deterrence could become united with the theory of advancement, and the field of crime be divided between the social politician, who prevents crime, and the doctor, who cures it.

Now, the Secession has hung five years of Klimt over us and, in a single room, we can study Mr Klimt's interpretation of philosophy, medicine and jurisprudence. Seeing this colour-drunk painter staggering through our modern life, one is either inclined to ridicule or, depending on mood and character, to be moved to pity. The only people who are contemptuous are those who have toadied to Mr Klimt — as companions or supporters — and take advantage of the ninety or thirty crowns they get for the Klimt publications they sell in the wake of the publicity he receives [...]

* *Die Fackel*, 21 November 1903.

Berta Zuckerkandl

'There's got to be a clean separation'*

I read the newspaper early in the morning. And there was one of those familiar bilious gripings of the Secession/Kunstschau/Gustav Mahler years with which many critics welcomed a golden age of Austrian art at the time. I read: "Gustav Klimt refuses to hand over to the Ministry of Education the ceiling paintings the state commissioned for the University hall. He has barricaded himself in his studio and declares that he will yield only to brute force. Measures are being taken to force the obstreperous artist to hand them over."

As soon as I read the report it was clear to me that Klimt had to answer this threat, that he would have to go public. I was editor of an early evening paper at the time. All copy had to be at the typesetters' by noon. There was no time to lose. At 9 o'clock I was outside Gustav Klimt's studio hidden away in a rear building in the Josefstädterstrasse. Everything still seemed calm there. No machine guns stared out at me. Only a note: "Don't ring. Won't be opened." However, I knew the knock that Klimt's friends used. And the door was opened, cautiously. "I must speak to you," I said quickly. "Today, you have no right to escape into a private fate. You must trumpet to the whole world what they are trying to do to art and artists."

The wild rhythm with which Klimt's words subsequently rained down can still be read on the yellowed sheets I found today. I shall never forget the wonderful drama of that raging storm. How I managed to write down the elemental eruption word for word was a miracle. Because Klimt stormed around the room as he spoke, tore pictures from the wall, threw them into a corner, emptied an inkpot, tore newspapers to shreds. The wrathful, rapid words still quiver on the yellow sheets:

"For an artist — a term of course I take in the highest sense — there is no situation more embarrassing than to create works for and be paid by a client who is not heart and mind completely behind the artist. Such a thing absolutely cannot happen to me, and for ages I've been looking at all the possible ways out of this situation, which I find absolutely humiliating for a real artist. Ever since that unfortunate 'state contract,' people in Vienna have got into

the habit of making Minister von Hartel responsible for all my other works. And gradually the Minister of Education seems to have taken it into his head that he really is responsible. That's why I'm vetted in unparalleled fashion at so many exhibitions. For example, I was forced in my big general exhibition to take down a picture that caused 'anxiety.' I did it because I didn't want to cause the Association any inconvenience. But I'd have stood by my work.

But in Düsseldorf, where our Austrian exhibition was an official one, someone from the Ministry of Education pressed for the removal of *Goldfish* before the opening because the German crown prince, who was to perform the opening, might have been shocked. It didn't happen, but you see what's possible.

The abrupt rejection of the exhibition project that the Secession drew up for St. Louis sprang from the same feelings of timidity. No, I've always been a terrible embarrassment for the Minister everywhere, and with the step I'm now undertaking I'm relieving him once and for all of the remarkable protectorship I've acquired there. I shall also never, certainly not under this ministry, participate in an official exhibition unless my friends force me to. I've had enough of censorship. I'm going to look after myself now. I want to be free. I want to regain my freedom, away from all these pointless absurdities that hold up my work. I reject all state support, I don't want any of it.

But what I've told you here is secondary. The main thing I want to confront is the way art is treated in the Austrian state and at the Ministry of Education. Whenever there's an opportunity, genuine art and genuine artists are under attack. They sponsor only what's feeble and false. Many things have happened to serious artists that I don't want to list here. I want to take up the cudgels for them and create clarity for once. There's got to be a clean separation. The state shouldn't be playing art patron when all it provides is charity at best. The state shouldn't arrogate to itself the dictatorship of the exhibition business and artistic debates where its duty is to act only as an intermediary and commercial agent and leave the artistic initiative entirely to artists. Officials should not be poking their noses into art schools and harassing artists, as currently happens in the most overweening fashion, without something being said about art politics of that kind in the strongest possible terms. If, as happened at the last meeting of the budgetary committee, the Secession was attacked by a speaker in the most humiliating and insulting way, and the Minister didn't feel prompted to say a word against it in reply, there should at least be a real artist who can prove by an action that real art wishes to have nothing more to do with authorities and agents like that. The spirit of mutuality has not accomplished this because the planned announcement of the artists' associations did not happen. All right then, an individual will have to do it. I'm not handing over my pictures because I want nothing more to do with clients who have no connection with real art and real artists."

This conversation with Klimt (merely summarised here) was published the same day. It was like a bomb going off. Klimt came off victorious. As he had wanted and demanded, the Ministry of Education was forced to take back the 18,000-crown advance from Klimt and leave the University pictures in his possession. Klimt had a lot to put up with in his later work as a result of this victory over official arrogance and the interference of the man-in-the-street. But — every crucifixion is a powerful example.

(1931)

* Berta Zuckerkandl, *Neues Wiener Journal*, 5 February 1931.

Hermann Bahr

Contra Klimt (*Beethoven Frieze*)[*]

Frankfurt, 20 April 1902

The representations of lasciviousness on the end wall of the room are among the most extreme ever devised in the field of obscene art. These are the paths Klimt wants to lead us to Beethoven!

Dr Robert Hirschfeld

Vienna, 20 April 1902

At first glance, the room on the left looks empty, but when one looks up at the walls, the disappointments multiply. A man and woman have their hands folded in front of them in Gothic style. A second gent, who was clever enough to hide his physique under armour, turns his back on them, and you can't blame him. The catalogue assures us that the couple have a "longing for happiness," which the "well-armed strong man" of course ignores. The narrow wall has fallen to "hostile forces" [...] Incidentally, the daughters have not fought in vain and have presented him with a pack of daughters. [...] They are just about the nastiest females I have ever seen. I merely report that Klimt dreamt them up to enrage us. In my mind, I quietly calculated how many millions these women would need in dowries to find husbands, particularly the fat one on the right, who is no whit excused by the fact she is called Excess.

Reichswehr Tageszeitung

Vienna, 28 April 1902

In the room opposite are the wall paintings by Klimt. Making a superficial estimate, Otto Wagner valued them at 100,000 crowns, so a report in an interview with him informs us. That's probably an exaggeration. But perhaps this high price will lure our state authorities into buying them, getting them moved to some suitable venue or other, for example a museum for ethnographical oddities, and thus conserving this contribution to *psychopathia pictoria* for posterity. Klimt — the most diligent and adroit of all quick-change artists — has this time come dressed up as Toorop. This appears to be the latest thing, *le dernier cri*. With a refined feeling for ornamental effect and with genuine taste that Toorop totally lacks, the most repulsive and revolting things ever produced by a painter's brush are shown here. Sodom and Gomorrah brought up to date, in white tie and tails, and with gardenia buttonholes. A depravity dreamt up by an apocalyptic imagination speaks from these emaciated or bloated figures, which are executed with a perfumed, cloying and yet stunning technique. The allegories are incomprehensible and banal withal; the internal connection with Klinger's Beethoven sculpture is as vague as possible — since you can relate anything you like to a genius — the external, formal, stylistic achievement being nil. "A beautiful body destroyed by an incurable disease," said Goethe of Kleist. One could say the same of Klimt, except that we suspect that this incurable disease is only simulated — it's not the done thing to be healthy these days. However, we do not consider Klimt a poseur; merely a spineless talent without *terra firma* or artistic ethos to hold on to, who, despite outstanding technical skills and splendid decorative imagination, bends to every external influence without a will of his own. The really great artists are not carved from such material.

Plein Air

[*] Hermann Bahr, *Gegen Klimt*, Leipzig/Vienna 1903, pp. 68, 69, 71–72.

Rosa Sala Rose

Glossary

Altenberg, Peter (pseudonym of Richard Engländer) (1858–1919)
Austrian writer and poet, born into a middle-class Jewish family. An active member of Viennese cultural and intellectual circles of the *fin de siècle*, he befriended the authors of the → Jung Wien (Young Vienna) such as Adolf → Loos, Karl → Kraus and Arthur Schnitzler. Alternberg defined his own style as "extracts of life" – brief impressions which are half way between dreams and reality, capable of giving the most banal detail a special significance. He was an admirer of Gustav Klimt, and through Hermann → Bahr he participated in the magazine → *Ver Sacrum* and wrote an introduction to the catalogue *The Works of Gustav Klimt* (1908).

Bahr, Hermann (1863–1934)
Essayist, critic and novelist. Always true to his motto that 'art should always revolutionary,' he embraced Naturalism, then later also Symbolism and Expressionism. During his stay in Vienna (1891–1912) he became a celebrated critic, and the frequent target of attacks by Karl → Kraus, his chief journalistic adversary. His artistic theories had a deep influence on the writers of the → Jung Wien (Young Vienna), notably Schnitzler and Hofmannsthal. A defender of the concept of 'the total work of art,' he became a supporter of the artists of the Secession. He participated in the draft of → *Ver Sacrum*, and became a close friend of Klimt. During the controversy provoked by the University paintings, Bahr, who had purchased Klimt's polemic painting *Nuda Veritas,* stood firmly on Klimt's side. In 1903, Bahr published a collection of hostile criticism of Klimt under the title *Gegen Klimt* (Contra Klimt).

Canon, Hans (pseudonym of Johann Strašiřipka) (1829–1885)
Painter and portraitist, he studied at the Vienna Academy of Fine Arts. After long journeys to west Europe, Italy and to several countries in the East, and a long stay in Germany (Karlsruhe and Stuttgart), Canon returned to Vienna and spent the rest of his life there. He became famous in 1858 for his painting *The Young Fisherwomen*, though his *St. John's Lodge*, exhibited in the Universal Exposition in Vienna, is perhaps one of his most remarkable, linking the theme of the adoration of Christ with Free Masonry. From that date, Canon dedicated himself to painting murals, mostly to decorate the buildings of the Ringstrasse, including the allegory the *Cycle of Life*, on the stairs of the Museum of Natural History. Although he remained truthful to Ruben's style, this work was an antecedent and inspiration for the themes of Klimt's University paintings.

Engelhart, Josef (1864–1941)
Austrian painter, a founder member of the Secession. His several journeys to Spain, Greece and Italy enabled him to learn foreign languages, a skill that later helped him to invite foreign artists to the first Secession exhibition. He advised Moll to move from the Secession to the Miethke Gallery, an act that provoked a controversial election that led some artist, notably Klimt, Josef → Hoffmann and Otto → Wagner, to abandon the Secession.

Fellner von Feldegg, Ferdinand (1855–1936)
Architect, philosopher and art critic. He studied at the Vienna Academy of Fine Arts, and during the period 1884–1919 was a teacher of architecture in the Professional School of Vienna. He was significant as a philosopher, developing a metaphysic theory according to which emotion is the basis of existence and of the universal order. In order to explore the basis of emotion, Fellner von Feldegg went back to the biological root of primitive forms, exploring the close links between the natural sciences and philosophy. A prolific writer, he was the author of several articles on Klimt.

Ferstel, Heinrich von (1828–1883)
Architect, designer of the new University of Vienna. Initially, his architectural style embraced both Neo-Gothic and Neo-Romanesque. After his journeys to Italy, however, he adopted a style based on Renaissance architectural forms. He died unexpectedly before completing his second major work, the new University. Ferstel planned to crown the ceiling of the great hall with one large painting and four smaller ones. This unfinished decorative scheme was later handed to Klimt and Franz von → Matsch.

Flöge, Emilie (1874–1952)
Dress-maker and fashion designer. She was a friend of the Klimt siblings from childhood, and her sister Helene married Ernst Klimt. She met Klimt in 1891 and later became his lover. In 1904, she and her sisters opened a fashion house in Vienna named *Schwestern Flöge* (the Flöge Sisters). They refused to use the repressive corset and complicated hairstyle of the period, instead designing loose dresses that resembled those in Klimt's paintings. Emilie Flöge modelled her own dresses at fashion shows. They had a great success among the Vienna aristocracy and the haute bourgeoisie, and especially among Jewish women. It is thought that around twenty dresses produced by the → Wiener Werkstätte (Vienna Workshop) and sold in the Flöge fashion house were designed by Klimt.

Hagenbund＊
Artists' association. Founded in 1900 under the name Künstlerbund Hagen, it was, after the Künstlerhaus and the Secession, the third most important artists' association in Vienna. In 1938 it was dissolved by the National Socialists. From 1902 it held exhibitions not only of members of the association, but also for guest exhibitors such as Oskar Kokoschka (1912) and Egon Schiele (1912).

Hartel, Wilhem von (1839–1907)
Austrian statesman. From 1900 to 1905, Hartel was Minister of Education and Culture. As vice president of the Academy of Science, he promoted international co-operation in scientific research. Hartel always showed a liberal and tolerant attitude towards art, patronising young artists and promoting modern and cosmopolitan art, a strategy he thought would ease the antagonisms of a country divided by national differences. During the confrontation provoked by the paintings of Klimt in the University, he always stood bravely on Klimt's side against the professors who condemned the paintings. But by 1901 he had begun to distance himself from Klimt, and told Klimt that his work was disrespectful towards the institution that had commissioned him. In 1904 Klimt sent him a letter withdrawing from the project and also offering to repay the fees he had received by that stage. Wanting to diffuse the controversy, Hartel accepted with relief.

Hevesi, Ludwig (1842–1910)
Writer and art critic. The son of a Hungarian doctor, Hevesi studied both medicine and classical philology in Vienna. As a critic he openly defended the first Secessionists such as Anton Romanko and Theodor von Hörmann, and in time became the chronicler of the Secession. He stood on the side of the so-called Stylists, among whom stood Klimt. He introduced the motto 'For the time, its art. For art, its freedom.' Hevesi also wrote novels, humorous articles and travel books. In 1920 he shot himself in his apartment in Vienna.

Hoffmann, Josef (1870–1956)
Austrian architect, designer and painter. His main artistic inspirations were ancient architecture and the British Arts and Crafts movement (he was a friend of Charles Rennie Mackintosh). He joined the Secession and rapidly established a reputation at the first Secessionist exhibition, in one of the pavilions of the Parkring. Together with Kolo → Moser he founded the → Wiener Werkstätte (Vienna Workshop), an institution that produced most of his works. In 1900 his style changed dramatically, moving from the Secessionist style to far simpler and more linear forms. The most remarkable example of his designs was the fourteenth Secession exhibition in 1902, the theme of which theme was the Beethoven monument by

Max → Klinger. He died ignored by younger artists. None of his interiors has survived, and his work was almost entirely forgotten until the 1970.

Hölderlin, Friedrich* (1770–1843)
German poet. His work stood apart form the German literature of 1800s, being a mixture of Romanticism and Classicism. He was largely forgotten until the later poet Stefan George started to edit his works. The poetry of Hölderlin was introduced in the Viennese literary circles through a friend of George, Hugo von Hofmannsthal. Unlike his contemporaries, who saw the ancient world as dead and distant, Hölderlin saw the truths of classical Greece as still alive and relevant, embodying both the beautiful and the terrible. He referred in his lyrics to the Greek idea of the "tragic destiny."

Jodl, Friedrich (1849–1914)
German philosopher and psychologist. After becoming a doctor of philosophy, history and the history of art in Munich, in 1896 he became a professor of philosophy in the University of Vienna. He lived in Vienna until his death. A follower of Auguste Comte and Ludwig Feuerbach, he was closely linked to the Monistic League. He was also the co-founder and director of the German Association for Ethical Culture. For Jodl, the task of art is to express reality. A positivist, Jodl became the most important opponents of Klimt's paintings, which he saw as obscure and symbolic, an escape from the realities of life.

Jung Wien (Young Vienna)
Group of writers based in Vienna. Their spokesman was Hermann → Bahr. Other members included Arthur Schnitzler, Hugo von Hofmannsthal, Peter → Altenberg, Richard Beer-Hofmann and Karl → Kraus. Karl Kraus later distanced himself from this movement. The group was loosely organised and did not have a well-defined public image.

For all of these authors, Bahr's theory of *Nervenkunst* ('nervous art'), according to which art should express the states of the spirit, was particularly important. Typically, the writers of Young Vienna employed a wide range of forms, often combining fiction and non-fiction. The group's journal was Herman Bahr's weekly *Die Zeit*.

Klimt, Ernst (1864–1892)
Austrian painter. He was the brother of Gustav Klimt, who was his senior by two years. In 1880 he married Helene Flöge, the elder sister of Emilie → Flöge, Gustav's lover. The death of Ernst left Gustav responsible for Helene and her daughter, as well as his own mother and sisters. These circumstances provoked a creative crisis in Klimt and helped him to opened up a new style.

Klinger, Max (1857–1920)
German painter and sculptor. He was educated in Karlsruhe and Berlin. He showed in his art an eclectic mix of the most remarkable trends of the time. Music and philosophy (→ Nietzsche and → Schopenhauer) had a great influence on him. Following Richard → Wagner, he tried to combine Christian and pagan themes in his art. He also experimented with sculptural techniques and materials, his use of polychrome stones being particularly innovative. He used this approach in his masterpiece, the Beethoven monument. Finally completed in 1902, after seventeen years of work, it was based on the description given by Pausanias of a statue of Zeus by the Ancient Greek sculptor Phidias. His use of expensive materials, such as gold, ivory and pearls enjoyed great success in Vienna, and anticipated some aspects of the Jugendstil (Art Nouveau). The young artists of the Secession greatly admired Klinger, and in the exhibition of 1902 they tried to realise the ideal of a 'total work or art' that Klinger had defended in his 1891 essay *Malerei und Zeichnung* (Painting and Drawing), in other words a work that harmoniously combined painting, sculpture and architecture.

Kraus, Karl (1874–1936)

Austrian essayist and journalist. Born into a Jewish family from Bohemia, Kraus studied philosophy and law in Vienna. He founded his own newspaper, *Die Fackel*. Highly critical of nationalism and actively supporting social democracy, it rapidly became a forum for ideological and cultural criticism, typically written in a sharply satirical style.

He opposed Expressionism because he saw it as an artificial fashion promoted by capitalism and the media. In his satire *Die demolierte Literatur* (Demolished Literature) of 1896, he criticised both the aesthetics and the social indifference of the writers of → Jung Wien (Young Vienna). Kraus was particularly vocal during the Klimt affair, not really to attack Klimt – though he never recognised his worth – but to poke fun at two of his own enemies, the journalists Hermann → Bahr and Ludwig → Hevesi, both keen supporters of Klimt.

Kunstgewerbeschule* (School of Applied Arts)

Art school founded in 1867 by the Österreichisches Museum für Kunst und Industrie (Austrian Museum of Art and Industry). The Kunstgewerbeschule obtained its prestige thank to R. Eitelberger and other well-know professors, including Josef → Hoffmann, Kolo → Moser and Alfred → Roller. Gustav Klimt studied there from 1876 to 1833. His brother → Ernst and his colleague Franz von → Matsch also studied there.

Künstlerhaus*

Artists' society. It was founded in 1861 to represent Viennese artists, sculptors and architects, under the name Genossenschaft der bildenden Künstler Wiens (Viennese Society of Artists). From 1876 known as the Gesellschaft bildender Küstler Österreichs (Co-operative Society of Austrian Artist). After the formation of the Secession in 1897, it rapidly started to lose its significance as a key supporter of young artists.

Lederer, August* (1857–1936)

Austrian industrialist. The owner of an important art collection, he is best remembered for his patronage of Gustav Klimt. In 1899, Klimt painted a portrait of his wife, Serena Lederer. August bought Klimt's *Philosophy* in 1905 and in 1915 the *Beethoven Frieze*. He was the owner of the largest collection of Klimt works at that time.

Lex Heinze

Controversial German law approved in February 1900. It prohibited prostitution, and also all 'immoral' representations in art, literature and the theatre. That meant prohibiting every painting or piece of literature that "even if they were not obscene, could offend the decent," a vague description that placed art under a very capricious censorship. This controversial law of a close neighbour was taken by Austrians as a sign of intellectual and cultural regression and provoked many aesthetic debates.

Lipiner, Siegfried (1856–1911)

Polish writer and translator. In 1871 he moved to Vienna, where he studied literature and science. From 1878 he dedicated himself to literary activities and to the translation of many Polish authors into German. He admired → Nietzsche, and sought a 'revaluation' of religion. He befriended Gustav → Mahler and became his intellectual mentor. His central belief was that of salvation through suffering, as represented by the mythological figure Prometheus.

Loos, Adolf* (1870–1933)

Architect and critic. He studied in Dresden. After a stay in the USA (1893–1896), he settled in Vienna. He was impressed by Otto → Wagner's theories. In his widely influential *Ornament und Verbrechen* (*Ornament and Crime*), an essay written in 1908, he declared himself opposed to the Jugendstil (Art Nouveau) and the → Wiener Werkstätte (Vienna Workshop).

Mahler, Gustav * (1860-1911)

Austrian composer. From 1897 he was the conductor of the Vienna State Opera, which under his direction experienced a revival. He brought numerous musical celebrities to Vienna (for example Bahr-Mildenburg) and introduced important innovations. From 1898 to 1901 he also was the conductor of the Philharmonic concerts. In 1902 he married Alma Maria Schindler (Alma Mahler-Werfel). From 1909 he was conductor of the Metropolitan Opera in New York. In 1909 he returned to Vienna, struck down by an incurable illness.

Matsch, Franz von (1861-1942)

Viennese painter and sculptor. In the early days of his career he worked closely with Gustav and Ernst Klimt. The three had so much success that they decided to set up their own workshop and created a business called the Künstlercompagnie (Artists' Company), which was dissolved in 1892. However, in 1894 he worked with Klimt again on the ceremonial hall of the new University.

Miethke Gallery *

Art gallery founded by H. O. Miethke in Vienna 1861. In 1904 it was acquired by the jeweller Paul Bacher, a friend of Klimt. Under the artistic direction of Carl → Moll it became the most prominent gallery in Vienna during the early years of the twentieth century. Until 1904, the gallery exhibited mostly Viennese painters, such as R. von Alt and H. Markart. In 1905, the gallery exhibited works of the → Wiener Werkstätte (Vienna Workshop), and after that mainly works by the Klimt group, though also foreign artists such as Picasso and Claude Monet. In 1919 it became the Haus der jungen Küntslerschaft (Young Artists' House), and in 1936 it was acquired by the Dorotheum auction house.

Moll, Carl (1861-1945)

Austrian painter. He began his studies at the Fine Arts Academy of Vienna, but had to end them due to his poor health. He decided to continue his studies under the painter Emil Jakob Schindler. In 1892, Schindler died and Moll married his widow, becoming the stepfather of Alma Scindler, who later married Gustav → Mahler. In 1897 Moll joined the Viennese Secession, and he was its president from 1900 to 1901. A skilled organiser, he was in charged of most of the exhibitions that involved foreign artists. In 1905 he abandoned the Secession and the Klimt group, mostly because of his relationship with the → Miethke Gallery.

Moser, Kolo(man) (1868-1918)

Painter, illustrator and designer. In 1897 he was one of the founder members of the Secession. Because of his experience as an illustrator, he was assigned the task of designing the Secessionist journal, → *Ver Sacrum*. He, together with Joseph Maria → Olbrich, participated in the building of the Secession exhibition hall, for which he designed the windows and the decorative friezes. In 1908 he joined the School of Applied Arts as a teacher, where he specialised in design objects and domestic goods. In 1901 he decorated the tenth exhibition of the Secession, and in 1903 founded, with Josef → Hoffmann, the → Wiener Werkstätte (Vienna Workshop). In 1907 he had to abandon the company because it was unprofitable. His financial position recovered with his marriage in 1911 to Editha Mautner-Markhof, and he was able to purchased two of the three paintings that Klimt produced for the University, *Medicine* and *Jurisprudence*. When he died, some of his collection went to the Österreichische Staatsgalerie Belvedere (the Austrian state museum), and some to the Lederer family.

Nietzsche, Friedrich (1844-1900)

German philosopher. During his studies (theology and classics) he was deeply influenced by Arthur → Schopenhauer and Richard → Wagner. His career began in 1862 with the publication of *The Birth of Tragedy from the Spirit of Music*. His most significant and influential contribution to the theory of art during the late nineteenth century was his concept of the essential unity of the 'Apollonian and the Dionysian.' Under rationalism, this unity was broken, he argued, but in the operas (or 'music dramas') of Wagner they were unified again. He later turned against Wagner.

Neumann, Wilhelm (1837–1919)
Theologian and priest. A reformist theologian, he introduced scientific seminars to the theology faculty of the University of Vienna. In 1899 he was elected Rector of the University, and was in that position during the controversy aroused by Klimt's faculty paintings, becoming the leader of the University's protest against the paintings.

Olbrich, Joseph Maria (1867–1908)
Austrian architecture and designer. In 1894, after his studies at the Vienna Fine Arts Academy, Olbrich started working for Otto → Wagner, and founded his own architectural office in 1898. He met Gustav Klimt around 1896, and became one of the founders of the Secession. His rapidly constructed, low-budget exhibitions centre, which was inaugurated in 1899, brought him international fame. It was a design that achieved a unified and harmonic environment for exhibiting paintings and sculptors, one truthful to Richard → Wagner's concept of a 'total work of art.' The façade as well as the interior, thanks to Klimt, was in a simple style, very rare for that epoch. The building had only one source of natural light, which could be adjusted as desire. Working to a commission from the Archduke of Hesse-Darmstadt, he later created an artists' colony in Mathildenhöhe, developing a very original architectural style that distanced him from the Jugendstil (Art Nouveau) and made him be an early precursor of Functionalism.

Reininghaus, Carl (1867–1929)
Austrian industrialist, owner of one of the most important Austrian collections of art. In 1903 he bought the *Beethoven Frieze*, which was just about to be destroyed. In 1915 he sold it to August → Lederer. Reininghaus supported many young and unknown artists, both by buying their works and by promoting competitions. He was a closed friend of Alma Mahler-Werfel, who introduced him to many Viennese artists and intellectuals.

Roller, Alfred* (1864–1935)
Set designer, painter and graphic artist. In 1897 he was a founder of the Vienna Secession, and in 1902 he became its president. From 1899 he was a professor at the Kunstgewerbeschule (School of Applied Arts) in Vienna, and in 1909 was elected its director. In 1903 Gustav → Mahler employed him in the Vienna State Opera, making him responsible for the set designs. He worked there until 1909. In a happy collaboration with Mahler, he transformed opera design, aiming to create a unique work of art that combined space, colour and light with music, words and gesture.

Salten, Felix (pseudonym of Siegmund Salzmann) (1869–1945)
Writer and theatre critic. He belonged to the → Jung Wien (Young Vienna) literary circle and was president of the Austrian PEN Club from 1917 to 1933. In 1939 he emigrated to Switzerland.

Schopenhauer, Arthur (1788–1860)
German philosopher. His pessimistic but eloquent writings were widely read at the turn of the century, notably by the Secessionists. The essence of his main work, *The World as Will and Representation*, influenced the *Beethoven Frieze*. He believed that our knowledge of the world is illusory, and that the reality behind appearances is a blind cosmic Will. Man is not free, but the slave of his nature, which is simply another aspect of Nature, unable to find final satisfaction or happiness. Man, in other words, is the plaything of forces over which he has no control and of which he is largely unaware (intellect is largely futile). Art is privileged in providing momentary relief from the endless round of striving and failing. The final escape is to be found in the release from desire (an idea derived from the Buddhist concept of Nirvana).

Servaes, Franz (1862–1947)
German writer, journalist and literary critic. After becoming a doctor of philology, he started a career in Berlin that brought him into contact with the key German writers of the period. His first publications were on art,

notably his 1902 monograph *Max Klinger.* Thank to Hermann → Bahr, in 1899 Servaes moved to Vienna to work as an art critic for the newspaper *Neue Freie Presse*, and in 1904 he became the director of its culture magazine. During this period, Servaes became one of the chief antagonists of the journalist Karl → Kraus. He returned to Berlin in 1905, after having achieved literary fame with a drama based on the life of the writer Heinrich Kleist.

Toorop, Jan (1858-1928)

Dutch artist. He was born in the former Dutch colony of Java, Indonesia, moving to Holland in 1872. He pursued his artistic education in Delft, Amsterdam and Brussels. By 1885 he had developed his own version of pointillism, a style he continued to employ until 1908. From 1908, influenced by Maurice Maeterlinck, he adopted Symbolist themes, attempting to personify the 'positive and negative.' His figures, their wavy hair and rounded auras showed the influence of Javanese shadow puppets. His use of space, and in particular the disposition of his figures, greatly influenced Gustav Klimt. In 1905, Toorop converted to Catholicism and from then on his themes were mostly religious.

Ver Sacrum

Magazine founded in 1898 by the Vereiningung bildender Künstler Österreichs (Austrian Artists' Association, i.e. the Secessionists). Its main function was to spread the ideas of the Vienna Secession. Its Latin name, which means 'Sacred Spring,' refers to the Roman practice, during times of danger, of sacrificing young people during the spring in order to ensure good fortune. The Greek goddess Pallas Athene was adopted as the journal's patron. Until 1899 it was a monthly magazine, after that a fortnightly. It had an untypical format, almost square, and due to its artistic quality and the few numbers published it rapidly became highly collectable. In *Ver Sacrum* the text was considered an essential element of the overall design, which is why great care was taken over the typography. The Secessionists showed their interest not only in the fine arts, but also in crafts and the other arts, so included literary texts and articles about music, mostly thank to the contacts made by Hermann → Bahr. In 1900, Klimt took part as an editorial adviser, and he also became one of the main graphic illustrators. The journal ceased publication in 1903, partly because it had already achieved its goal (to promote the Secession), and partly because of the tensions caused by the division of the artists into two group: the Stylists (*Stilisten*), led by Josef → Hoffmann and Klimt, and the Naturalists (*Nurmaler*), led by Josef → Engelhaft.

Waerndorfer, Fritz* (1868-1939)

Industrialist. He came into contact with the artists of the Secession thank to Hermann → Bahr, and financed the → Wiener Werkstätte (Vienna Workshops), founded in 1903 by Josef → Hoffmann. He owned a large collection of art and his patronage was important for many artists of the Secession. He owned *Hope* and *Pallas Athene* by Klimt. In 1902 he asked the Scottish artist and designer Charles Rennie Mackintosh to design a music room for his house in Vienna; the living room was designed by Josef Hoffmann and by Margaret Macdonald, Mackintosh's wife. The frieze of the living room was inspired by the works of the Belgian poet Maurice Maeterlinck. Klimt would have known this work because he knew Waerndorfer: the slender figures created by Margaret Macdonald Mackintosh clearly inspired the Floating Figures of the *Beethoven Frieze.*

Wagner, Otto* (1841-1918)

Architect and art theorist. He was the most celebrated architectural authority in Vienna at the end of the nineteenth century and the beginning of twentieth. His practical and theoretical work was always guided by his endeavour to create a 'total work of art.' Even though he strongly supported the transition to modern realism and functionalism, he remained loyal to the belief that architecture must go beyond simple functionalism.

Wagner, Richard* (1813-1883)

German composer. After reading Schopenhauer's *The World as Will and Representation* in 1854, Wagner developed the idea that the arts, and especially music, by uniting intellect and the instinct, were able to

reveal the original unity of all beings. His aim was a 'total work of art,' an idea he developed not only in his operas (or 'music dramas'), but also in his writings, which were widely discussed by the Viennese Secessionists.

Weininger, Otto* (1880–1903)

Austrian philosopher. He studied science, mathematics and philology. In 1902 he converted from Judaism to Catholicism, and the following year committed suicide in a house in which Beethoven had once lived. In his controversial *Gender and Character* of 1903 he asserted that all humans were essentially bisexual, and that men were intellectually superior to women, for the feminine was governed by instinct, the masculine by intellect. His ideas on gender had a profound impact on Klimt.

Welträtsel (The Riddle of the Universe)

A term popular in Viennese cultural and intellectual circles in the early years of the twentieth century. It originated with the German naturalist Ernst Haeckel, who in 1899 published an essay under this title. The essay was a response to the ideas of the scientist Emil du Bois-Reymond, who had tried to define the seven riddles of the world, in other words the seven limits that nature imposes on human knowledge. For Haeckel, modern science had reduced these seven riddles to one: What is the true essence of the universe? Haeckel's book was so popular that the word 'Welrätsel' became widely used in the scientific, philosophical and cultural debates of the era. For the critic Ludwig → Hevesi, the sphinx that appears in Klimt's *Philosophy* is an allegorical representation of Wetlrätsel.

Wickhoff, Franz (1853–1909)

Austrian art historian and founder member of the 'Viennese School' of art history. In 1885, after working as curator at the Museum of Arts and Industry, he became a professor at the University of Vienna. During the controversy created by Klimt's paintings in the Great Hall of the University, he supported Klimt. He communicated his support by sending a telegraph to the Rector, and on 9 May 1900 he gave a public speech under the title 'What is Ugly?' In his response to such critics of Klimt as Friedrich → Jodl, he argued that they were blinded by traditionalism and so were incapable of appreciating contemporary expressions of beauty.

Wiener Werkstätte* (Vienna Workshop)

Artists' association, founded by Josef → Hoffmann and Kolo → Moser in 1903 under the name Wiener Werkstätte GmbH. Its members were artists, designers and craftsmen who had been inspired by the ideas of the English and Scottish Arts and Crafts movement. Aiming to reform art by reviving the crafts, this institution worked with the Viennese → Kunstgewerbeschule (School of Applied Arts) and the Viennese Secession. The many products of the Wiener Werkstätte ranged from architecture to simple everyday objects. Its main achievement was to replace luxuriant Jugendstil (Art Nouveau) ornamentation with simple geometrical shapes, a style that decisively influenced twentieth-century industrial design.

Zuckerkandl-Szeps, Berta (1864–1945)

Journalist. Born Berta Szeps into a Jewish family, she married Emil Zuckerkandl and was the sister-in-law of the French Primer Minister Georges Clemenceau. Her home became a meeting place for famous personalities from the world of arts and culture in Vienna at the turn of the century, including Sigmund Freud, Hugo von Hofmannsthal, Gustav → Mahler, Max Reinhardt and Arthur Schnitzler. She followed her father's career, becoming a journalist for the *Neuer Wiener Tagblatt*. She wrote many articles for this newspaper and for other publications, where she always passionately defended new artistic trends, and was a keen supporter of Klimt.

* Written by Dietrun Otten.

Bibliography

Bisanz-Prakken, Marian, *Der Beethovenfries. Geschichte, Funktion, Bedeutung,* Salzburg, 1977.

Bisanz-Prakken, Marian, 'Der Beethoven-Fries von Gustav Klimt in der XIV. Ausstellung der Wiener Secession (1902),' in: *Traum und Wirklichkeit, Wien 1870–1930,* exh. cat., Historisches Museums der Stadt Wien, Vienna 1985, pp. 528–543.

Dobai, Johannes / Novotny, Fritz, *Klimt,* Salzburg, 1967.

Egger, Hanna / Robertson, Pamela / Trummer, Manfred / Vergo, Peter, *Ein moderner Nachmittag. Margaret Macdonald Macintosh und der Salon Waerndorfer in Wien,* Vienna, 2000.

Exh. cat., *Ver Sacrum. Die Zeitschrift der Wiener Secession, 1898–1903,* Historisches Museum der Stadt Wien, Vienna, 1983.

Exh. cat., *Max Klinger, Wege zum Gesamtkunstwerk,* Roemer- und Pelizaeus-Museum, Hildesheim, 1984.

Exh. cat., *Gustav Klimt. Modernism in the Making,* Colin Bailey (ed.), National Gallery of Canada, Ottawa 2001.

Hiles, Timothy W., 'Gustav Klimt's Beethovenfrieze. Truth and The Birth of Tragedy,' in: *Nietzsche and the Arts,* Cambridge, 1998.

Hofmann, Werner, *Gustav Klimt und die Wiener Jahrhundertwende,* Salzburg, 1970.

Huemer, Christian, 'Gustav Klimt–The Prophet of Viennese Modernism. Marketing and Cult at the Secession,' in: Stephan Koja (ed.), *Gustav Klimt. Landscapes,* München/Berlin/London/New York, 2002.

Leshko, Jaroslav, 'Klimt, Kokoschka und die mykenischen Funde,' in: *Mitteilungen der österreichischen Galerie,* XIII, 1969, 57, pp. 18–40.

Nebehay, Christian M., *Gustav Klimt. Dokumentation,* Vienna, 1969.

Nebehay, Christian M., *Ver Sacrum, 1898–1903,* Vienna, 1975.

Nebehay, Christian M., *Gustav Klimt. Das Skizzenbuch aus dem Besitz von Sonja Knips,* Vienna, 1987.

Schorske, Carl E., *Fin-de-siÈcle Vienna: Politics and Culture,* New York, 1980.

Strobl, Alice, 'Zu den Fakultätsbildern von Gustav Klimt,' in: *Albertina Studien,* II, 1964.

Strobl, Alice, *Gustav Klimt. Die Zeichnungen 1878–1918,* catalogue in 4 vols, Salzburg, 1980–1989: vol. 1 (1878–1903), vol. 2 (1904–1912), vol. 3 (1913–1918), vol. 4 (Supplement).

Vergo, Peter, 'Gustav Klimt's Beethoven Frieze,' in: *The Burlington Magazine,* CXV, 1973.

Vergo, Peter, 'Gustav Klimt und das Programm der Universitätsgemälde,' in: *Klimt-Studien,* Mitteilungen der österreichischen Galerie, 22–23, 1978/79, Salzburg, 1978.

Contemporary texts

Ausstellungskatalog der XIV. Ausstellung der Vereinigung bildender Künstler Österreichs Secession Wien. Klinger, Beethoven, Vienna, 1902.

Bahr, Hermann, *Gegen Klimt,* Leipzig/Vienna, 1903.

Bahr, Hermann, *Rede über Klimt,* Vienna, 1901.

Hevesi, Ludwig, *Acht Jahre Secession (März 1897–Juni 1905). Kritik–Polemik–Chronik,* Vienna, 1906 (reprint: Klagenfurt 1984).

Klinger, Max, *Malerei und Zeichnung,* Leipzig, 1891.

Lux, Joseph August, Das neue Kunstwerk in Deutschland, Leipzig 1908, Wiens heiliger Frühling, pp. 88ff.

Lux, Joseph August, 'Beethoven und die moderne Raumkunst,' in: *Deutsche Kunst und Dekoration,* X, April–September 1902, pp. 480ff.

Strzygowski, Josef, Die bildende Kunst der Gegenwart, Leipzig, 1907, pp. 27, 239f.

Zuckerkandl, Berta, 'Eine reinliche Scheidung soll sein,' in: *Wiener Allgemeine Zeitung,* 14 November 1903.

Index

This book has been published in conjunction with the exhibition
La destrucción creadora. Gustav Klimt, el Friso de Beethoven y la lucha por la libertad del arte,
held at the Fundación Juan March, Madrid, from October 6, 2006 to January 14, 2007

Exhibition:
Curator: Stephan Koja. Assistant: Dietrun Otten
Exhibition organisation: Fundación Juan March (Madrid)

Cover: Gustav Klimt, *The Hostile Forces*: *Typheus* and *Lasciviousness* (detail from the *Beethoven Frieze*)

Endpaper (front):
Some members of the Secession in the main hall of the Beethoven Exhibition 1902. From the left: Anton Stark, Kolo Moser (seated, with hat), Gustav Klimt (seated) behind, Adolf Böhm, Maximilian Lenz (lying), Ernst Stöhr (with hat), Wilhelm List, Emil Orlik (seated), Maximilian Kurzweil (with cap), Carl Moll (lying), Leopold Stolba, Rudolf Bacher

Frontispiece:
Gustav Klimt, *Choir of the Angles of Paradise* and *"This Kiss to the Entire World"* (detail from the *Beethoven Frieze*)

Page 4:
Gustav Klimt, *The Arts* (detail from the *Beethoven Frieze*)

Page 6:
Beethoven Exhibition 1902, left side-hall with Gustav Klimt's *Beethoven Frieze* (detail)

Page 9:
Beethoven Exhibition 1902, main hall with Max Klinger's Beethoven sculpture; in the background, Alfred Roller's *Falling Night*

Endpaper (back):
Beethoven Exhibition 1902, left side hall with Gustav Klimt's *Beethoven Frieze*, on the far wall two reliefs by Ernst Stöhr, one relief by Josef Hoffmann above the door and, in front of this, a *Girl's Head* by Max Klinger

Fundación Juan March
Castelló, 77
E-28006 Madrid
Teléfono: + 34 (91) 435 42 40
Telefax: + 34 (91) 431 42 27
www.march.es

Prestel Verlag
Königinstraße 9
D-80539 München
Telefon +49 (89) 38 17 09-0
Telefax +49 (89) 38 17 09-35
www.prestel.de

Prestel Publishing Ltd.
4, Bloomsbury Place
London, WC1A 2Qa
Tel.: +44 (020) 7323 5004
Fax.: +44 (020) 7636 8004

Prestel Publishing
900 Broadway, Suite 603
New York, NY 10003
Tel.: +1 (212) 995 2720
Fax.: +1 (212) 995 2733
www.prestel.com

Projekt Management: Victoria Salley, Anja Besserer
Copy-edited by: Chris Murray, Crewe
Translated by: Paul Aston (foreword, contemporary documents), Robert McInnes (captions, Koja, part of Strobl), (glossary), Bronwen Saunders (part of Koller, Perlhefter)
Design and layout: Wolfram Söll, designwerk, Munich
Production: Cilly Klotz, René Güttler
Typesetting: EDV-Fotosatz Huber, Germering
Origination: Reproline Mediateam, Munich
Printing: Aumüller, Regensburg
Binding: Conzella, Pfarrkirchen

Printed in Germany on acid-free paper.

English trade edition:
ISBN: 978-3-7913-3757-9

German trade edition:
ISBN: 978-3-7913-3756-2

Spanish catalogue edition:
ISBN: 84-7075-536-6 Fundación Juan March (Madrid)
ISBN: 84-89935-62-9 Editorial de Arte y Ciencia, S.A. (Madrid)